Photo2006

CEO & Creative Director: B. Martin Pedersen

Editors: Natalie Kresen, Carla Miller
Designer: Danielle Macagney
Production Manager: Luis Diaz

Published by Graphis Inc.

(opposite page) Georg Wendt (next page) Phil Marco

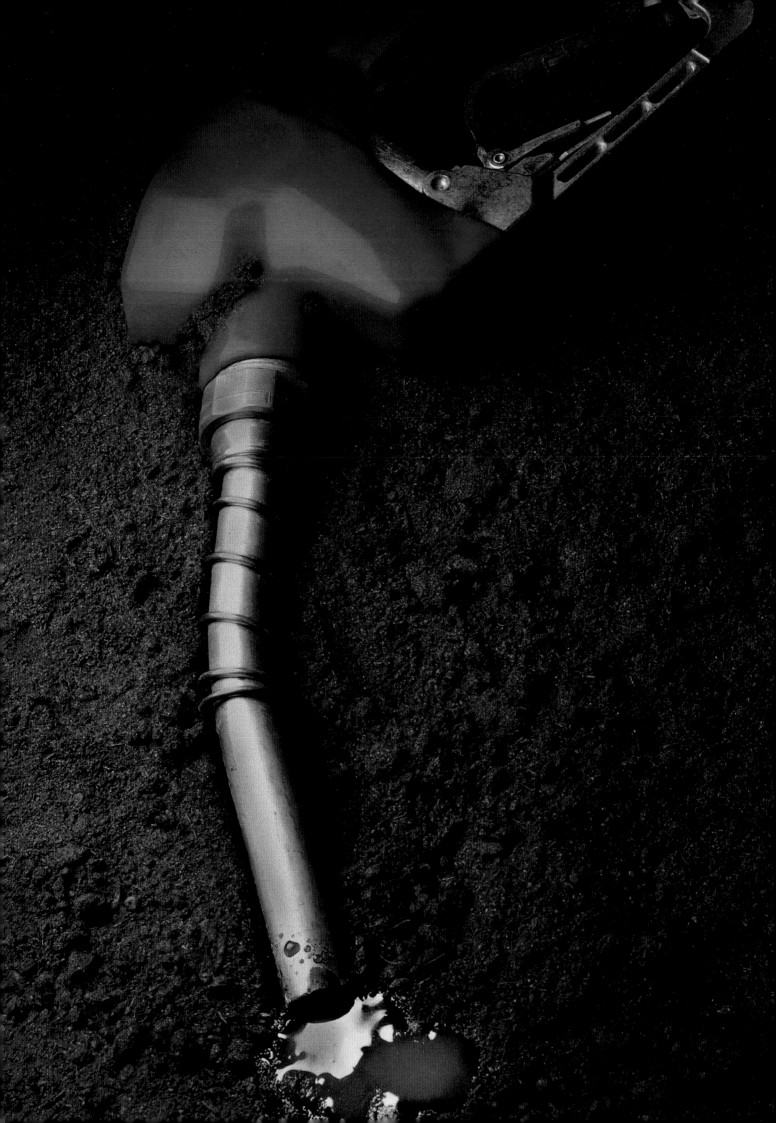

Contents Inhalt Sommaire

Remarks: We extend our heartfelt thanks to contributors throughout the world who have made it possible to publish a wide and international spectrum of the best work in this field. Entry instructions for all Graphis Books may be requested from: **Graphis Inc.**, 307 Fifth Avenue, Tenth Floor, New York, New York 10016, or visit our Web site at www.graphis.com.

Anmerkungen: Unser Dank gilt den Einsendern aus aller Welt, die es uns ermöglicht haben, ein breites, internationales. Spektrum der besten Arbeiten zu veröffentlichen. Teilnahmebedingungen für die Graphis-Bücher sind erhältlich bei: **Graphis Inc.**, 307 Fifth Avenue, Tenth Floor, New York, New York 10016. Besuchen Sie uns im World Wide Web, www.graphis.com.

Remerciements: Nous remercions les participants du monde entier qui ont rendu possible la publication de cet ouvrage offrant un panorama complet des meilleurs travaux. Les modalités d'inscription peuvent être obtenues auprès de: **Graphis Inc.**, 307 Fifth Avenue, Tenth Floor, New York, New York 10016. Rendez-nous visite sur notre site web: www.graphis.com.

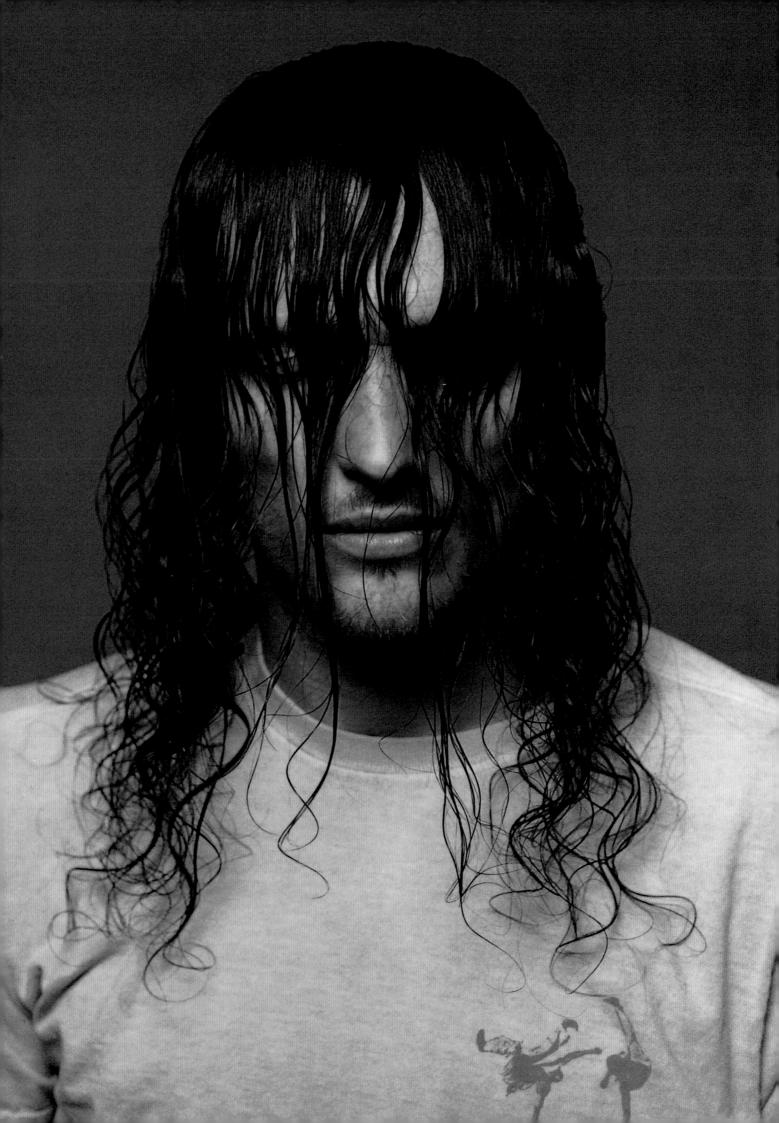

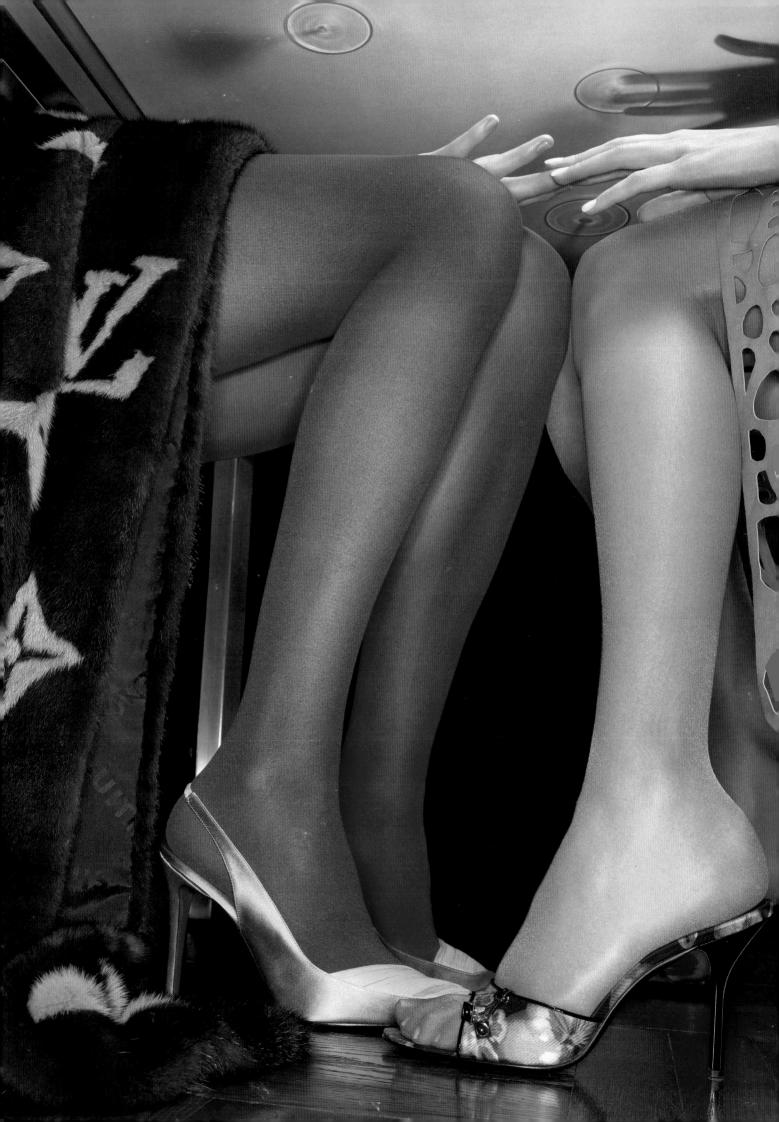

Q&A Bill Diodato Under the Table

What is the story behind this photograph?

I had a dinner party about a month before this shoot and happened to notice all this sexiness under the table. I was shocked at the amount of money spent on furs, shoes, and the rest of the fashion accessories no one was even seeing because they were under the table. When the fashion director, Ann Song, contacted me about a fashion accessory story, the first thing that came to mind was that party and what a great snapshot of capitalism this concept would be.

Who has been your most significant influence?

Personally speaking, my father has always provided me with the intellectual space a father and son need to exist in. Professionally speaking, the career I admire most is Irving Penn's. He is one of the few artists to successfully bridge the gap between the commercial world and the art world.

What is the "eclectic mix of influences" that manifests themselves in your work?

Movies, music, sculpture, sports, and conceptual art.

You call your work "a cultivated response to pop culture." What does this mean and how does it affect your photographs?

An alternative view or every day popular culture and lifestyle. Popular is not synonymous with good or great.

Do you preconceptualize what you are going to shoot?

When it is not planned, I pretend it is.

Historically, fine art photographers have sought to separate themselves from commercial and industrial photographers yet you choose to explore what you call "the fine line" between them. How does this influence your work?

For the most part, the artist is not swayed by demographics nor are they usually swayed by money. They create for themselves. A commercial photographer like myself has a concept but my concept needs to be altered as to be sure it hits it's demographic and conforms to the clients needs. I challenge myself to explore the creative process as far as the commercial world will allow me.

Do the squiggly lines morphing in your photos on your website say anything about your creative process?

The drawings were designed to illustrate the creative process from concept to finished photograph. Most of my work is narrative based which can be difficult to convey in a single image promotional piece or to open a website hence the drawing morphing into a photograph.

If you could no longer take pictures, what would you do? Did you ever consider another profession?

If I could no longer be a photographer, the natural choice for me is to be a creative director, film director, or totally switch careers and go into real estate. As far as another profession, if I had the genetic make-up, I would have been a professional athlete.

What photograph or series of photographs is your proudest achievement?

It hasn't been done yet.

What advice do you have for a starting photographer?

Learn the history of the medium. Knowing what came before you helps you understand where you are going.

What professional goals do you still have for yourself?

To play Roger Federer for the US Open Championship.

See pages 37, 38, 45, 52, 139, 154, 172, 192, 200, 201 & 202

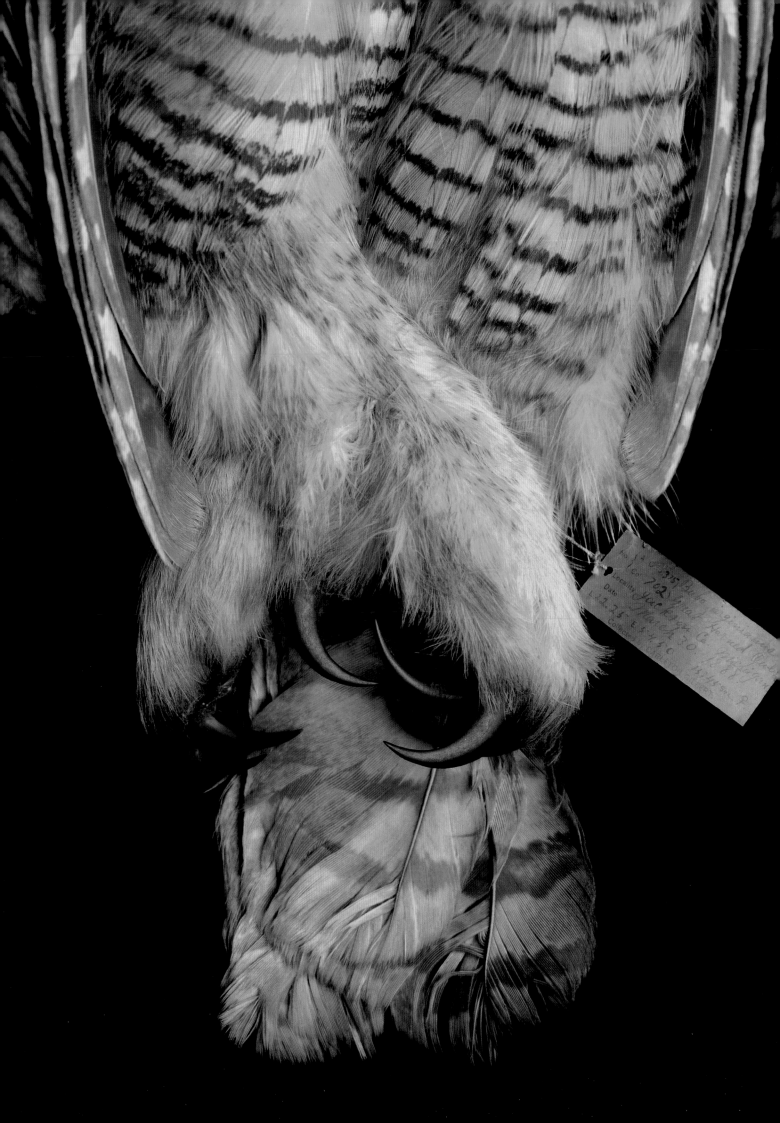

Q&A MarkLaitaBirdSpecimens

What did the client ask for? Were they pleased with the result? Is it what they expected or were they surprised?

Some projects come to you with a lot of freedom. The clients in these cases are just looking for a great image. That freedom always inspires me to something great for them.

What camera and film did you use?

These images are 20x24 Polaroids. I've been using a 20x24 Polaroid camera a lot lately. Everyone else is using digital so going in the opposite direction is interesting.

You have a group of work described as "Life." How different is it to work with death as you did in this series?

I had photographed some beautiful living birds such as owls, hawks, pheasants, flamingoes a few years ago, but never thought the images captured their spirit. I shot one bird "skin," as ornithologists call them, and found it much more interesting. That led to the series I later shot.

When did you take your first picture and when did you know you wanted to be a professional photographer?

As an orphan in Madrid, a street photographer took me under his wing and taught me how to use a view camera. His girlfriend's brother was a famous matador who let me take his portrait. I sold more prints of that picture than Spain sold olives that year.

Who has been your mentor or most significant influence?

Edward Curtis, who photographed Native Americans from the late 1800's through the early 1900's did some important and beautiful work while overcoming some great obstacles. I think about his strength and sacrifices often.

You have two of the six 8x10 Gowlandflexes in the world. What do you use for them?

I use them for portraits. They have a viewfinder unlike any other 8x10 camera. Peter Gowland is a delightful genius.

How do you think photography will evolve given the emergence of digital technology? Has it changed the way you work?

Kodak and Polaroid were great stewards for photography for many years. Photography is obviously going through a major transition. I love the way the image gets crafted shooting film with an 8x10 view camera. The rhythm to shooting digital is very different. For projects where extreme detail isn't necessary, digital is a pleasure to use.

Tell me about your CD "And Then There Was Bass."

Some have described my CD "And Then There Was Bass" as the "Stairway to Heaven" of acid house music. I prefer to think of it as techno's "Free Bird."

Are you still a DJ?

Once a DJ, always a DJ. Kind of like an astronaut.

Is there a relationship between your love of acid rock and techno music and your photography?

Music, photography, literature, film, and nature are all related and inspiring.

What photograph or series of photographs is your proudest achievements?

That's like asking which one of your kids is your favorite.

What do you most appreciate in a client?

Bring me to a shoot and I'm happy. Bring me a good ad and I'm really happy. I get asked what I like to shoot most. I don't care what the subject I shoot, but I do love to shoot great ads.

See pages 166,168,169,170,171,194,195,208,230,231,232 & 233

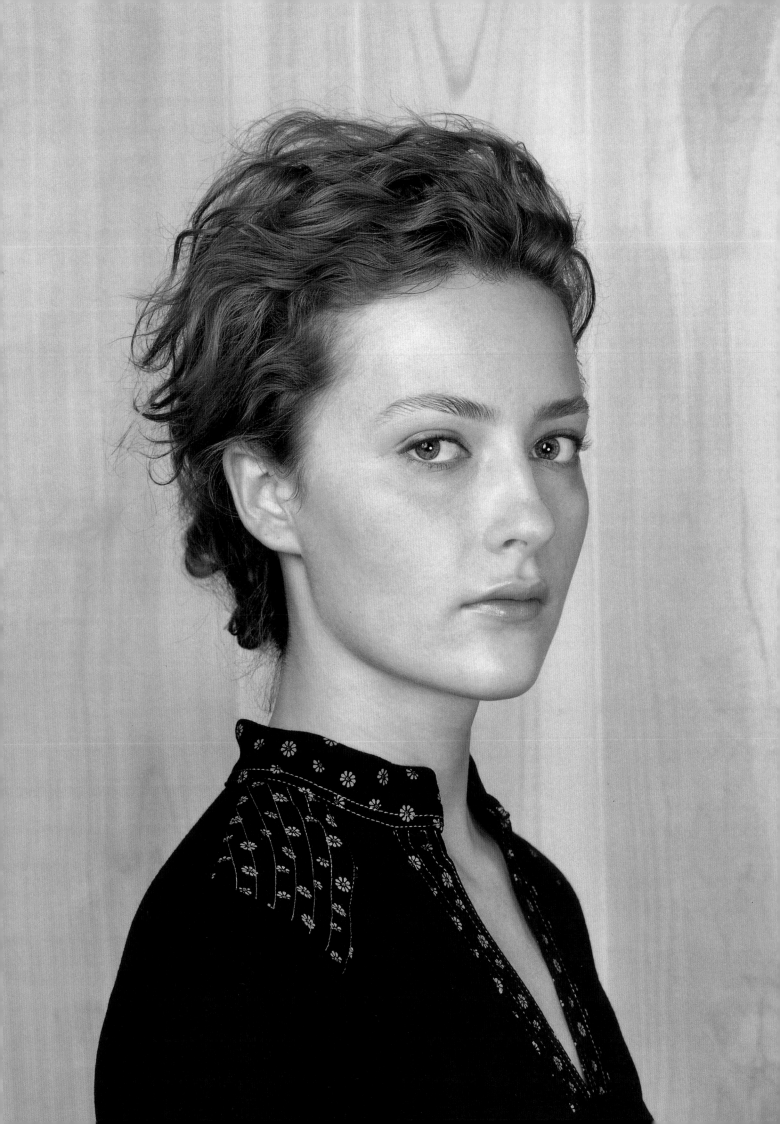

Q&A Craig Cutler Portrait Study on Wood

What is the story behind this photograph?

I wanted to do a series of pictures of beautiful women without it being about fashion. I envisioned a classic portrait session, similar to something a Flemish painter would do, but blended into the contemporary world. We substituted paneling for velvet drapery.

What camera and film did you use?

I used a medium format camera with color negative film. We print everything in the studio. The printer I work with has been printing for me for a long time. He is an important link in creating the final feeling.

Many photographers pick a specialty, you work across a wide range of disciplines. How are you able to do this?

I never think in terms of categories. I love the fact that one week I'm shooting big trucks in Canada and the next week I'm shooting portraits. Plus, I get bored easily.

Do you approach all disciplines the same way or do you have different approaches to say portraiture and architecture?

I probably approach everything the same way. Even when you intentionally try to change "your eye"— as my friend Rodney Smith once told me: "it's what they hire you for."

When did you take your first picture and when did you know you wanted to be a professional photographer?

I took my first picture on a field trip for school to an Amish Farm. I was able to sneak several pictures of the farmers with a Kodak box camera I used to own. It had this great "pop-up" view finder. As far as being a photographer, that evolved from studying graphic design in college. I realized that after sketching a concept, I also wanted to shoot it.

Who has been your most significant influence?

Early on, I would have to say Irving Penn. Everyone else seemed a distant second to me. I was also a big follower of Daniel Jounanneau, who did these great still-lifes in Paris Vogue. More recently, I enjoy Thomas Ruff and Rineke Dijkstra for their portrait work. Also, William Eggleston always inspires me to look at a location differently.

Are there young and upcoming photographers who excite you?

My printer Jon Shireman excites me. We've worked together for over ten years. He's constantly exploring new directions in the darkroom.

How do you think traditional photography will evolve given the emergence of digital technology?

We are always combining traditional photography with digital photography. In some ways it makes things faster, in others much slower. Clients expect a lot more. We are constantly sending off files to clients during shoots. I hate that. I can only imagine how nice it used to be before Polaroid came out. In certain shoots, it is fun to know that you've captured exactly what you want. For the most part though, the whole subject of digital photography bores me. Yes, everything is going that direction – but it's still a tool. A bad concept cannot be saved with digital technology. The day they stop making Tri-X is the day I'll quit photography.

Aside from photography, how do you spend your time?

I swim every morning. It is the only time I can clear my head. As far as free time, there isn't any. I have three kids under the age of thirteen.

See pages 66,68,69,98,99,101,130,131,140,176,177,196,197,198,199&233

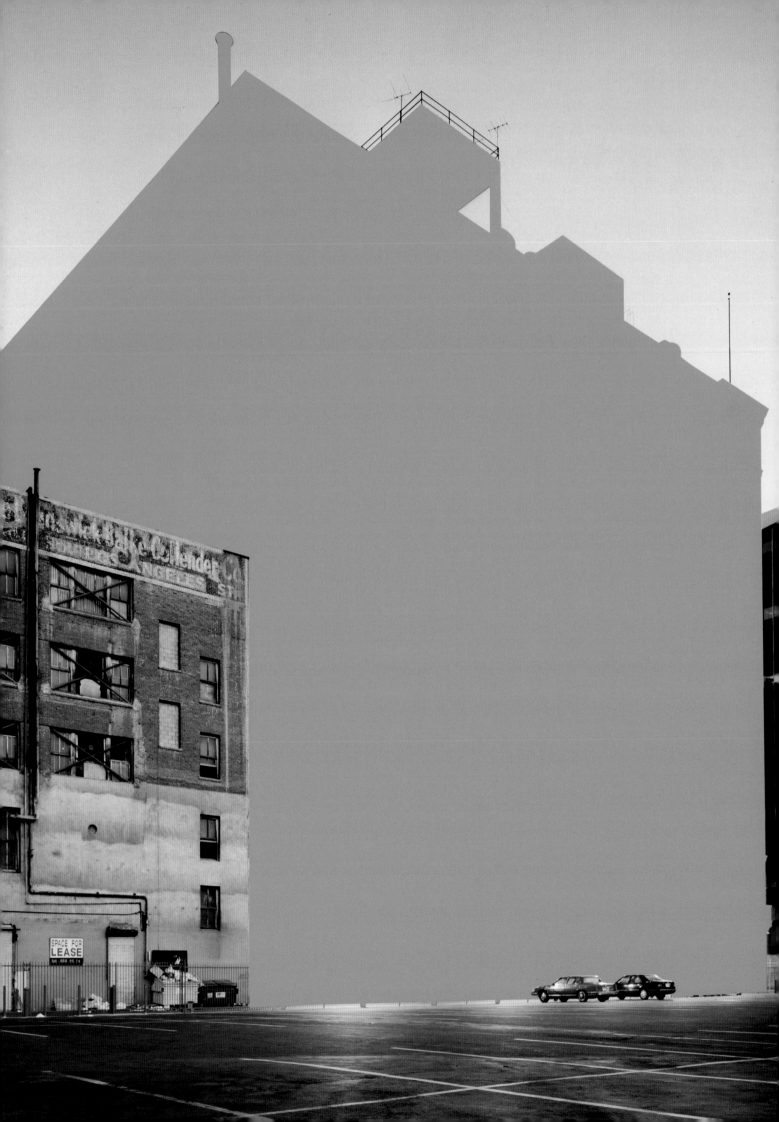

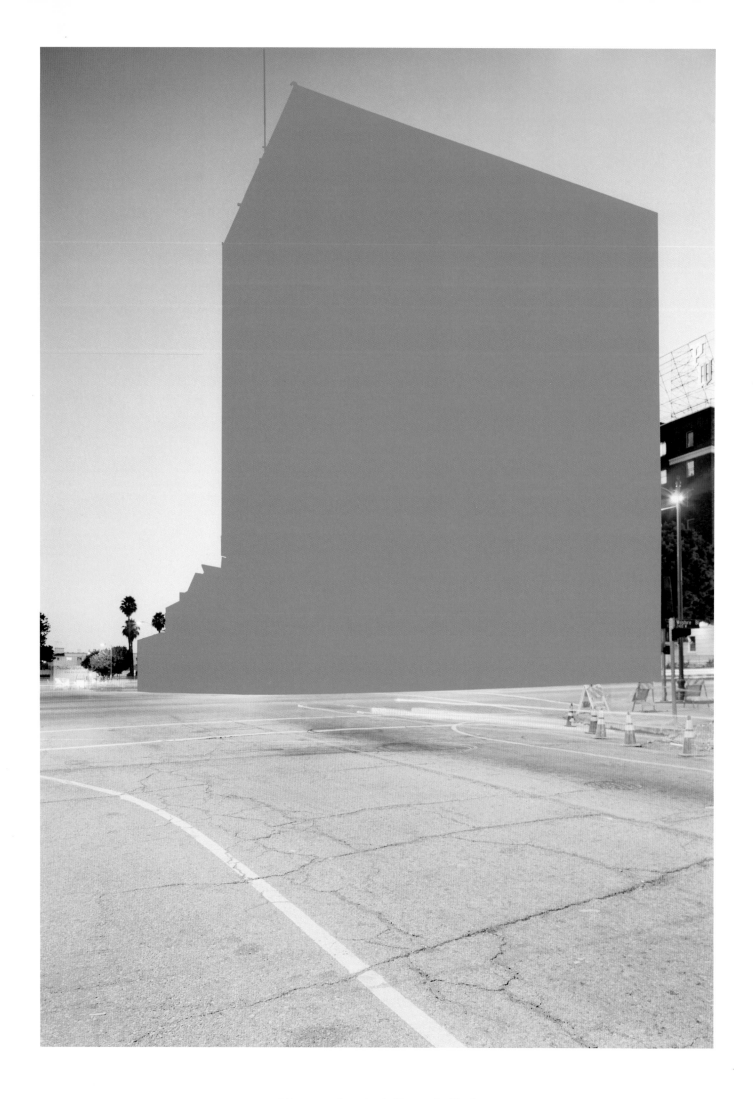

(this page and previous) Mauren Brodbeck

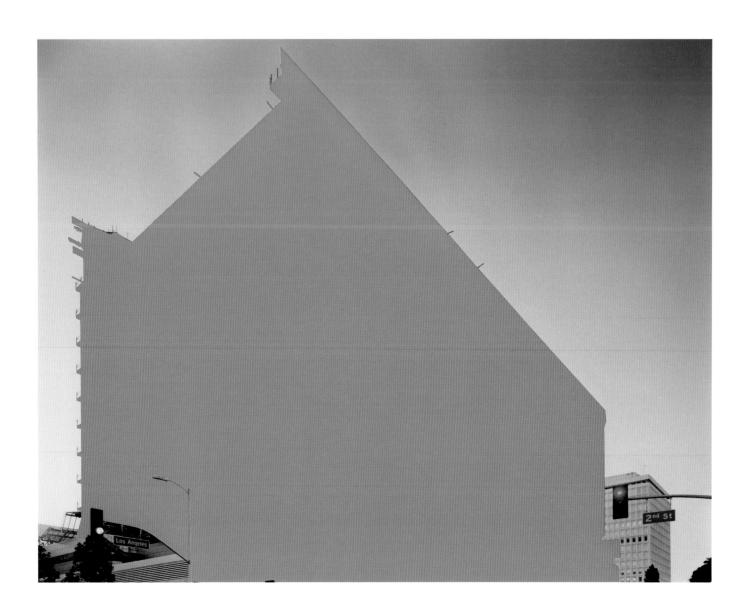

Mauren Brodbeck

Sean Perry

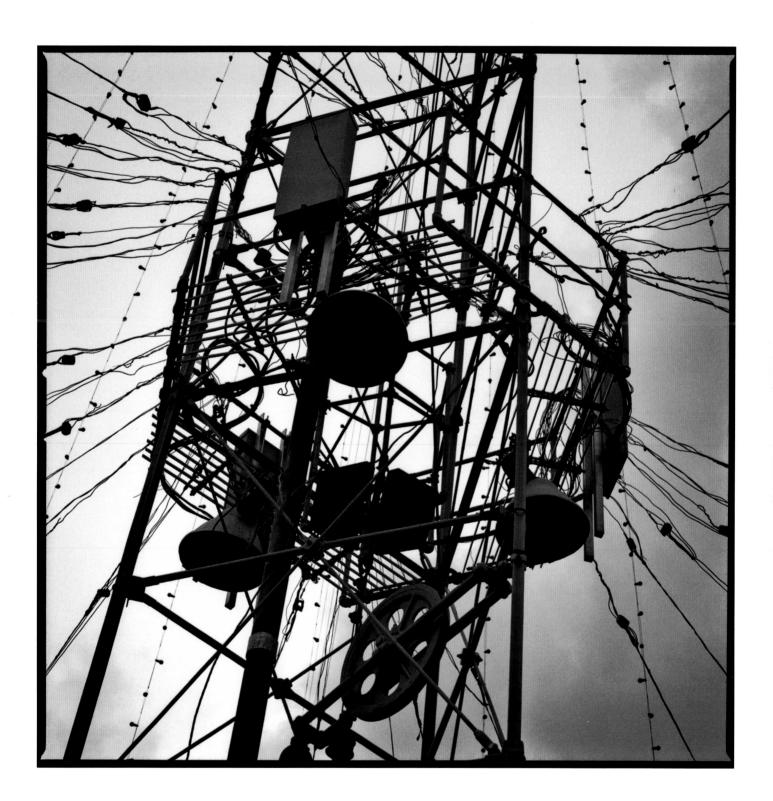

Sean Perry

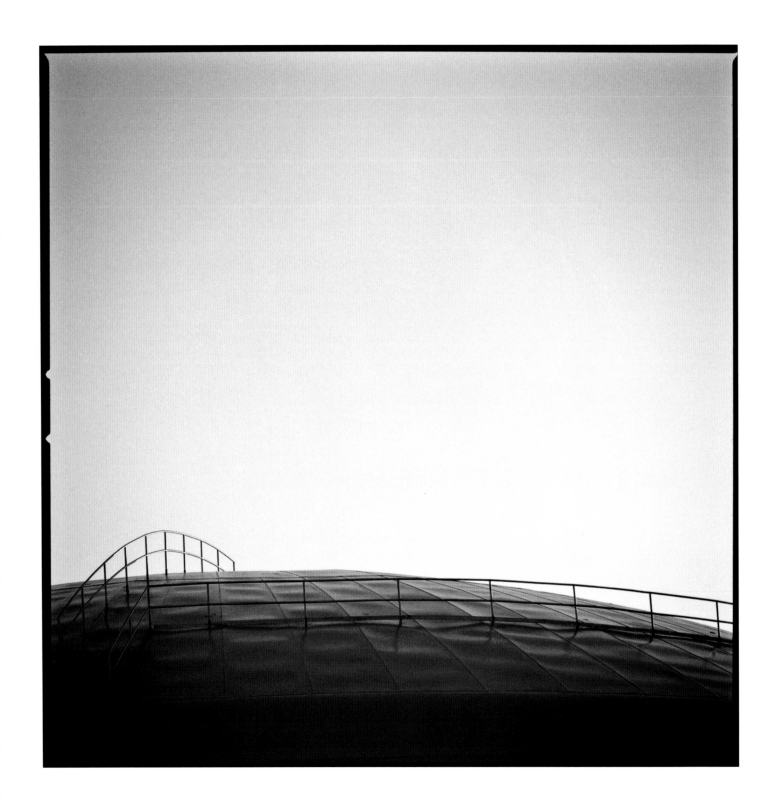

Sean Perry

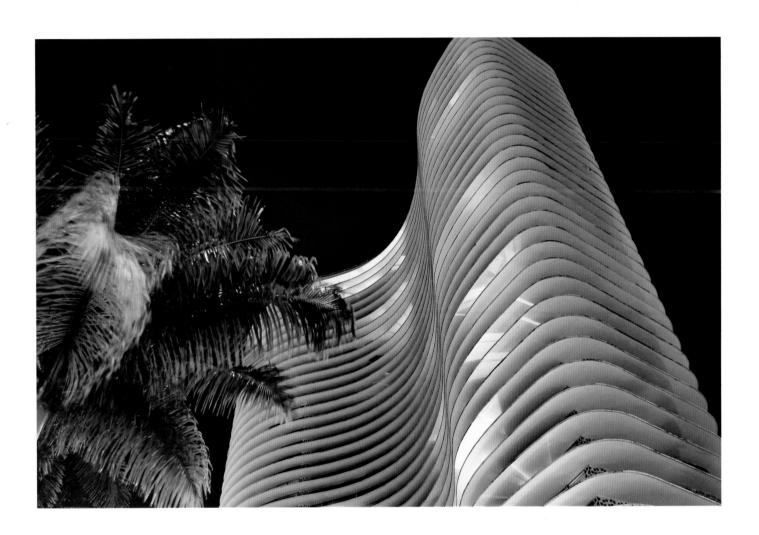

Marcelo Coelho

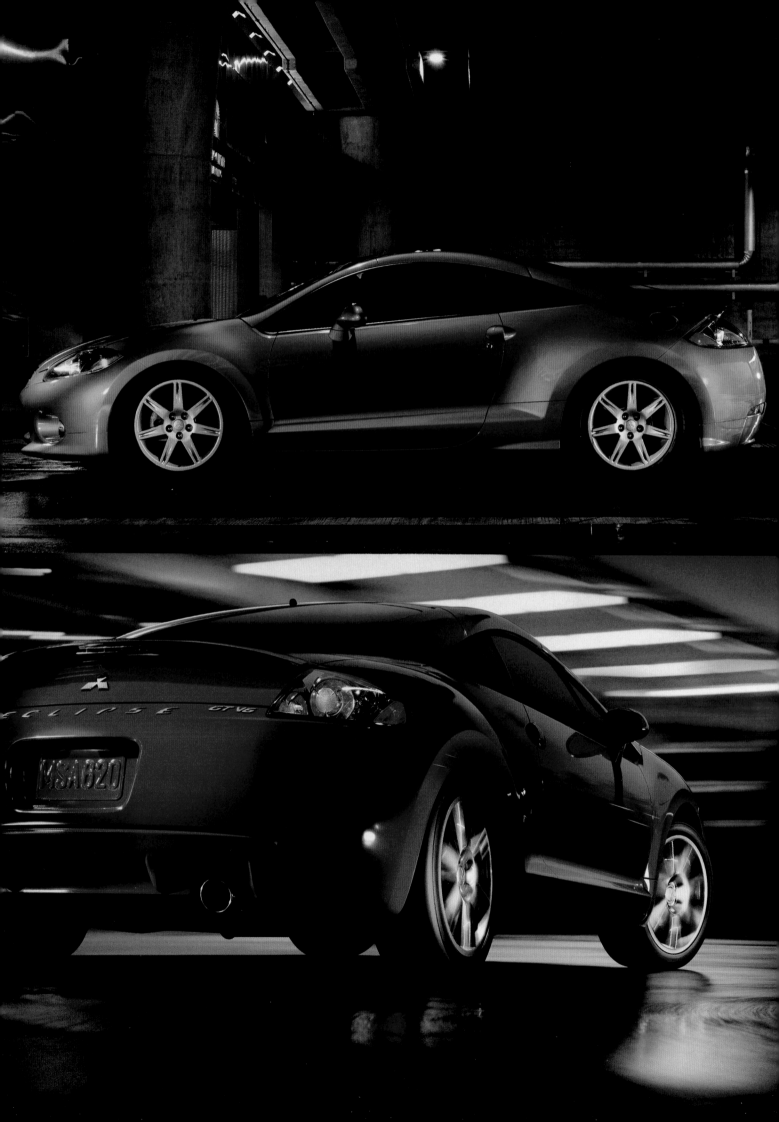

Automotive

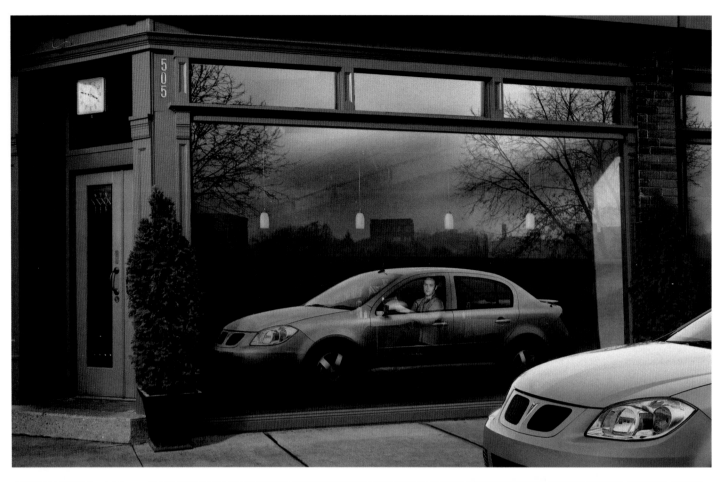

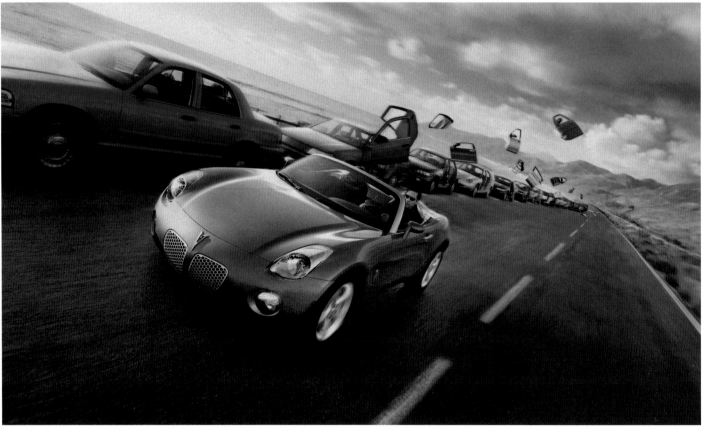

(previous page) Jeff Ludes (this page) George Simhoni

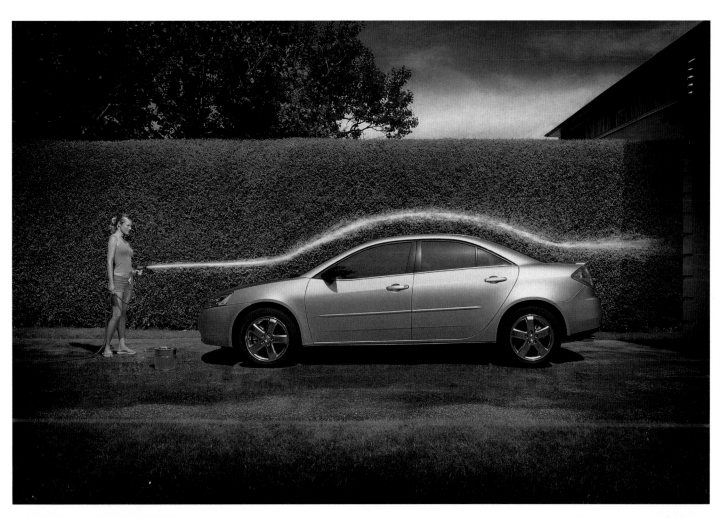

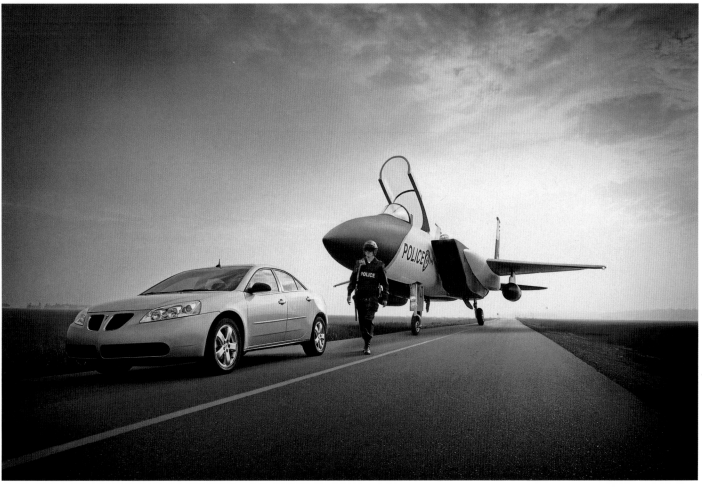

Chris Gordaneer

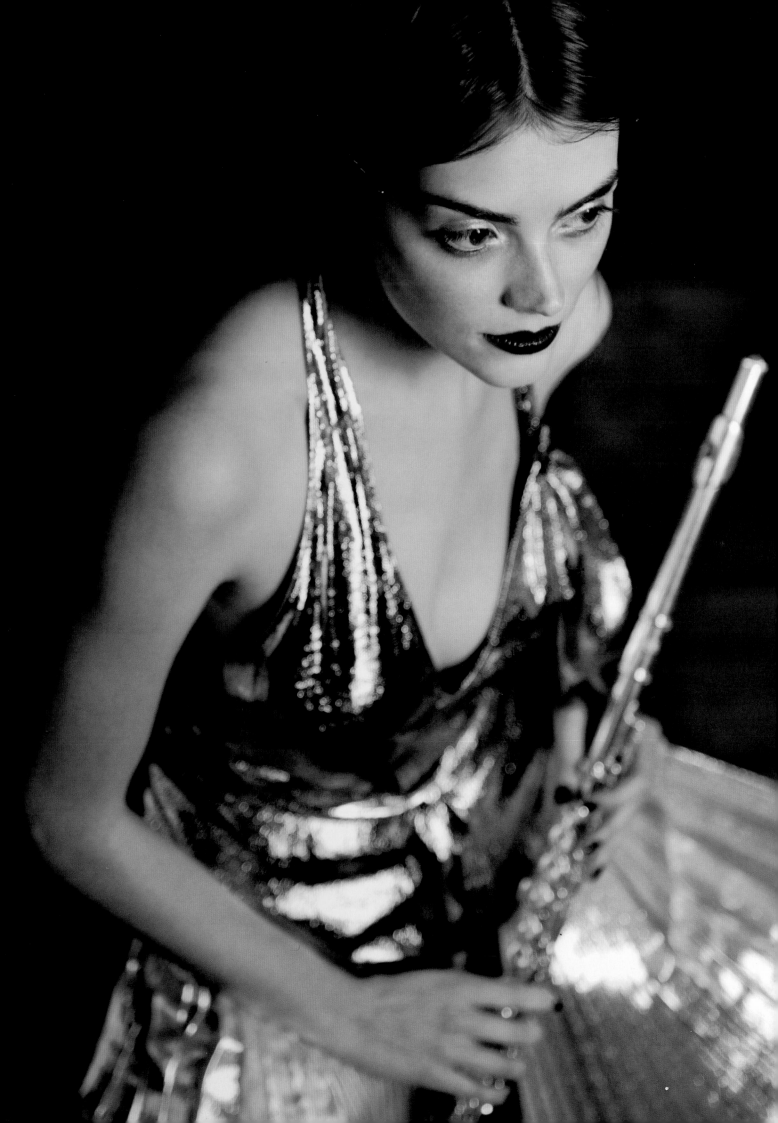

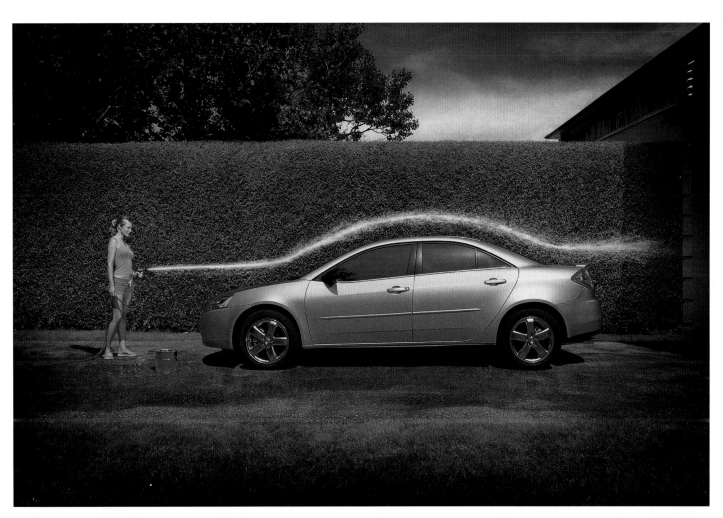

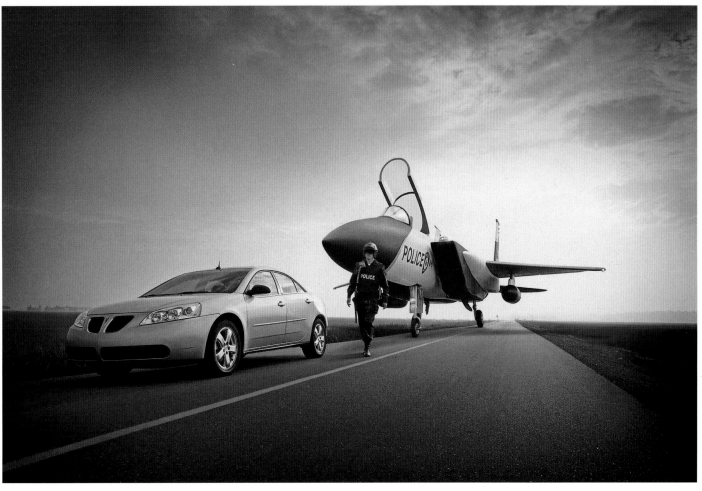

Chris Gordaneer

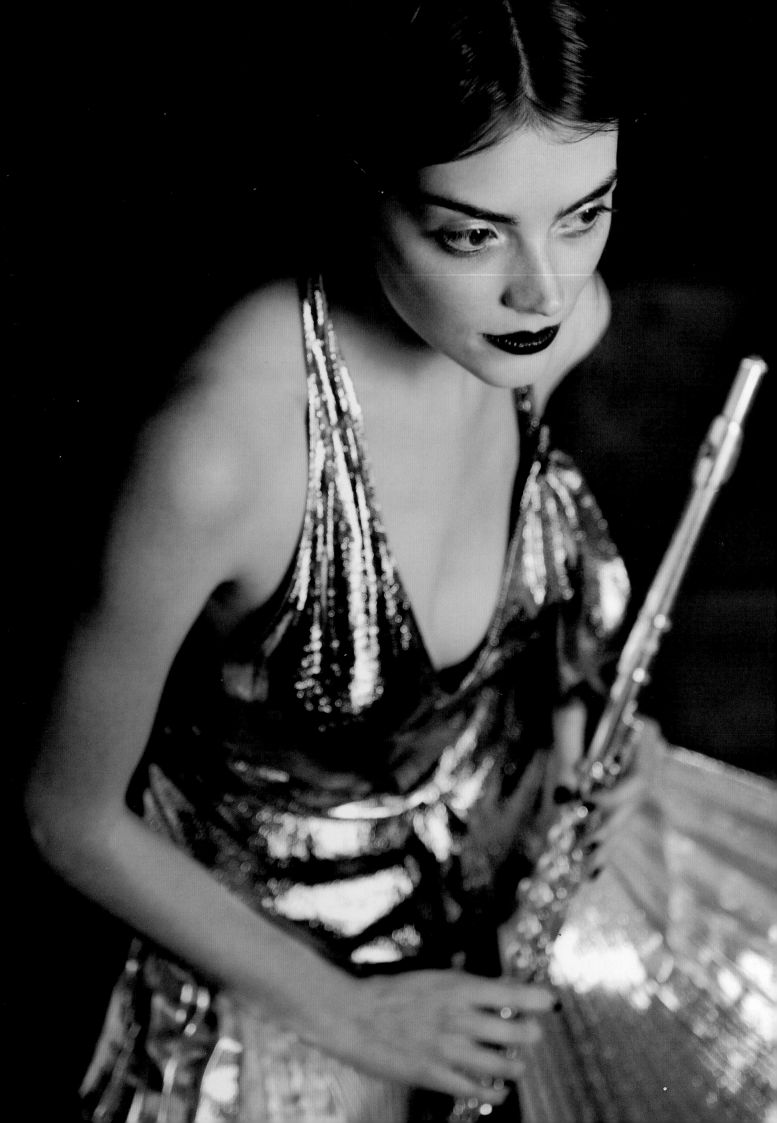

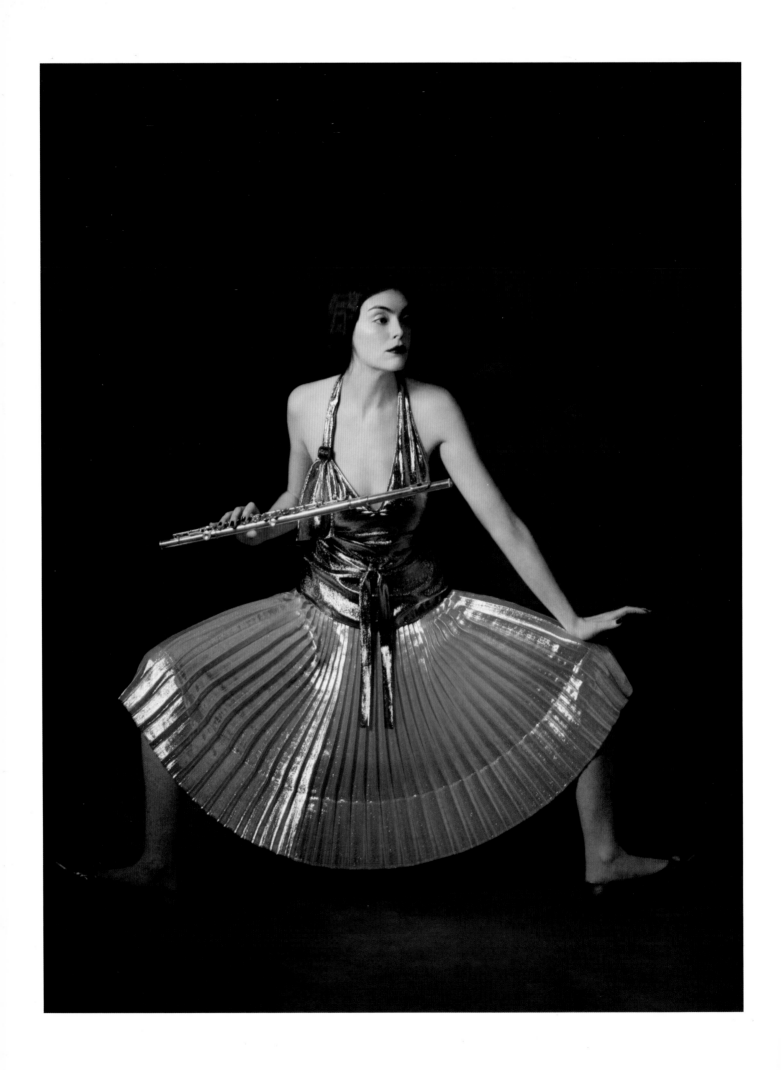

(this page and previous) Caterina Bernardi

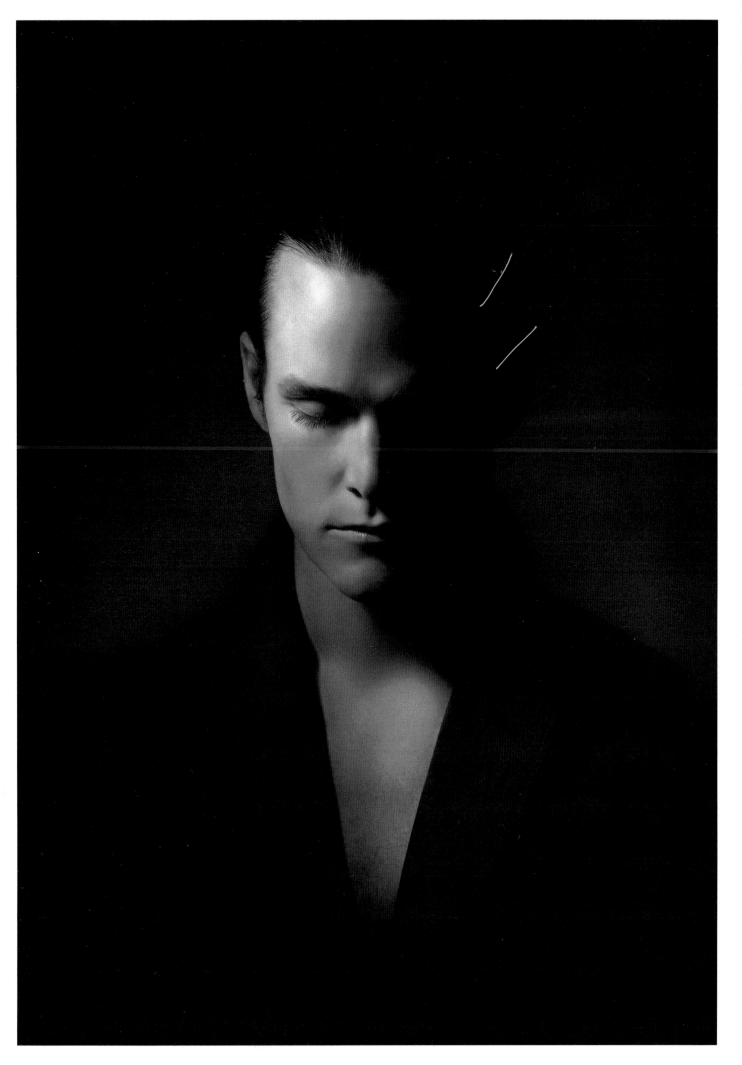

Packert White

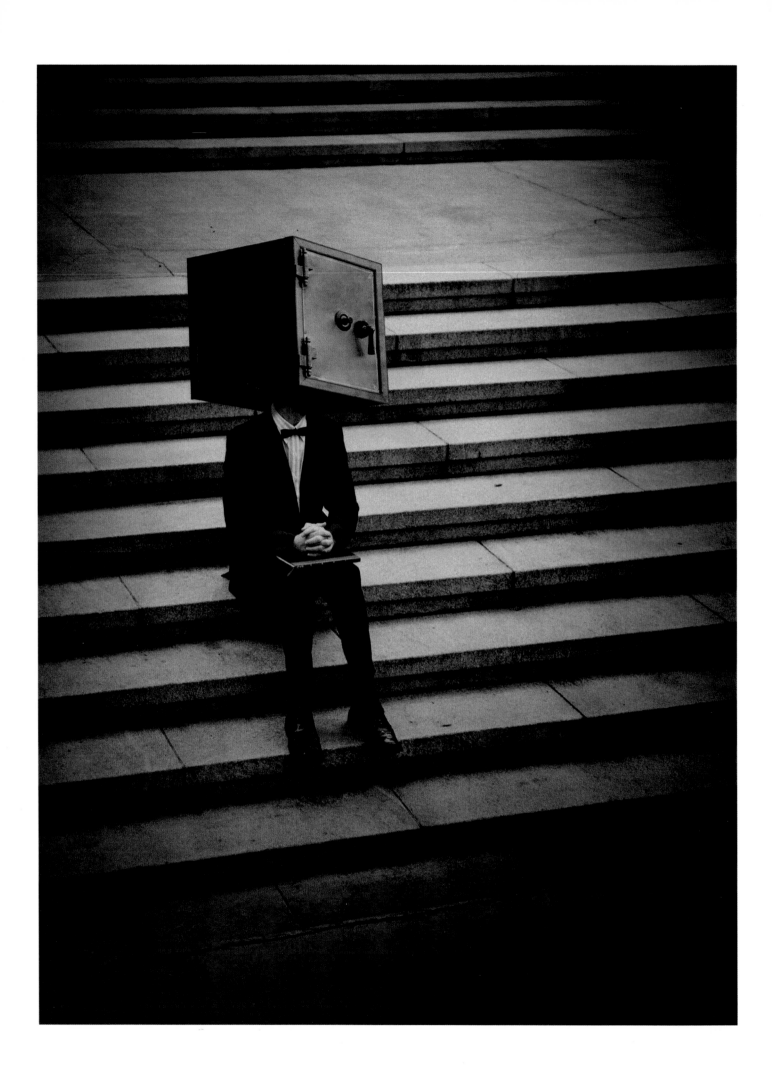

Joseph Rafferty, Angela DeCristofaro

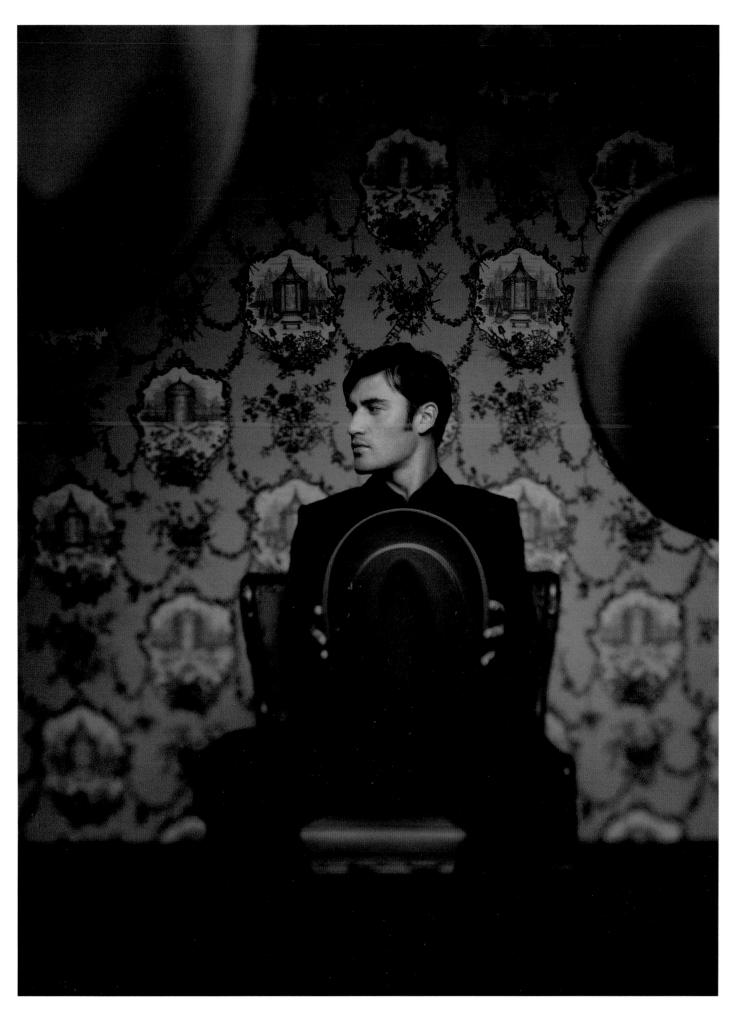

Cristiana Ceppas

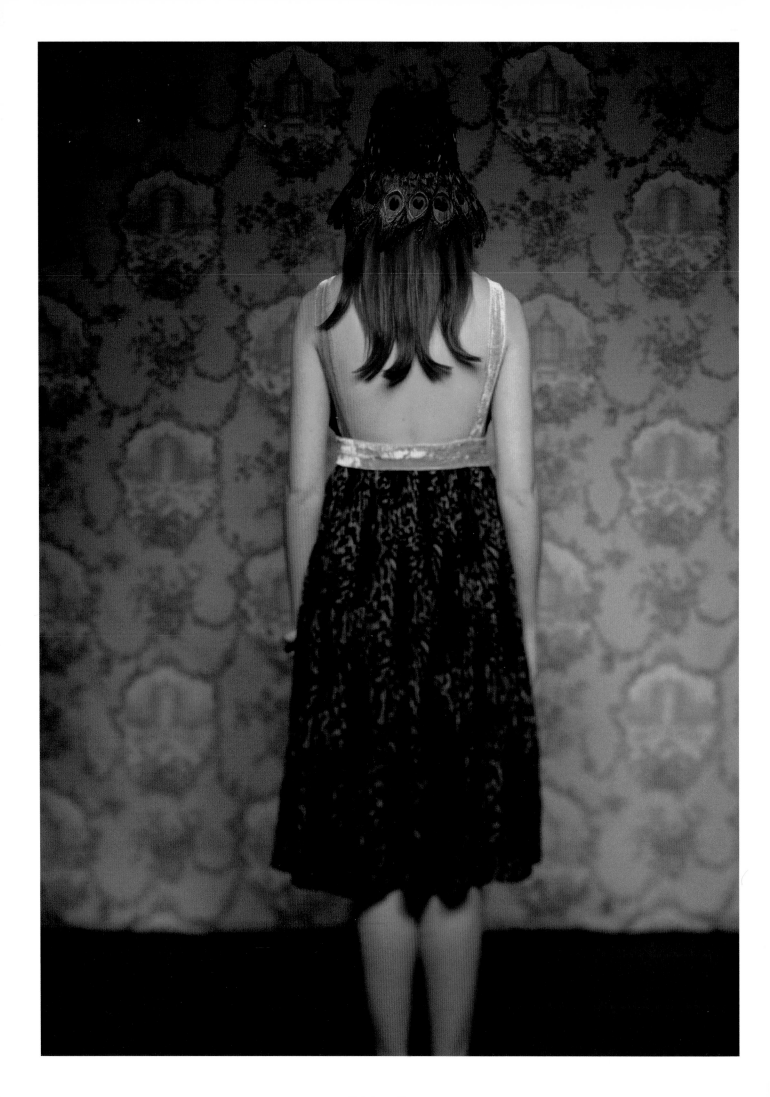

Cristiana Ceppas

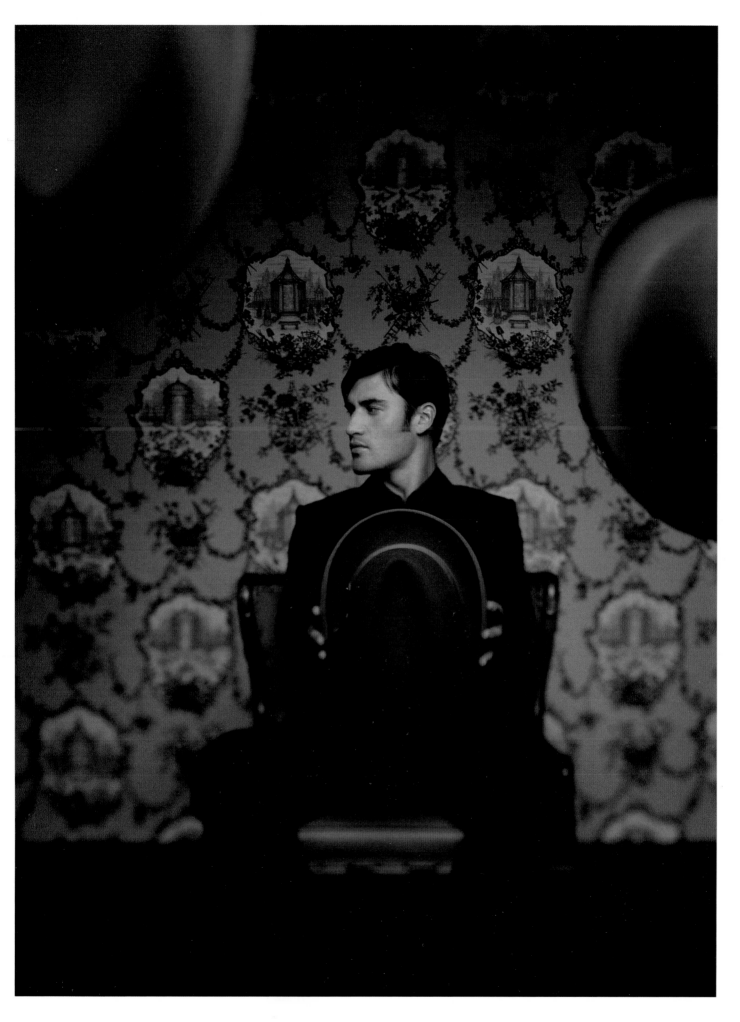

Cristiana Ceppas

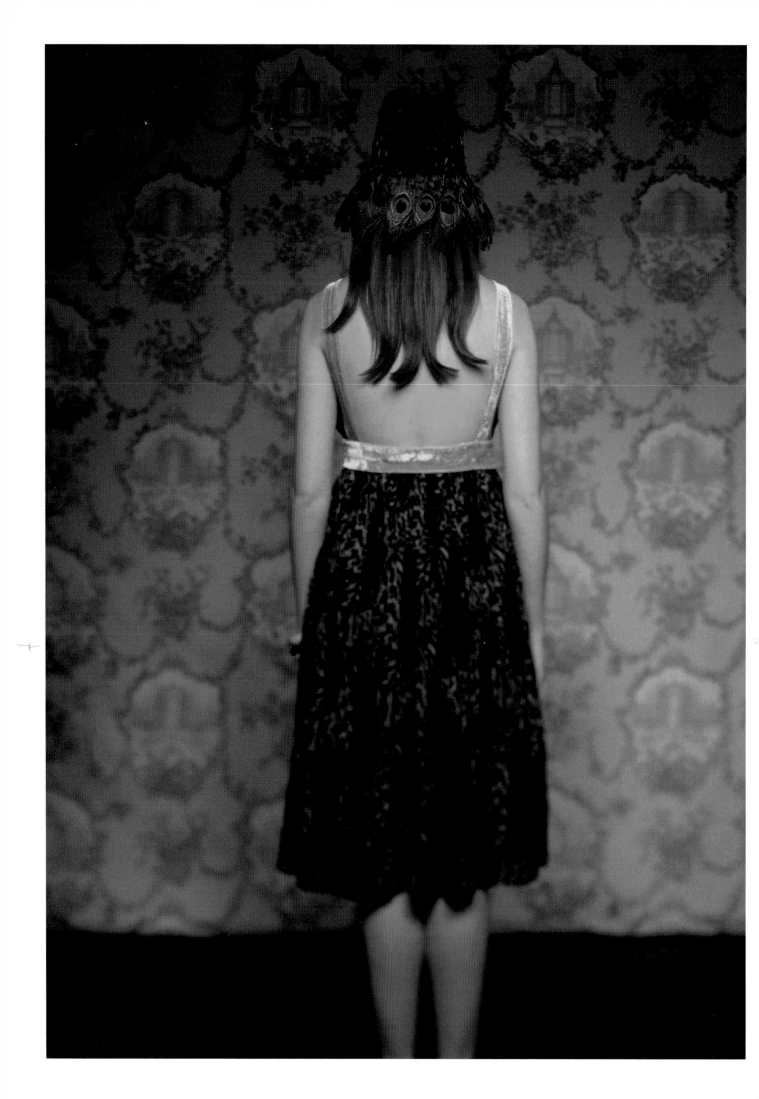

Cristiana Ceppas

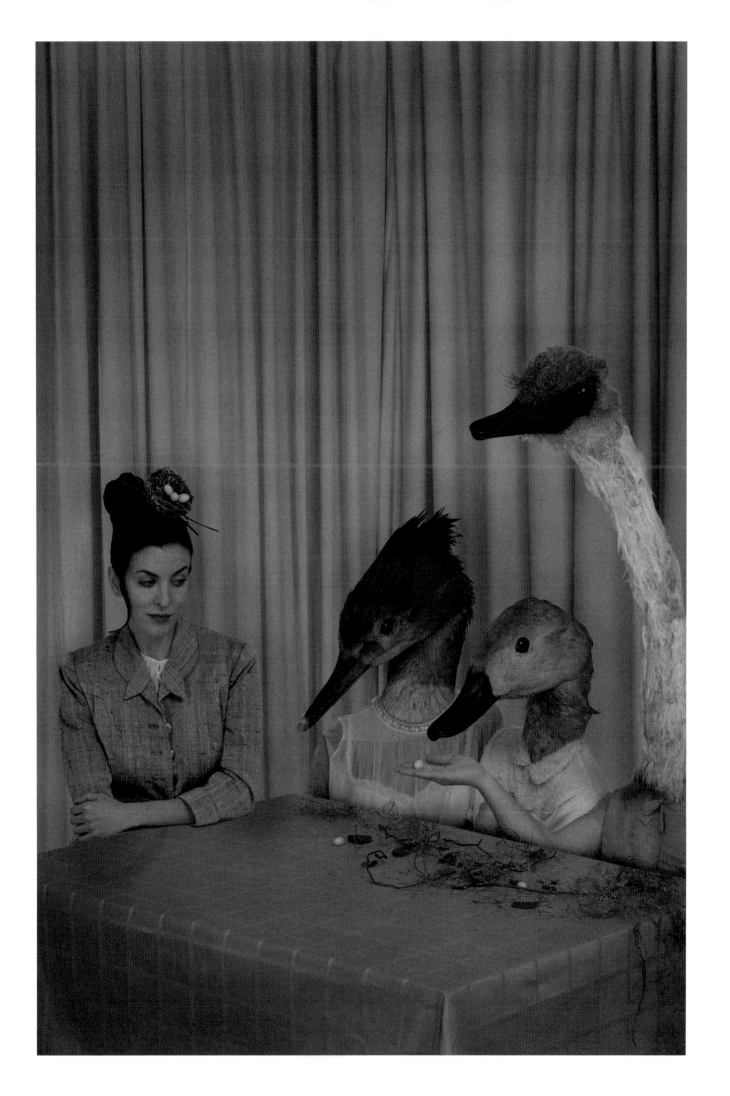

Joseph Rafferty, Angela DeCristofaro

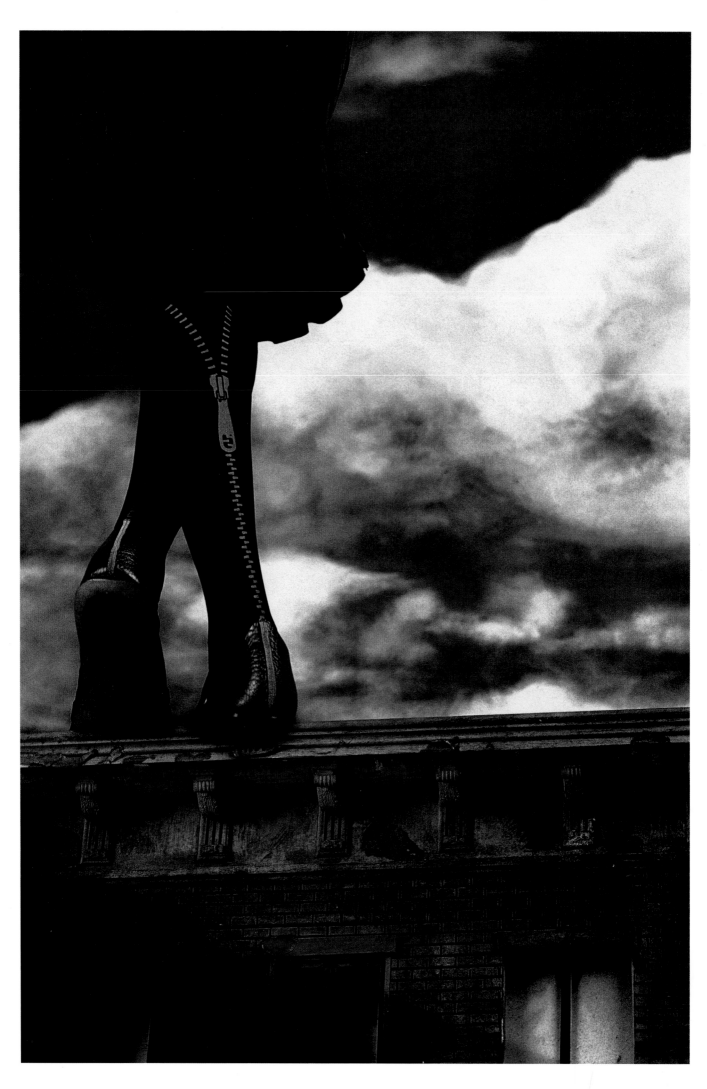

Joseph Rafferty, Angela DeCristofaro

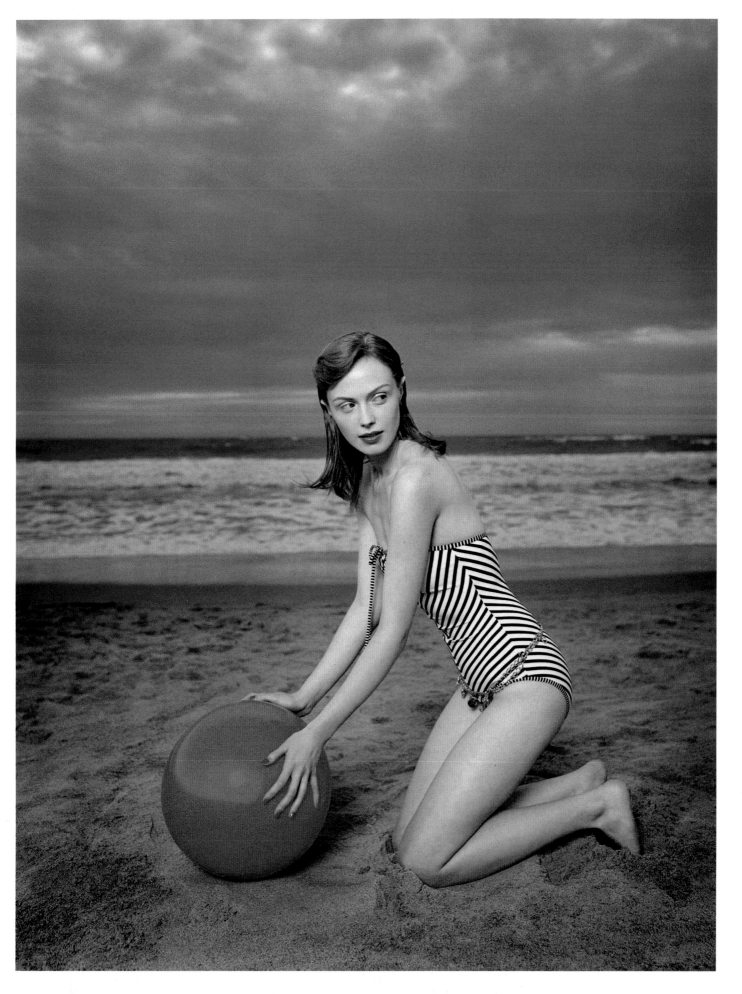

Matthew Welch

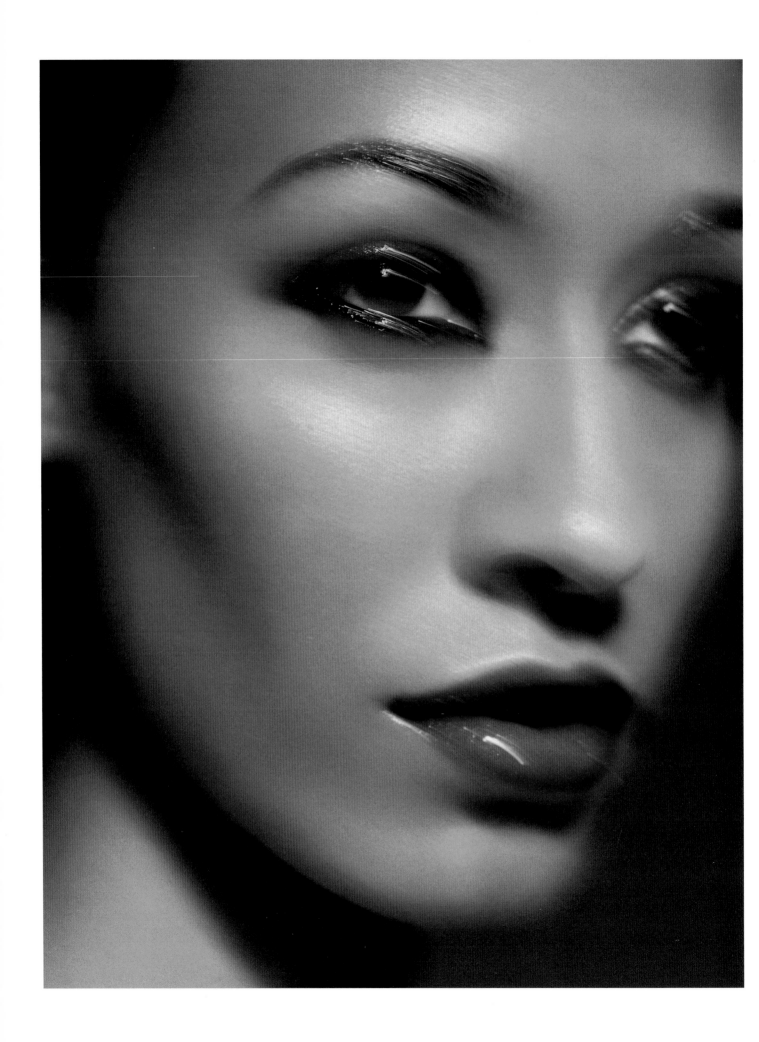

Timothy Hogan

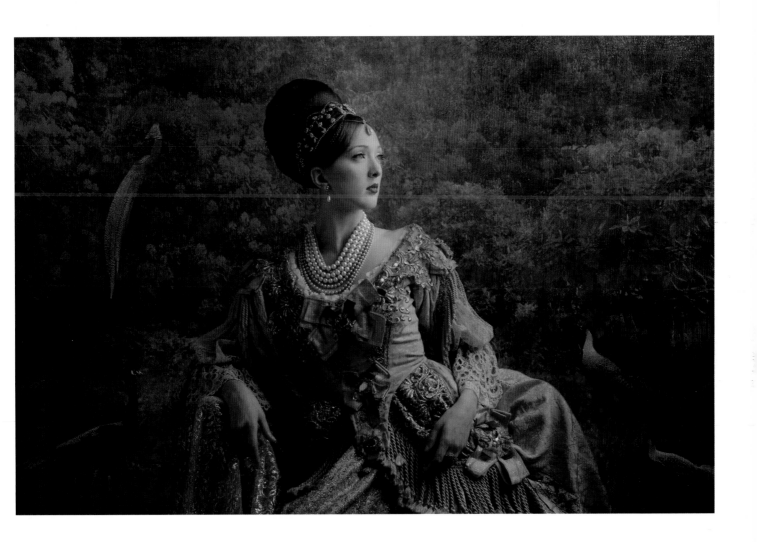

Bill Diodato

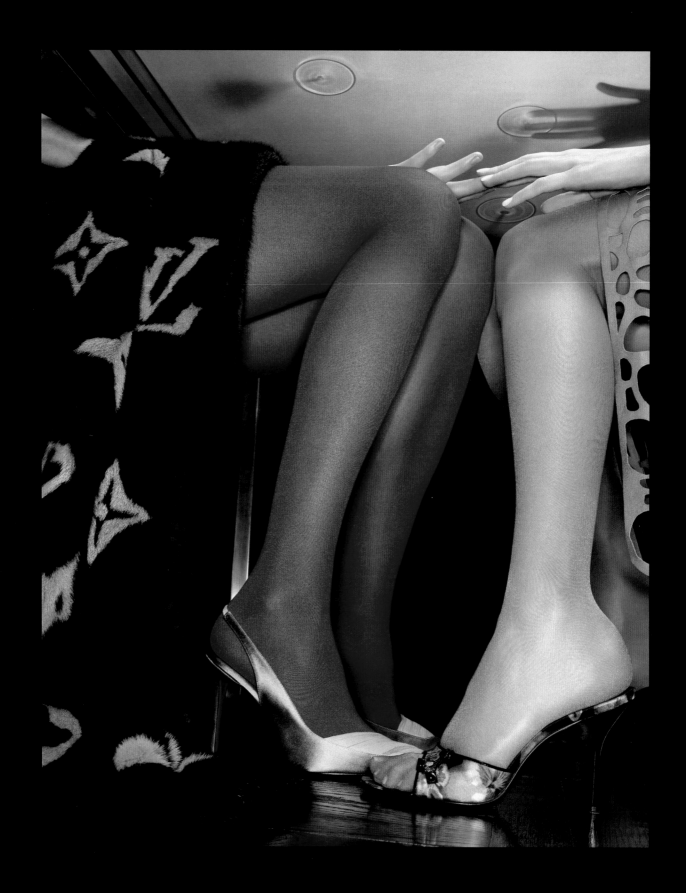

Bill Diodato

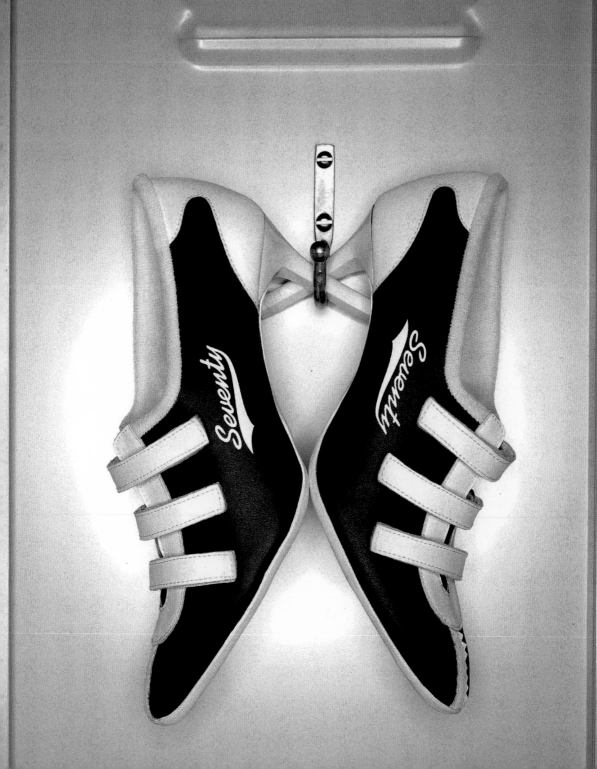

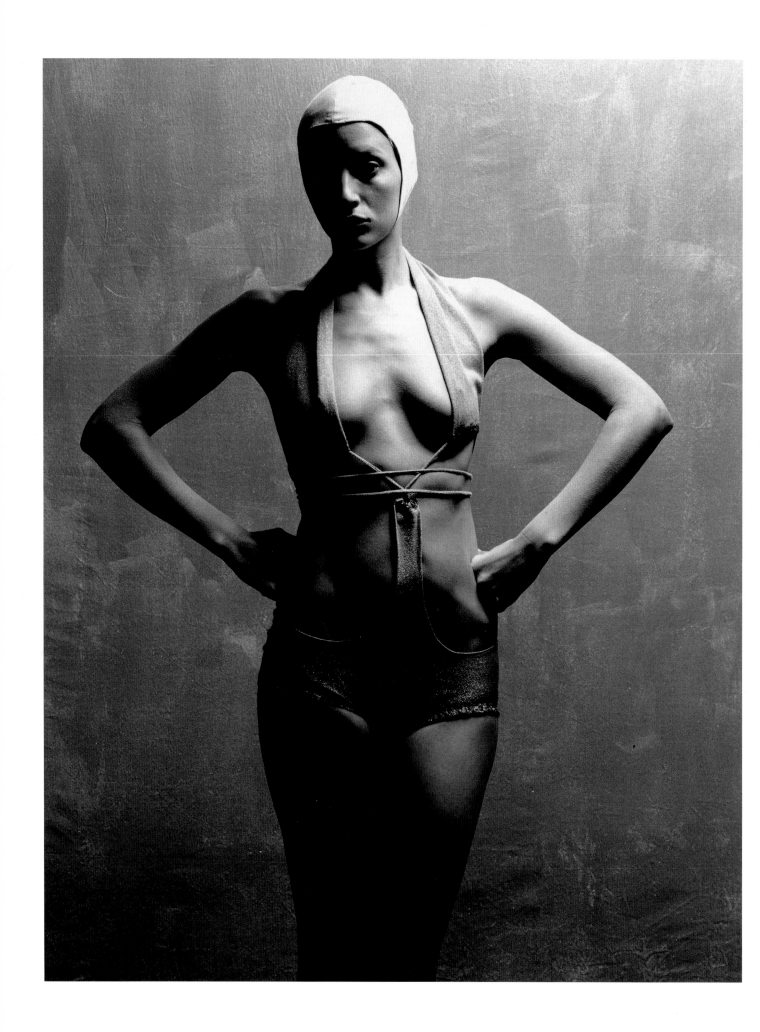

Kah Leong Poon

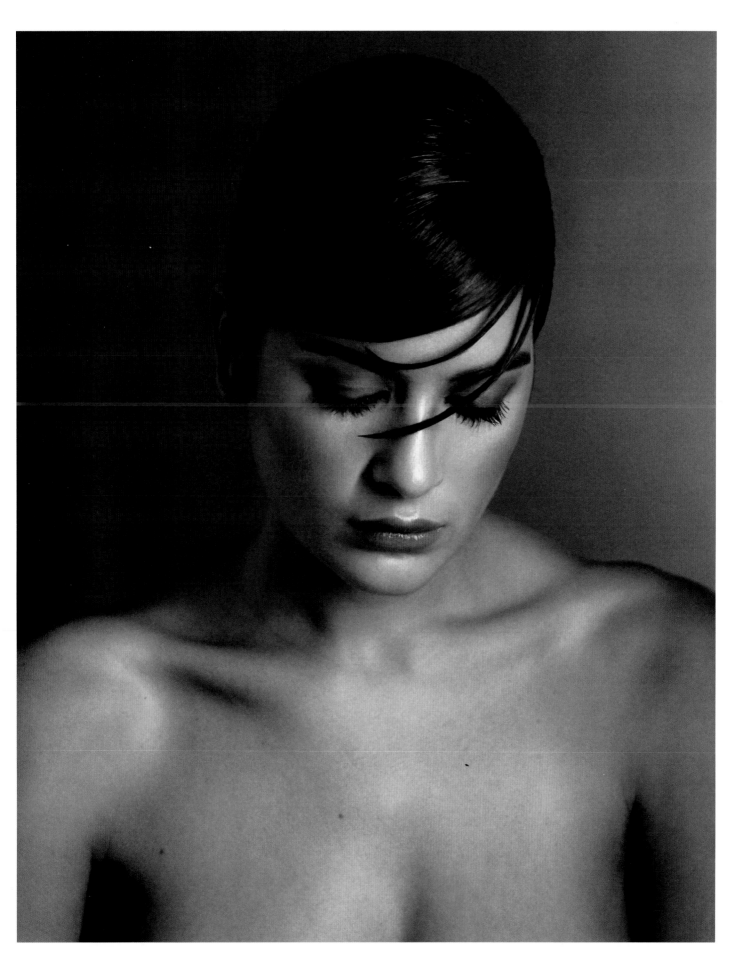

TC Reiner

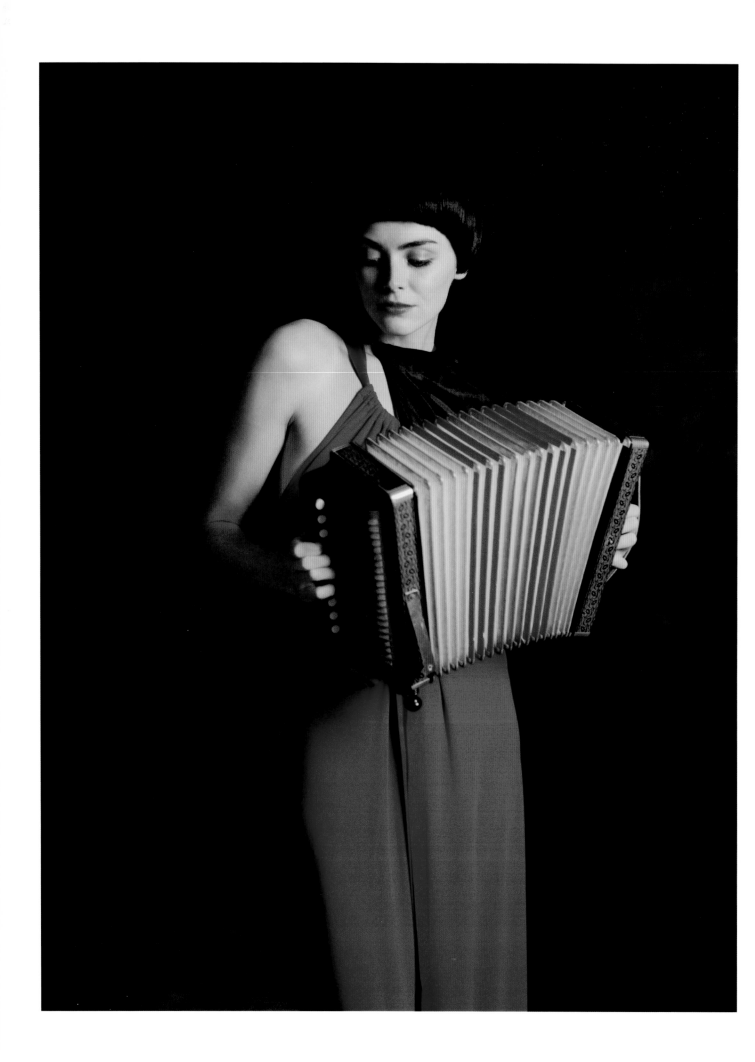

Caterina Bernardi

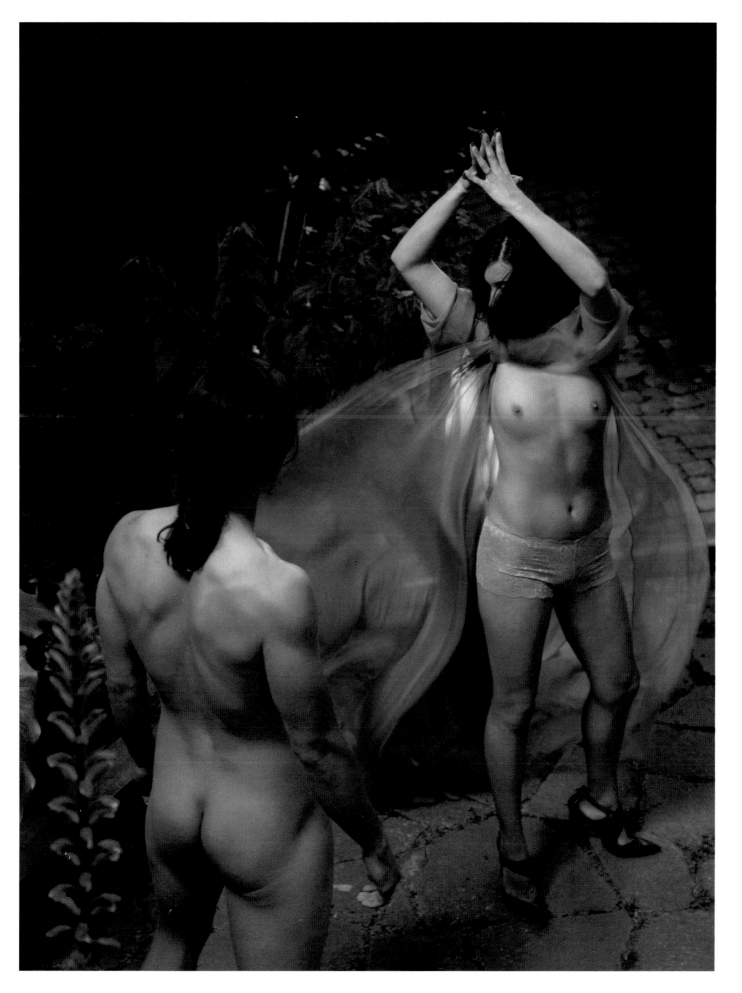

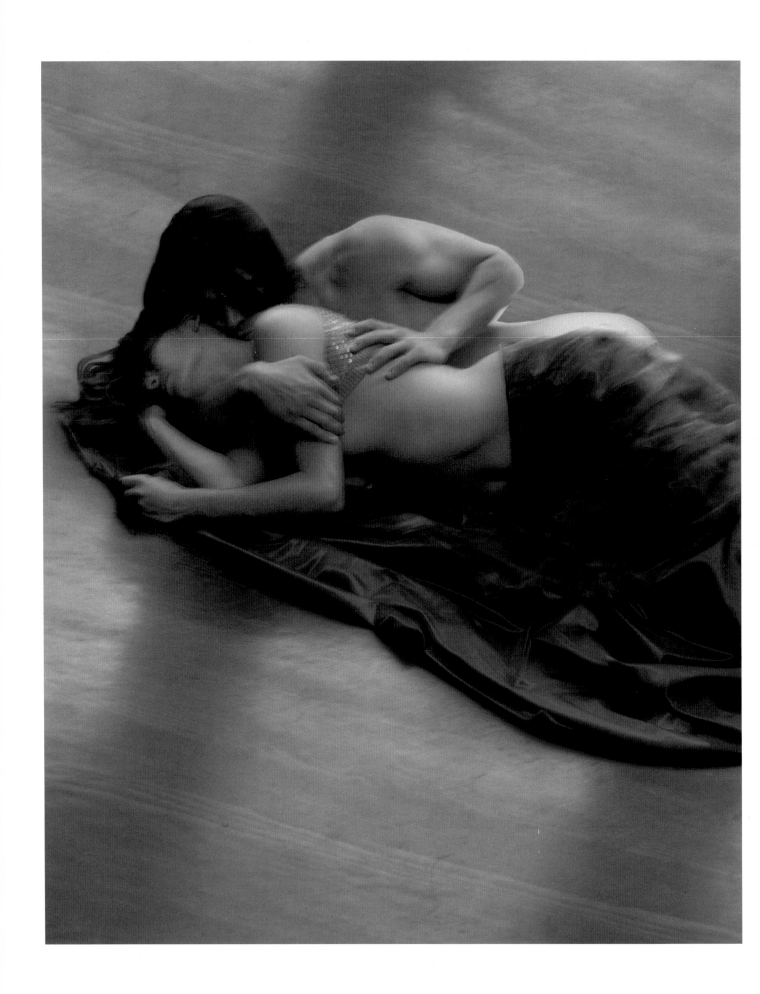

Michele Clement

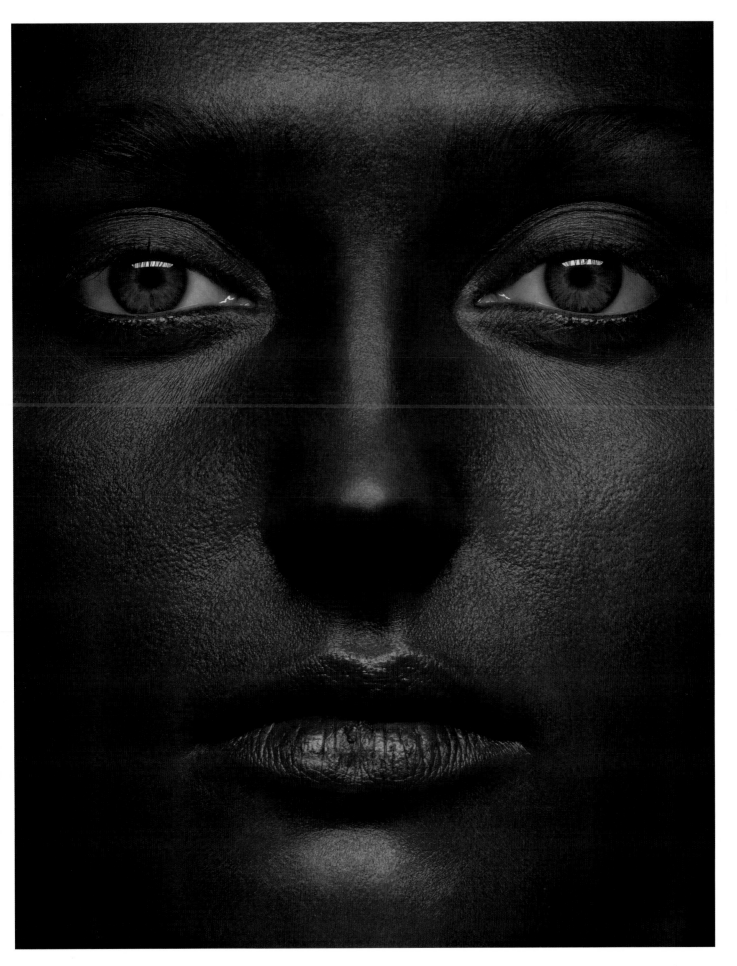

Bill Diodato

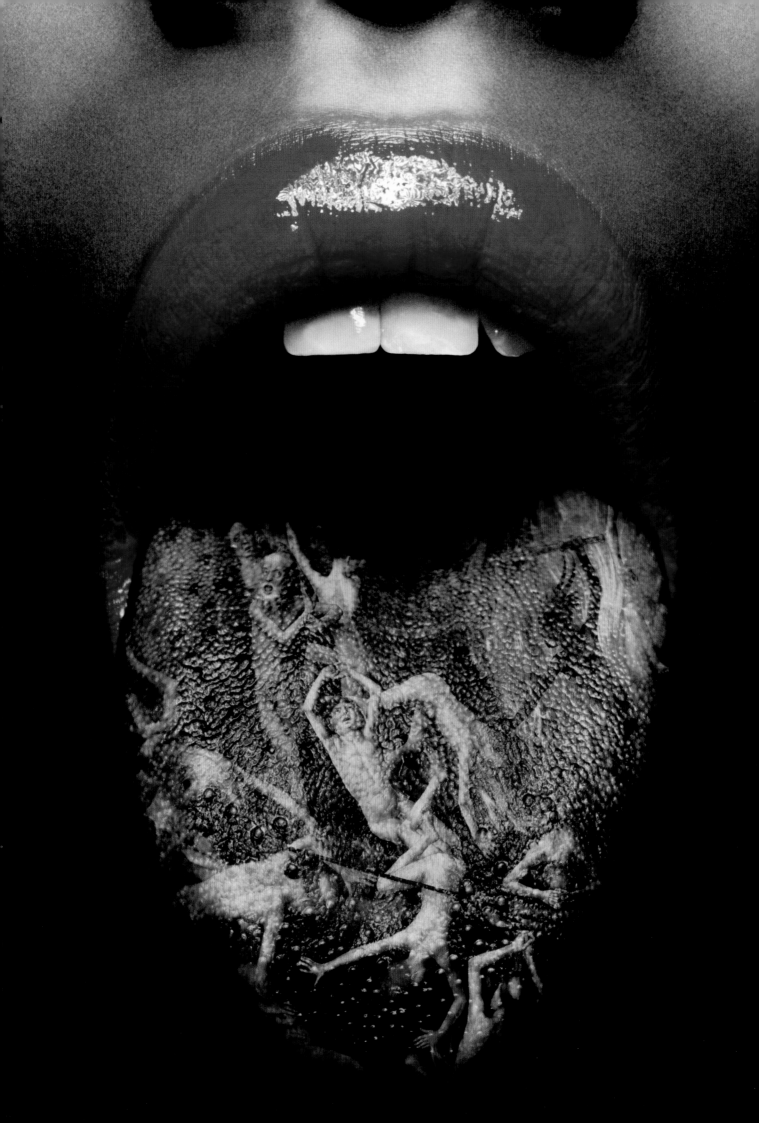

Digital

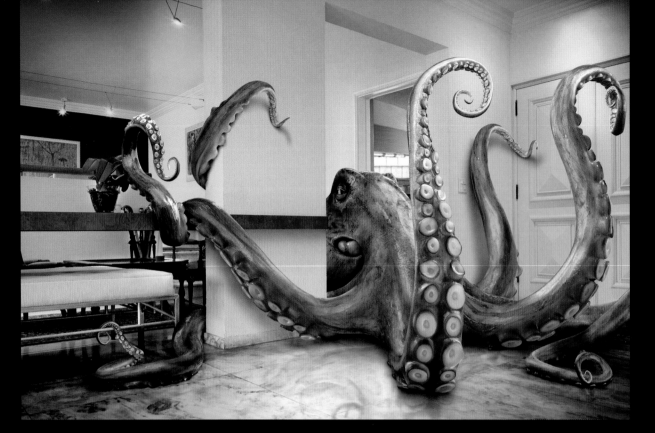

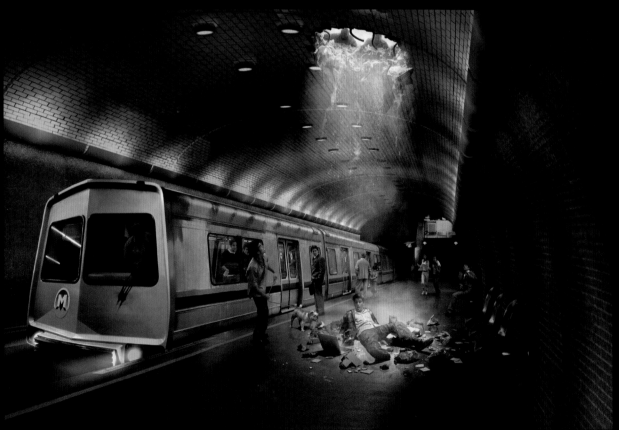

(previous page) George Wendt (this page) Leonardo Vilela

Phil Marco

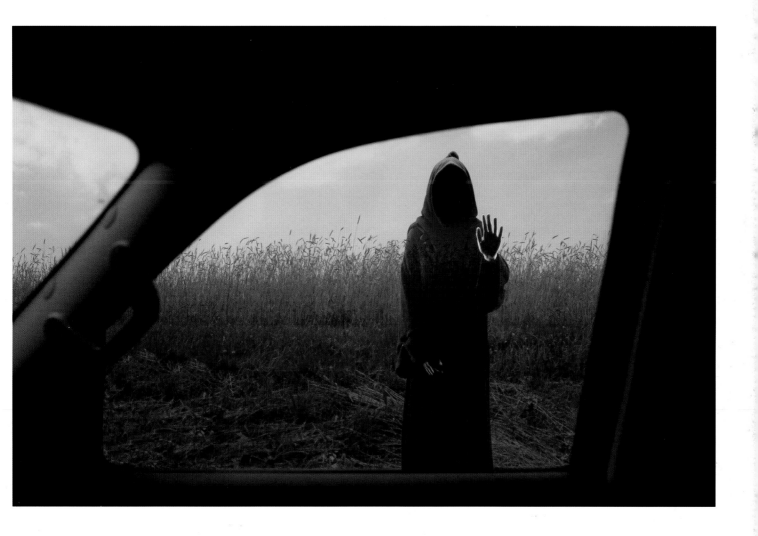

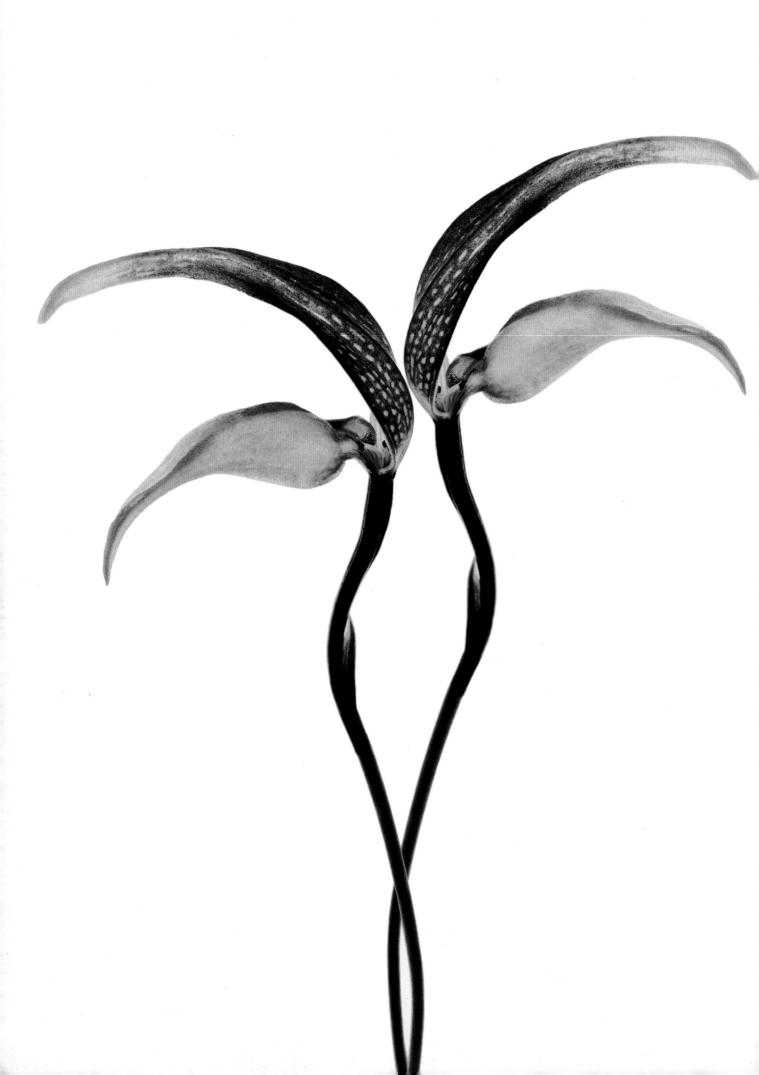

Flowers

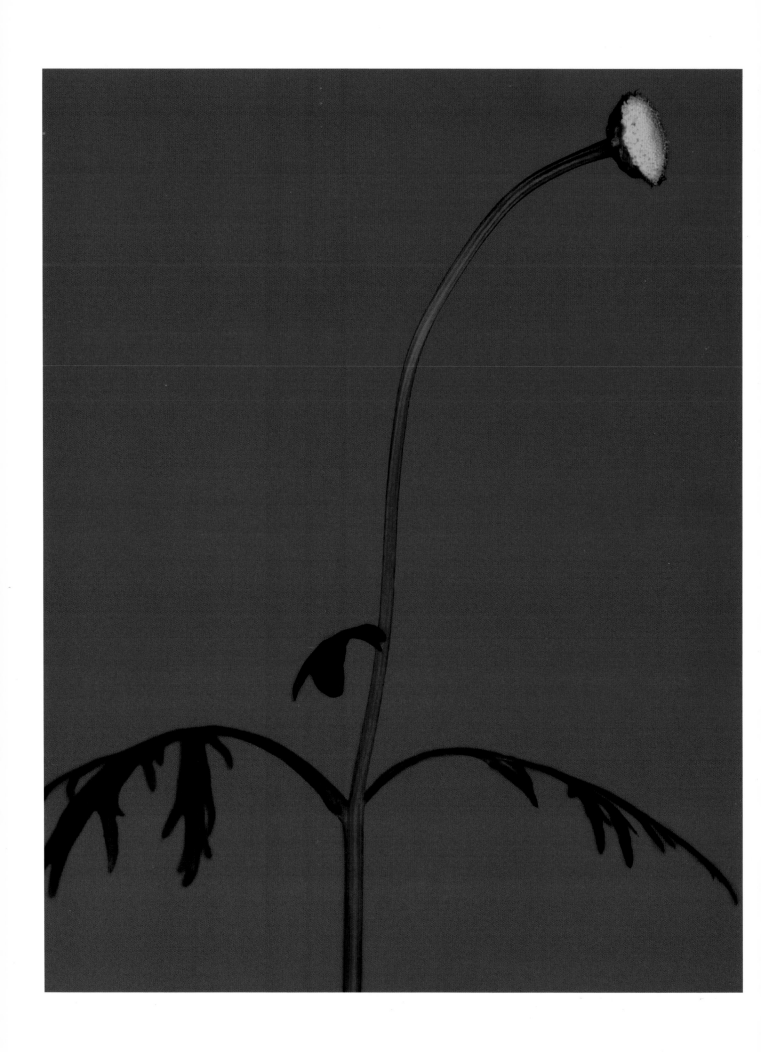

(previous page) joSon (this page) Bill Diodato

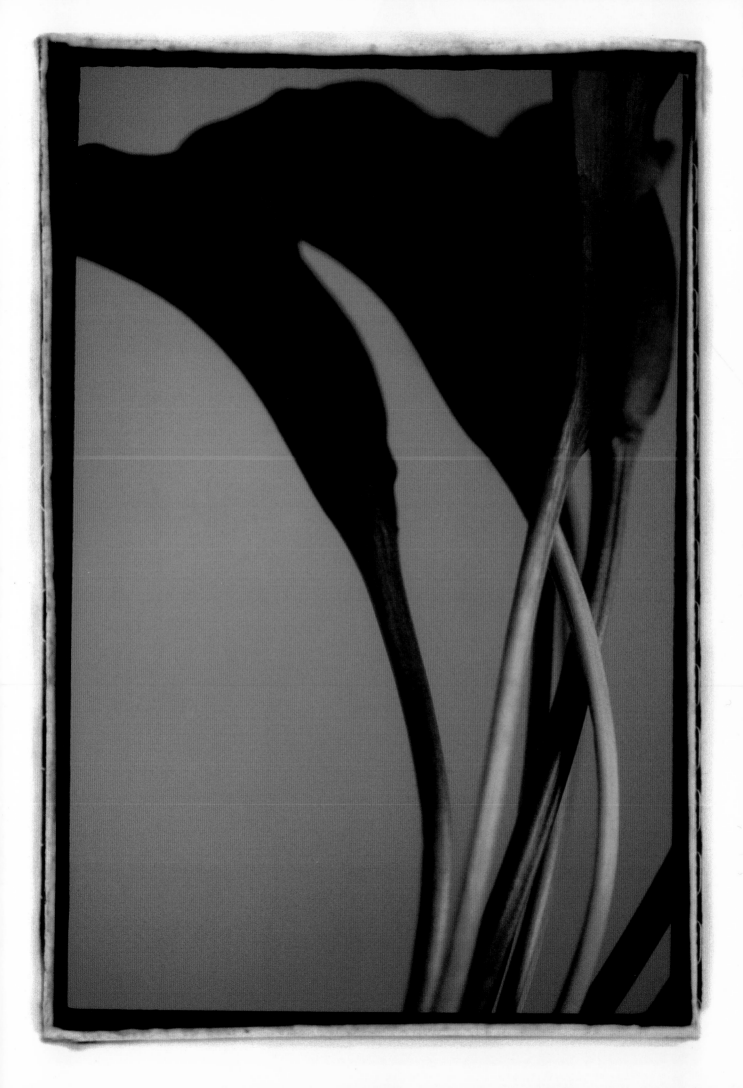

Brandon Jones

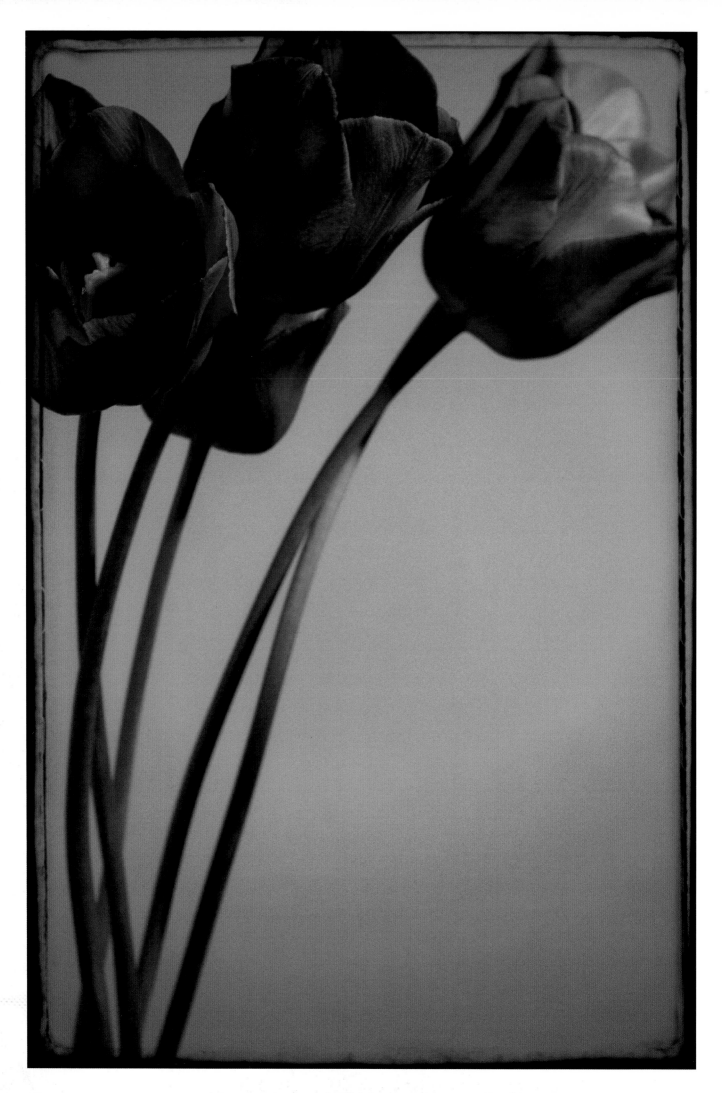

Barndon Jones

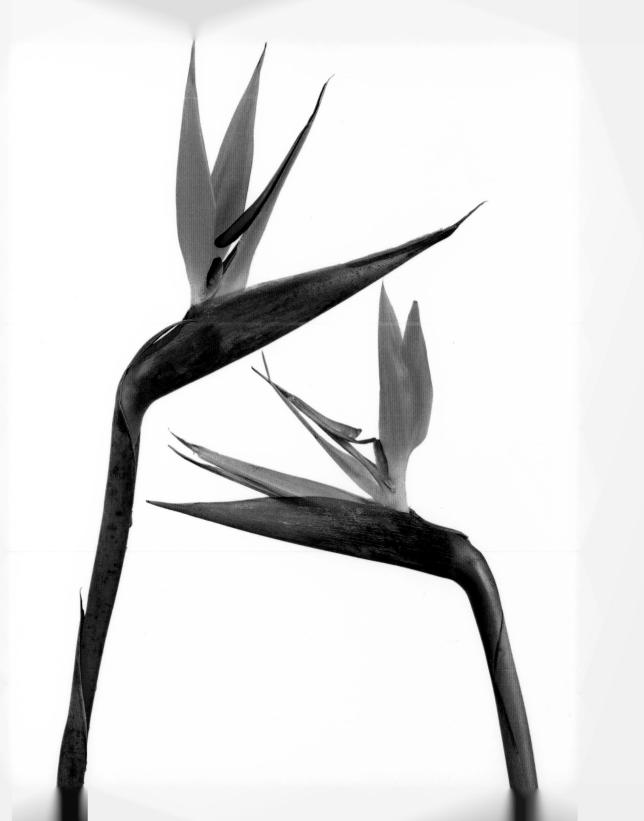

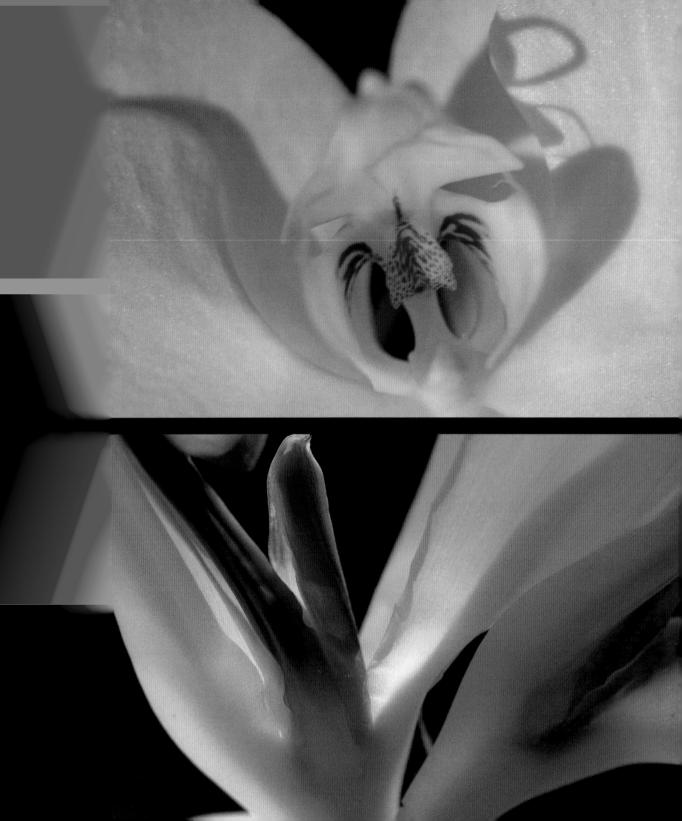

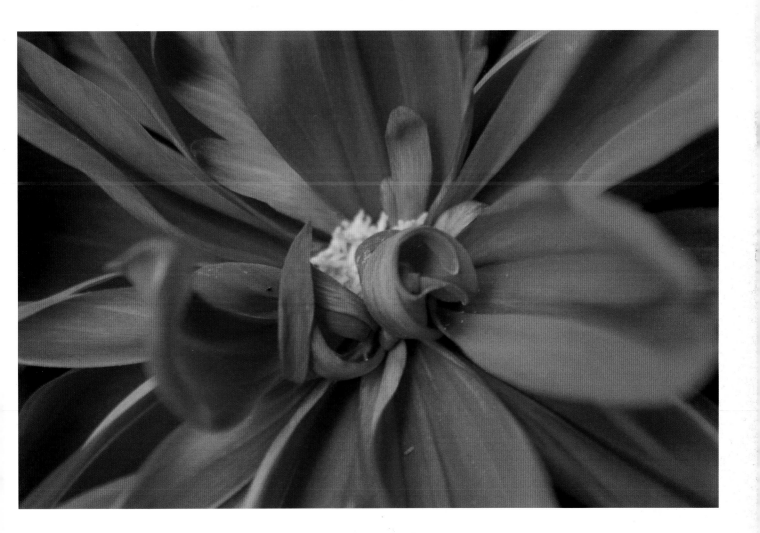

Lonnie Duka

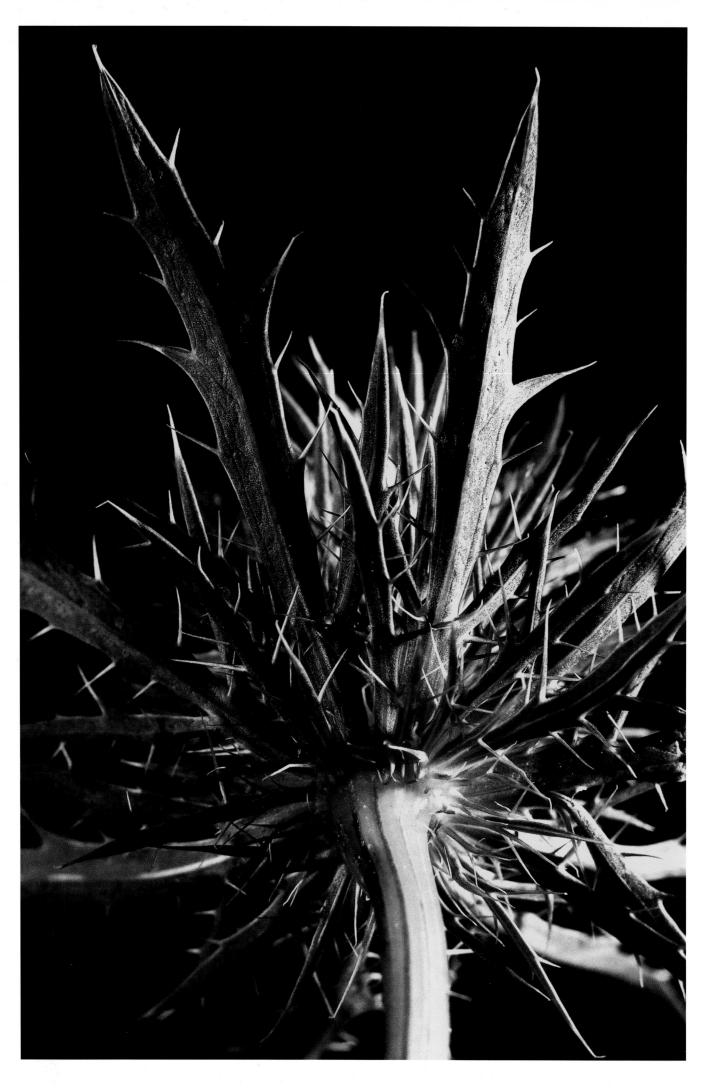

Ted Morrison

Brett Traylor

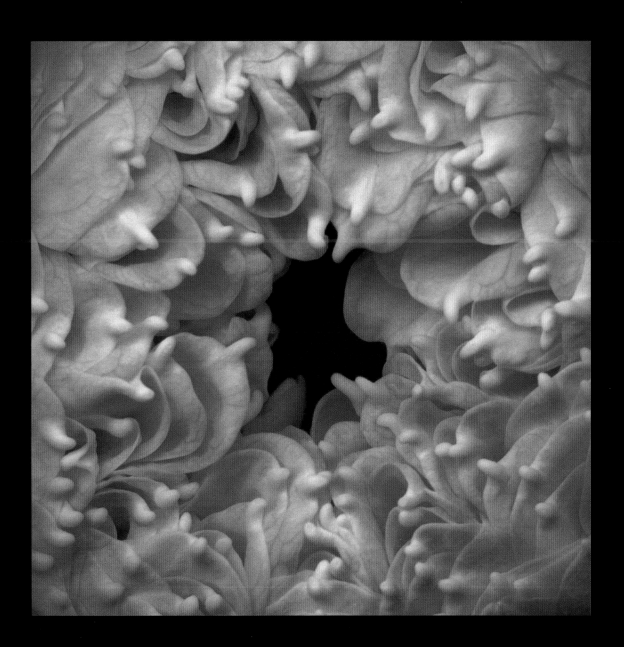

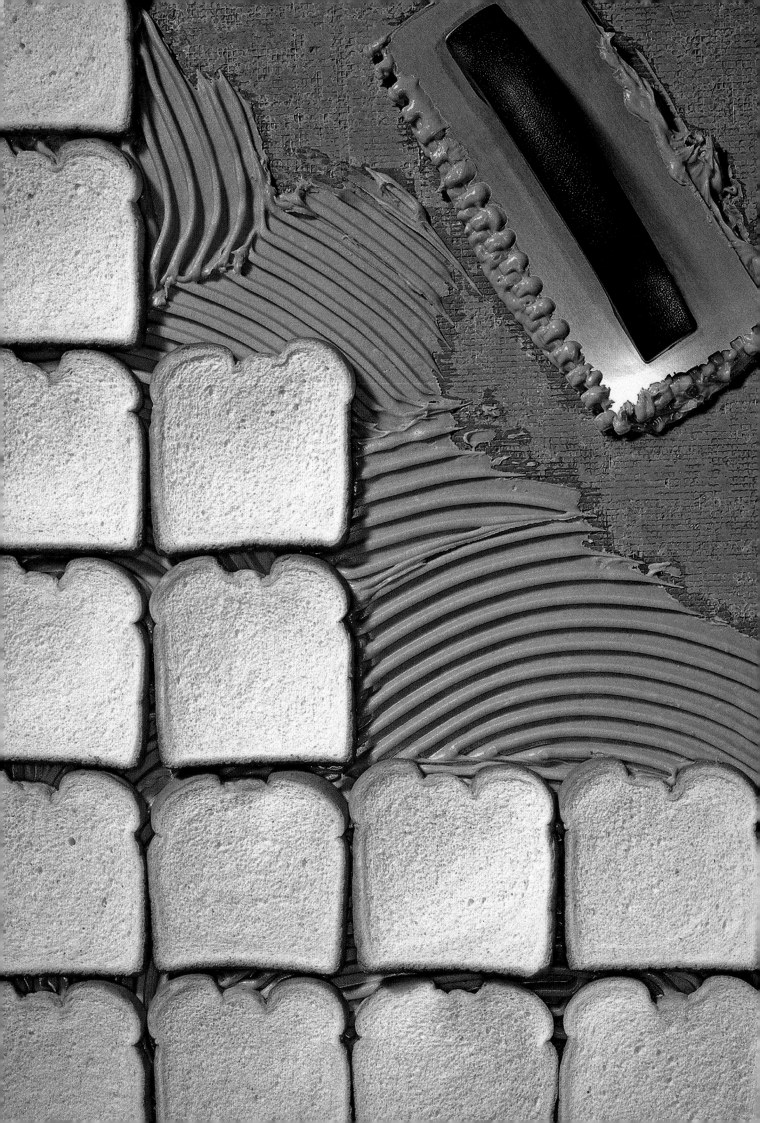

Food&Beverage

Food&Beverage

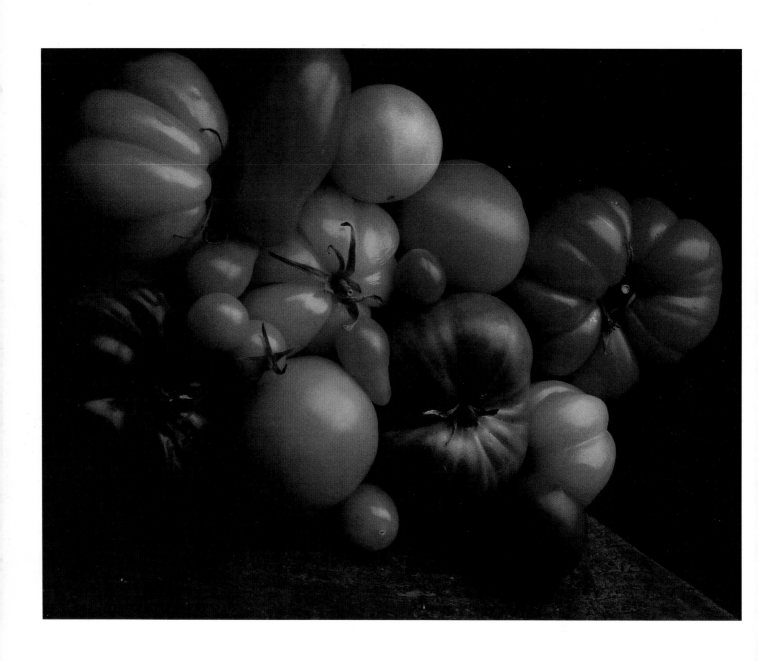

(previous page) Hollar + Reimers (this page) Ira Kahn

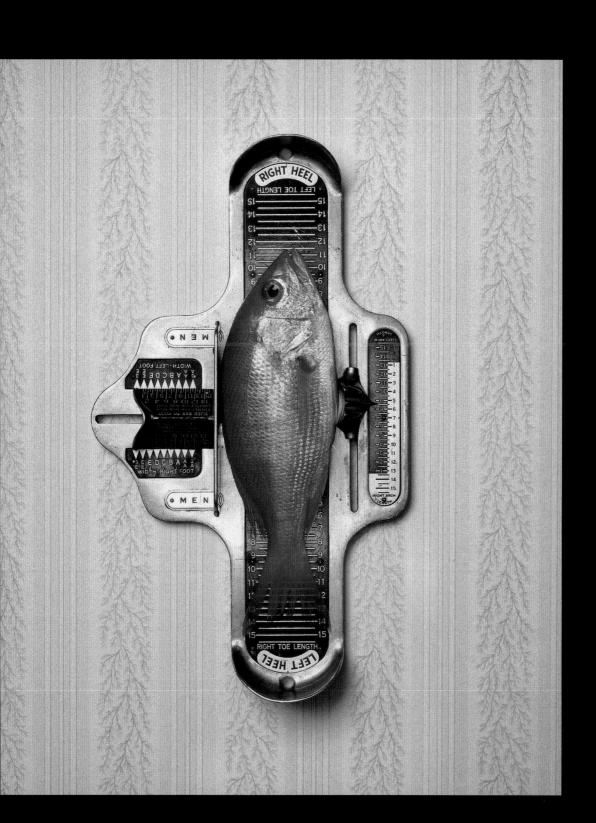

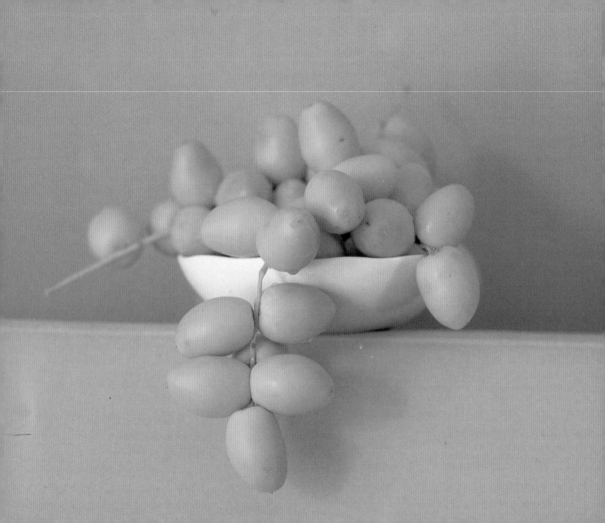

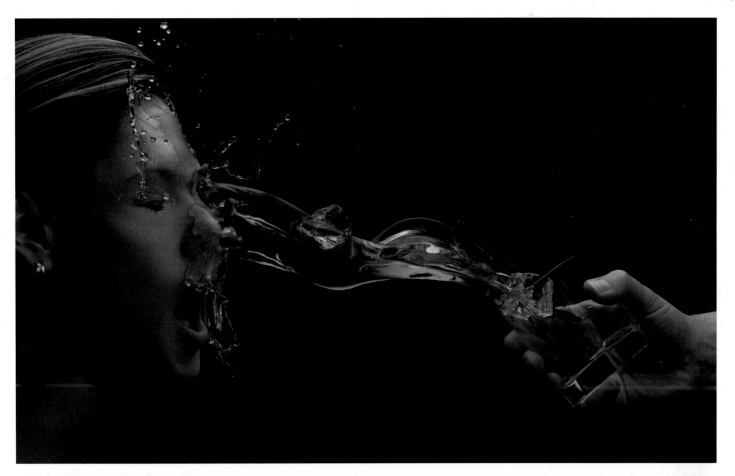

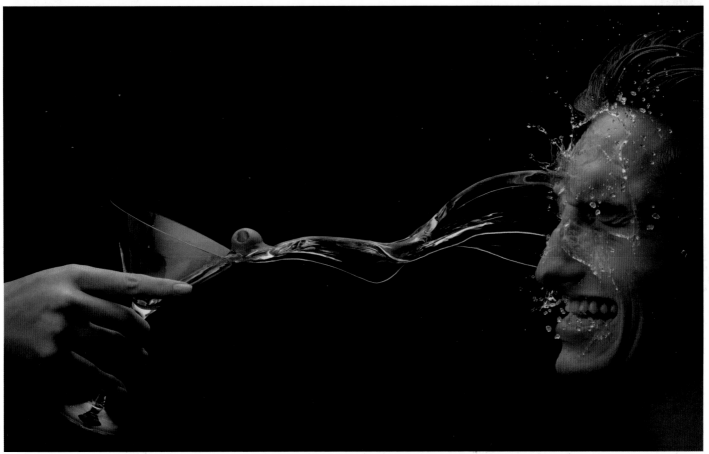

Steve Bronstein

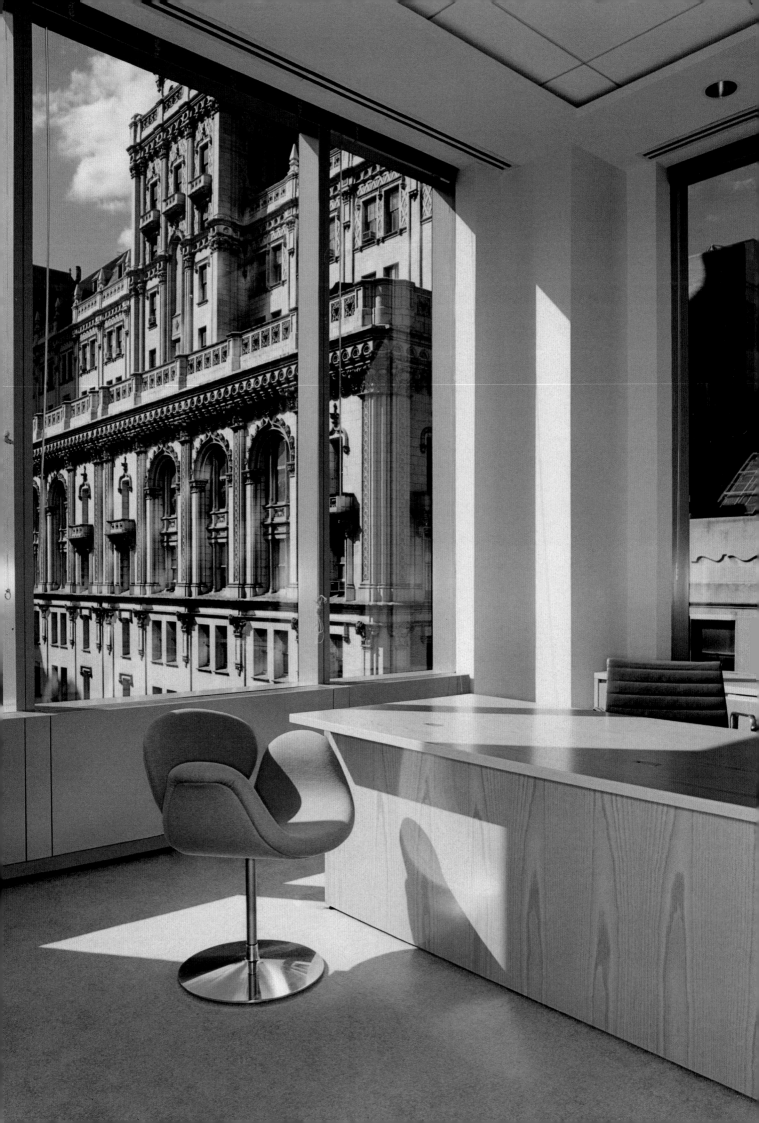

Interiors

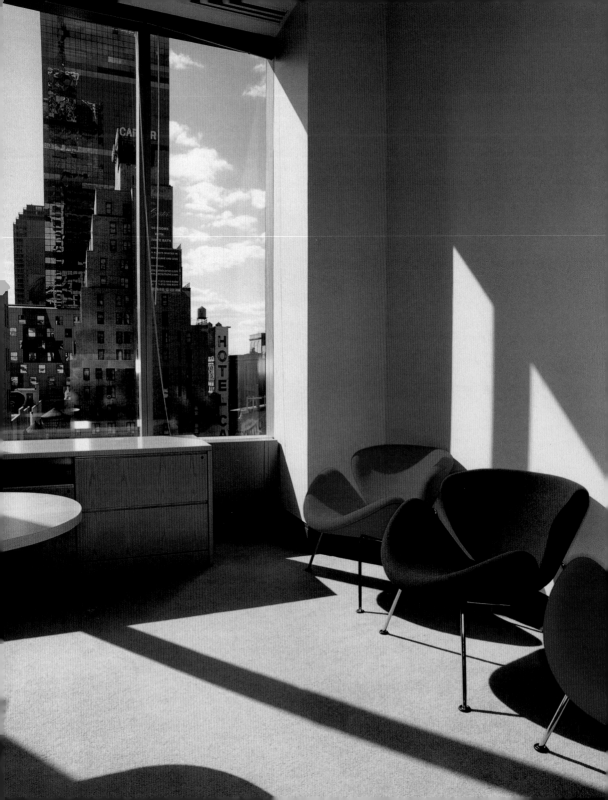

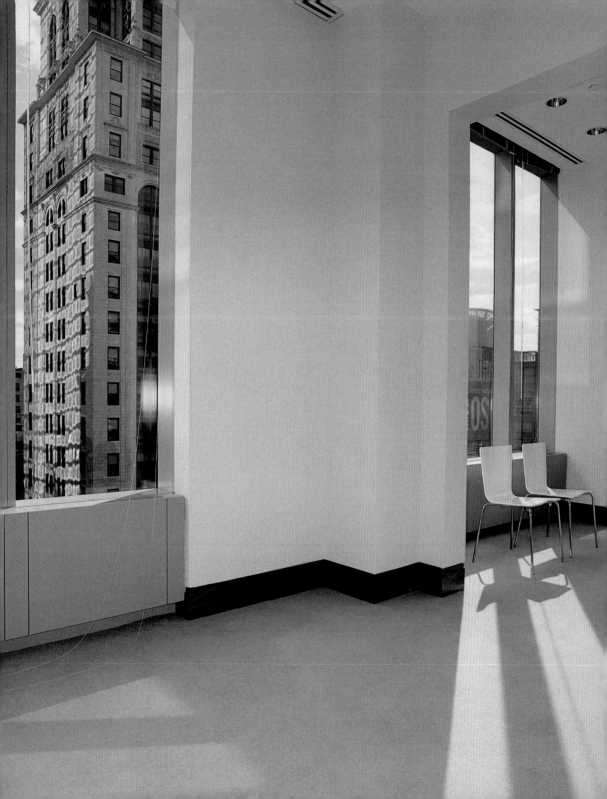

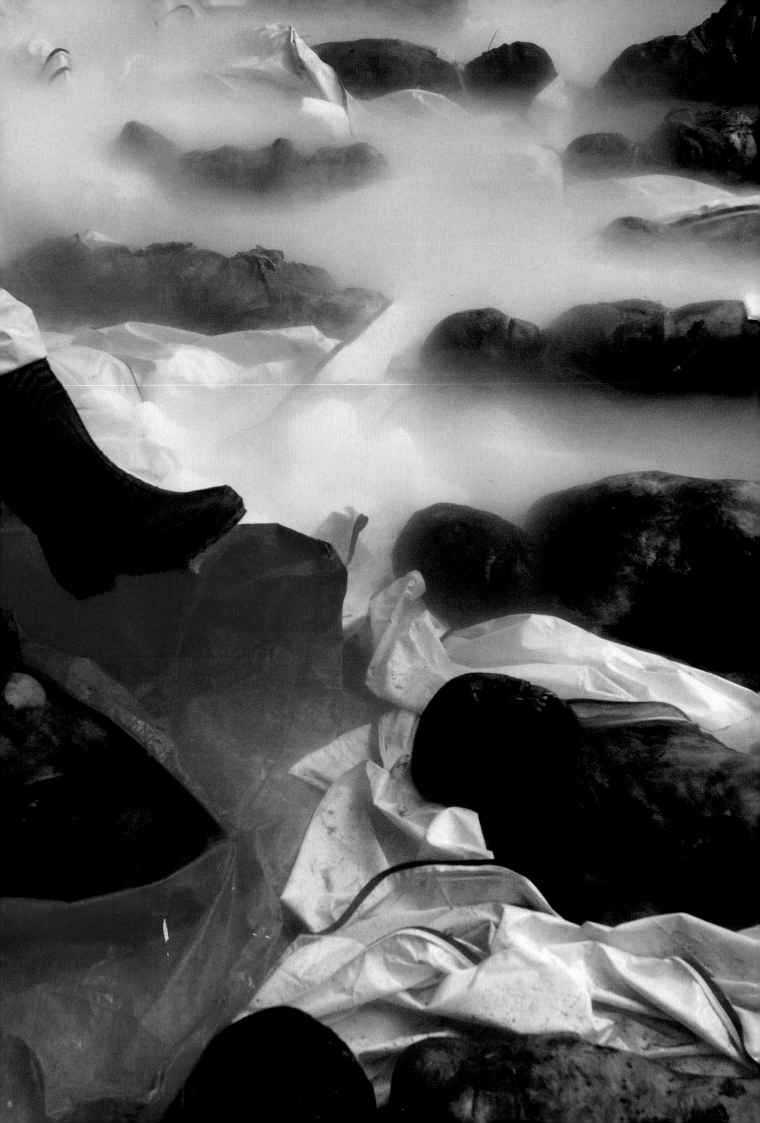

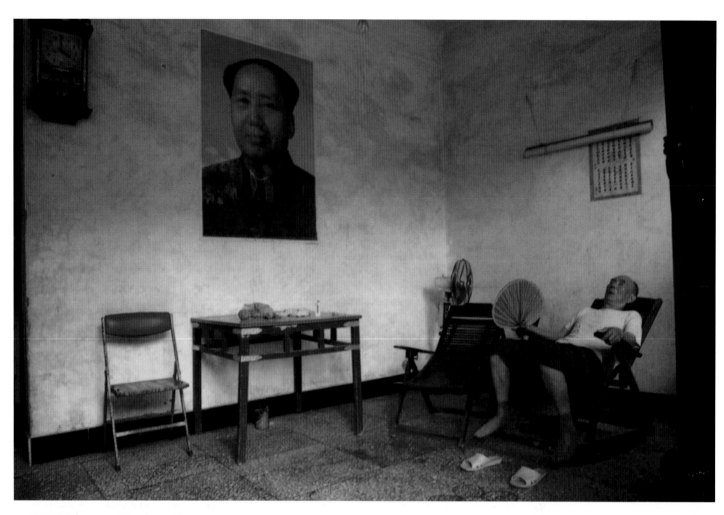

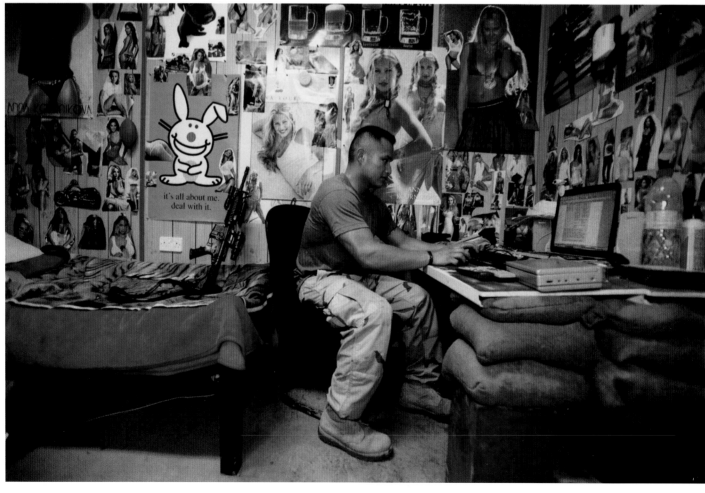

(previous page) Craig Cutler (top) Natalie Behring (bottom) Brent Stirton

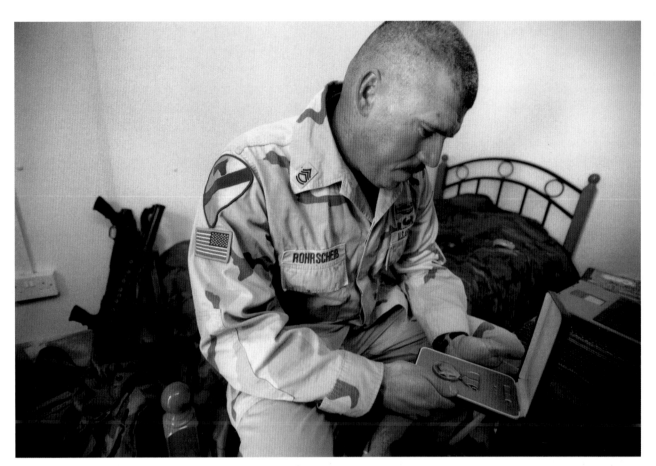

(page 68) January 11, 2005; Khao Lak, Thailand; Corpses lie on the ground in a dry ice mist, keeping cool, while volunteers take a rib for Dna samples, at the Yan Yao temple in Thailand where forensic scientists are working on the identification and storage of the dead. Most of the bodies are Thai, but occasionally a foreigner is found. Mandatory Credits: Photography by David I. Gross, from Zuma Press. (bottom, previous page and this page) The Arkansas National Guard is stationed in Taji, Iraq. This series was filmed for the Discovery Times Channel program, Off to War.

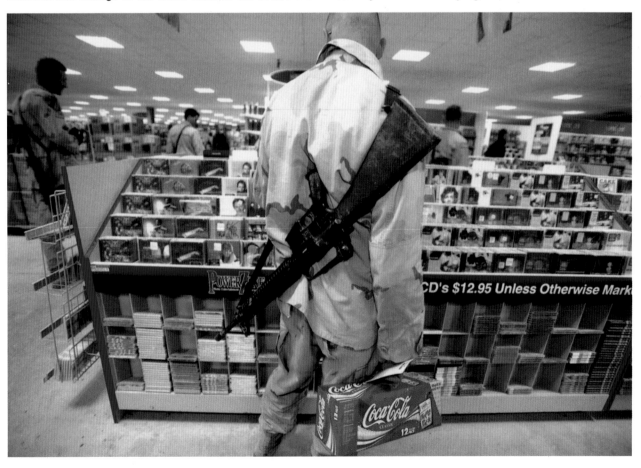

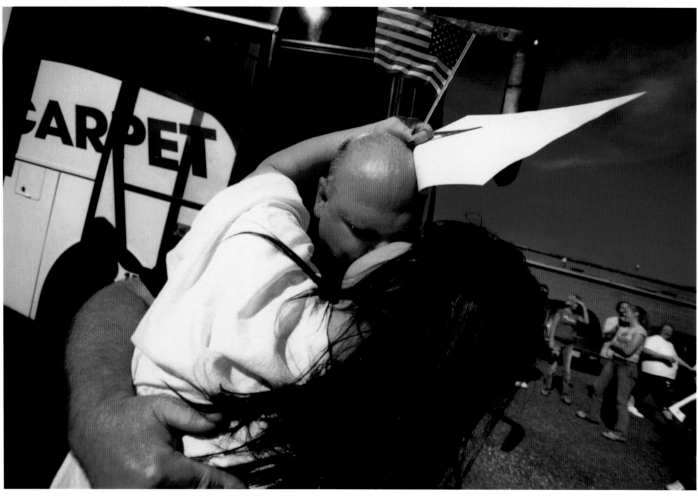

Brent Stirton

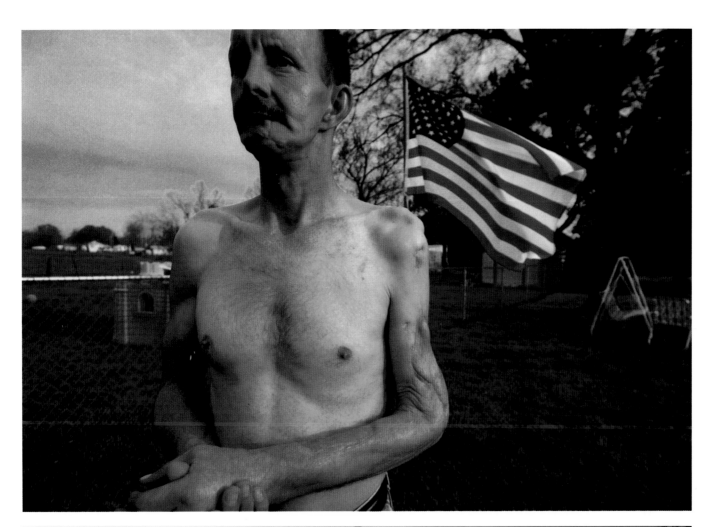

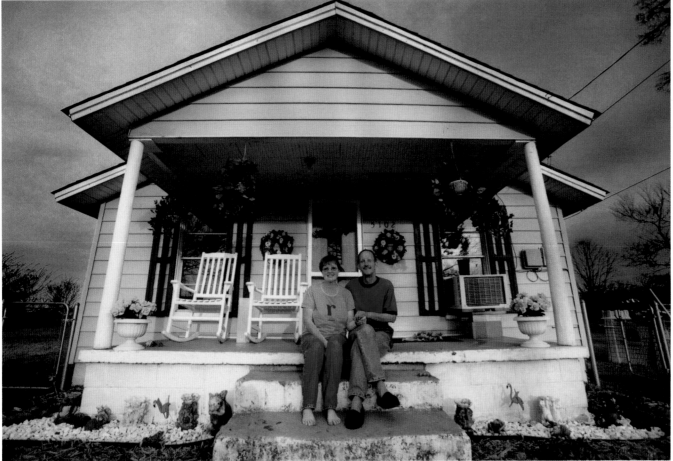

(this spread) The Arkansas National Guard returns home, with joy and tragedy, after having served for 14 months in Iraq.

Brent Stirton

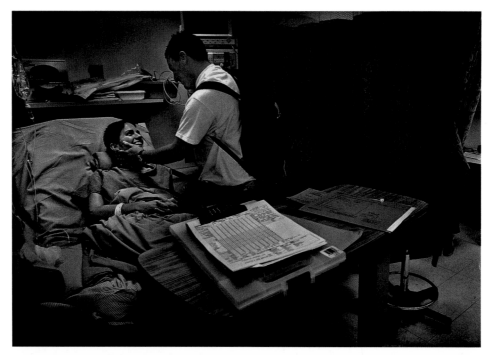

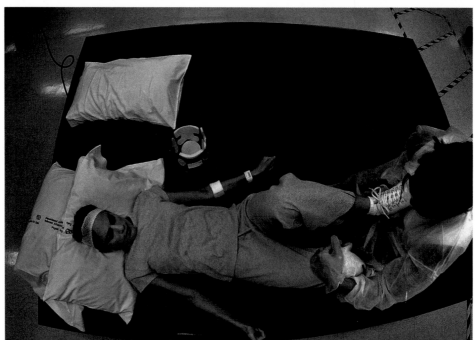

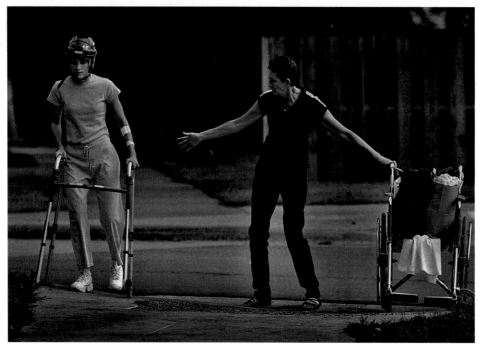

Jim Gehrz

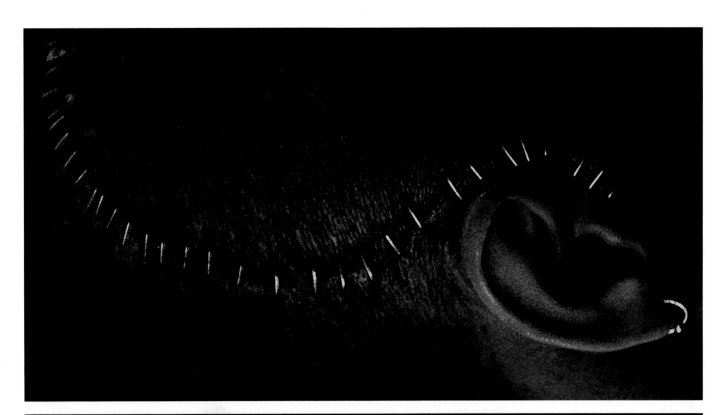

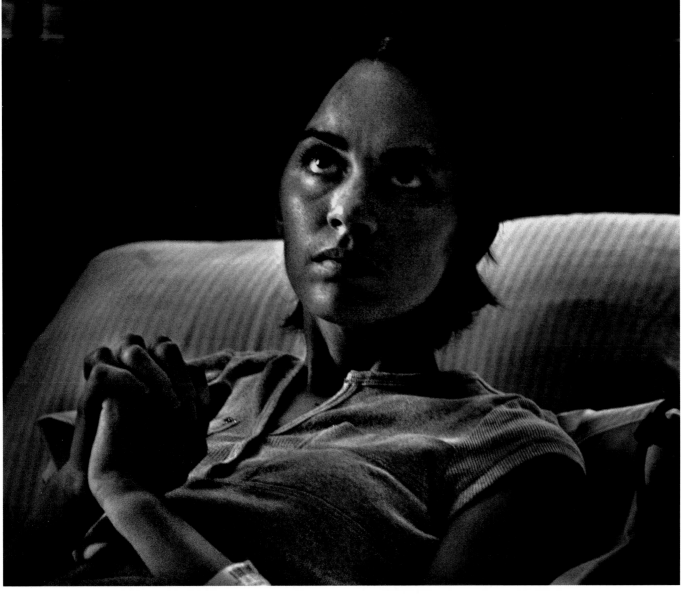

United States. Army Staff Sergeant Jessica Clements, 27, was given less than 2% chance of survival. She is one of 12,000+ U.S. soldiers wounded (more than 1,600 have been killed) in the Iraq War. Jessica Clements, a former model and massage therapist, was critically injured outside Baghdad when a roadside bomb exploded beneath her convoy sending shrapnel into the right side of her brain. Clements beat the odds with her courage and character. Behold her life-affirming and determined recovery.

Jim Gehrz

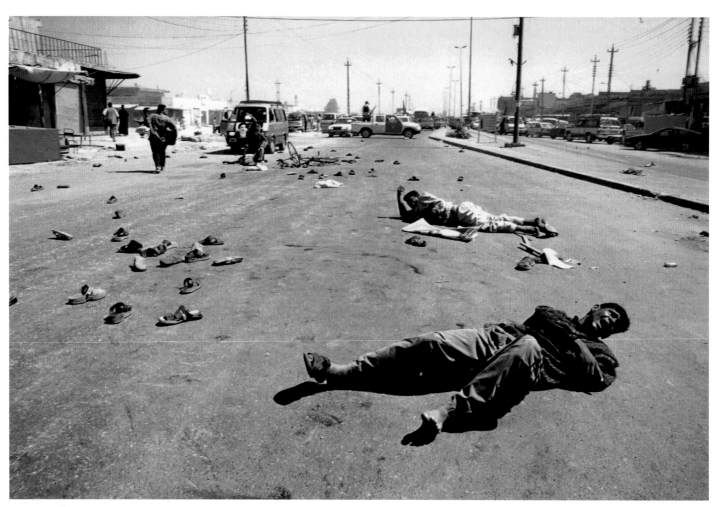

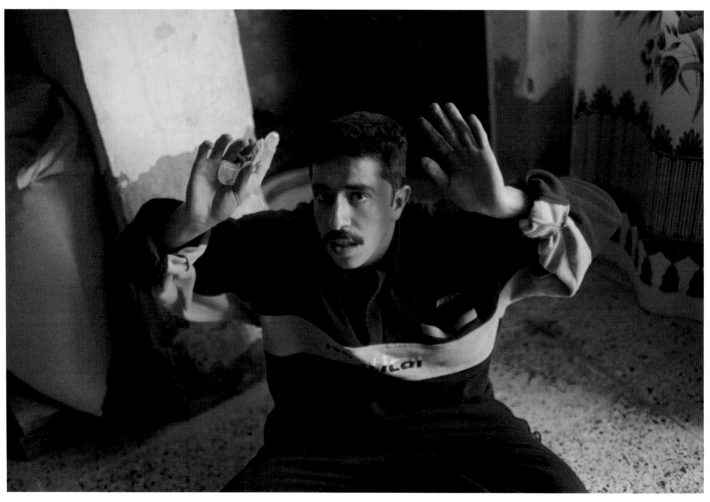

(top) Jerome Sessini, (bottom) Gary Knight

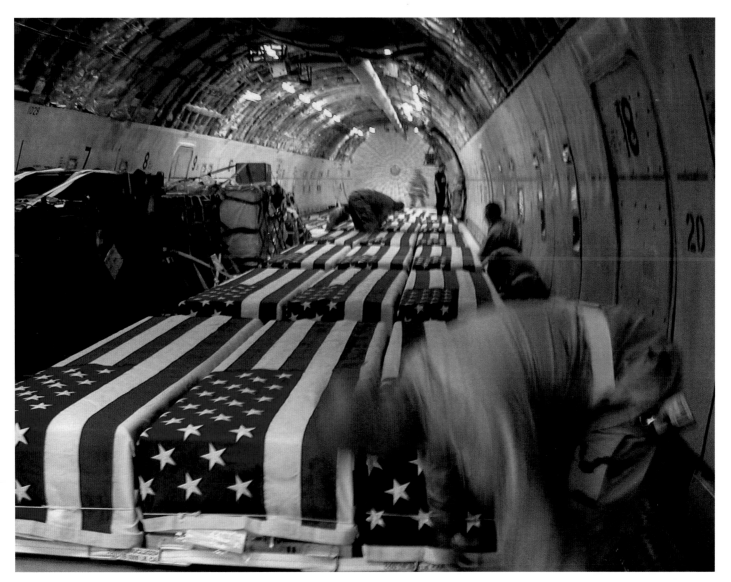

(top, opposite page) A Man lies in the streets of Najaf after police open fire on protesors there. Hundreds of loyal Shiite supporters came from all over Iraq to accompany the Ayatolla Sistani in Najaf who had come to bargain for a peaceful alliance and an end to the crisis in the Holy city with the Medhi, loyal supporters of Moqtada al Sadr. (bottom, opposite page) A raid in the city of Tikrit during which plastic explosives were recovered. A number of people were detained. Members of TF/122 part of the 4th ID were involved. (this page) April 9, 2004; Kuwait, Kuwait; Exclusive! Twenty-one flag draped coffins are carefully strapped down and checked prior to being returned to the United States aboard US military transport aircraft. The soldiers were all killed in Iraq.

Jeff Minton

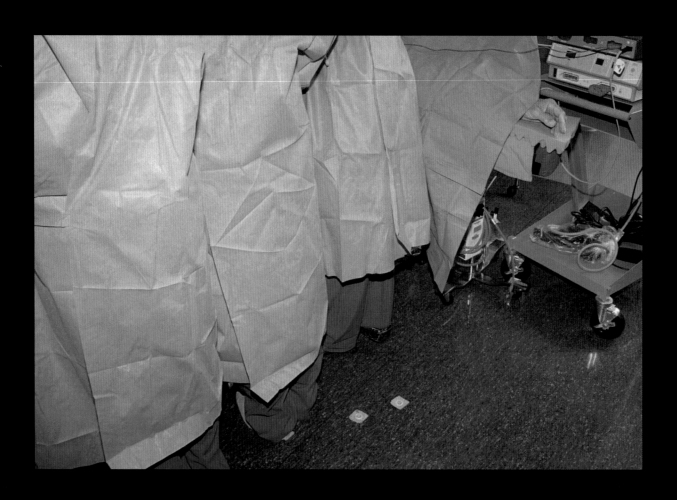

Jeff Minton

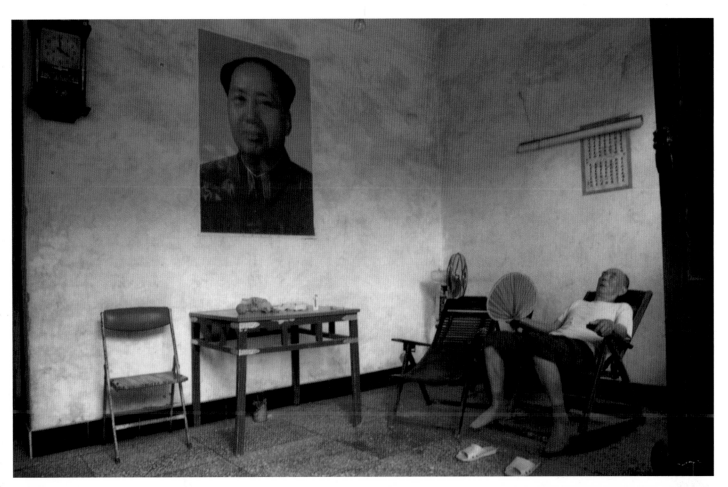

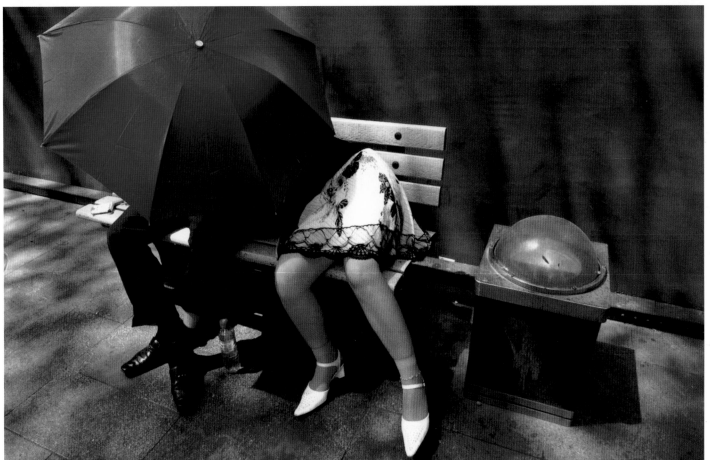

(opposite page) Surgeons at work (top) Man resting, Yangshuo (bottom) Couple on bench, Beijing

Natalie Behring

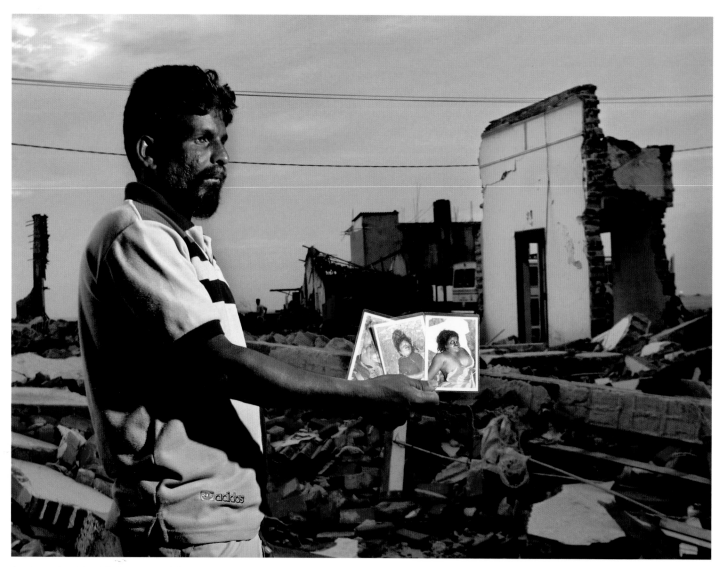

January 8, 2005; Wellawawta, Sri Lanka; E. Jayantha, 43, stands on ther ruins of his house in Wellawawta, Sri Lanka, holding pictures of his daughter and wife. 'I was working as a porter when the Tsunami hit. I went to the second floor of a house and I waited until the danger was over and returned to see my house totally destroyed. After three days of looking for my family, a soldier came to my sister's house with these photos. I was relieved with this confirmation, not like others who do not know the fate of their family.'

(next page) The article tells the story of Ken Thigpen, who traded his life as a pimp and a drug dealer for a life as a pizza delivery man to raise his son Kevion alongside Jewel, Kevion's mother. Welfare reform which targets single-mother famlies has sent many more women than men into the work force, transforming their lives. But evidence shows that it has not neccessarily improved the lives of their children. The missing link being a consistant father/partner making Ken an anomaly.

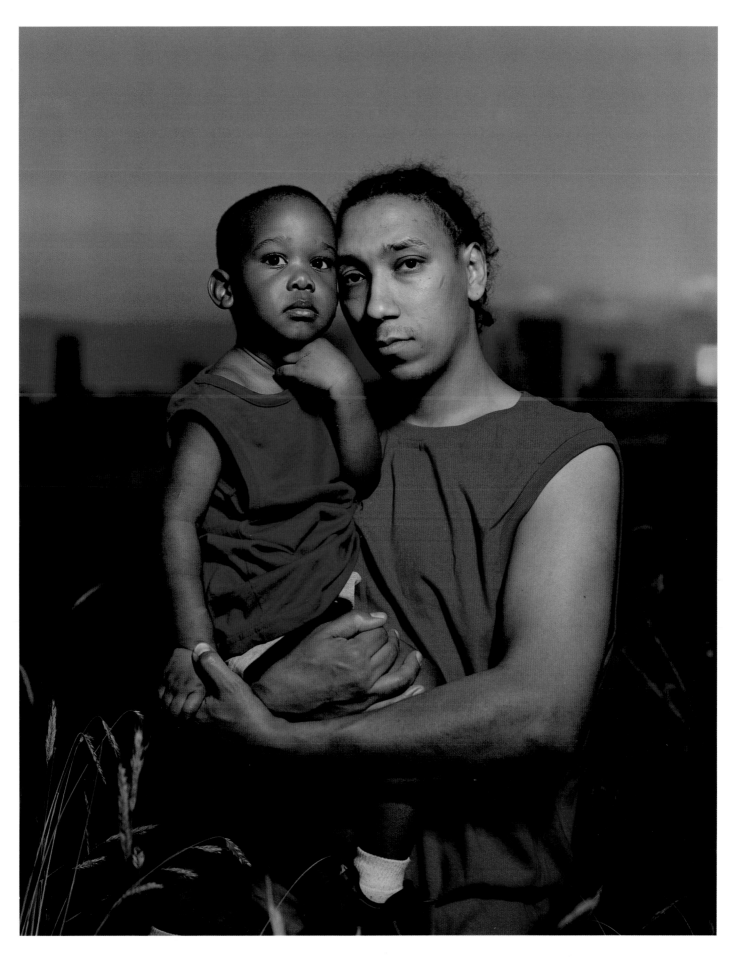

Alessandra Petlin

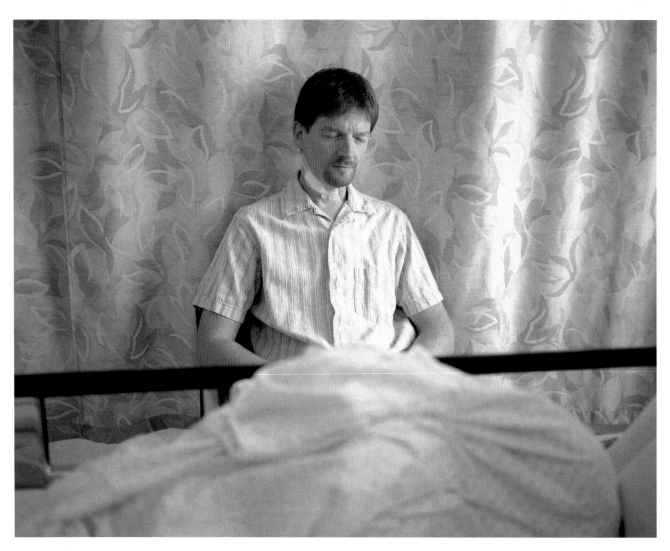

Stephanie Diani

Just weeks before our 1st anniversary, almost exactly a year from the date my mother's 2nd bout with cancer began, my husband was diagnosed with non-Hodgkin's lymphoma. Photographing him throughout his 6-month treatment helped me to put his disease in a box and gave me an outlet for the rage, anxiety and exhaustion that I felt.

Stephanie Diani

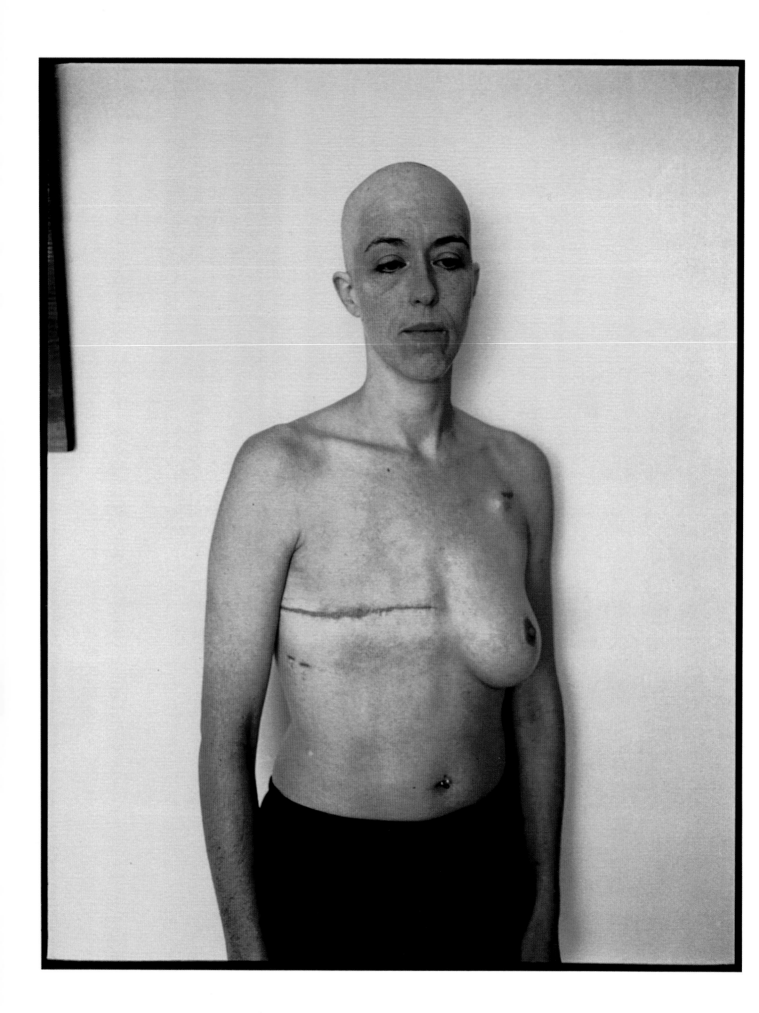

Anette Aurell

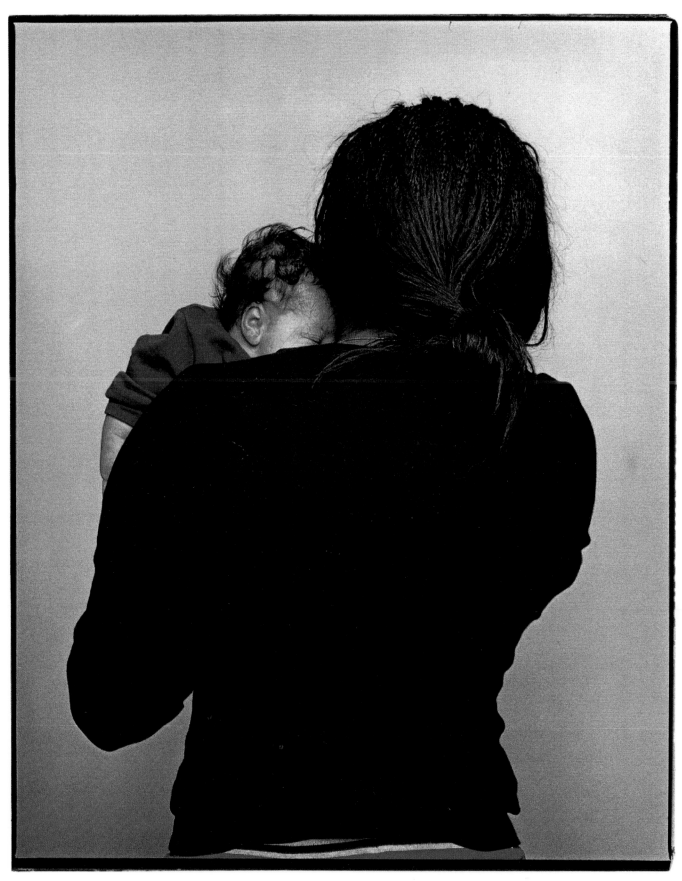

(opposite page) Photographed by Anette Aurell for Newsweek magazine. Breast cancer survivor Suellen Bennett. The photograph was taken at her home in North Brunswick, New Jersey.

(this page) Photographed by Ethan Hill for Newsweek magazine. This is a woman suffering from AIDS. Subject does not wish for her name to be released.

Ethan Hill

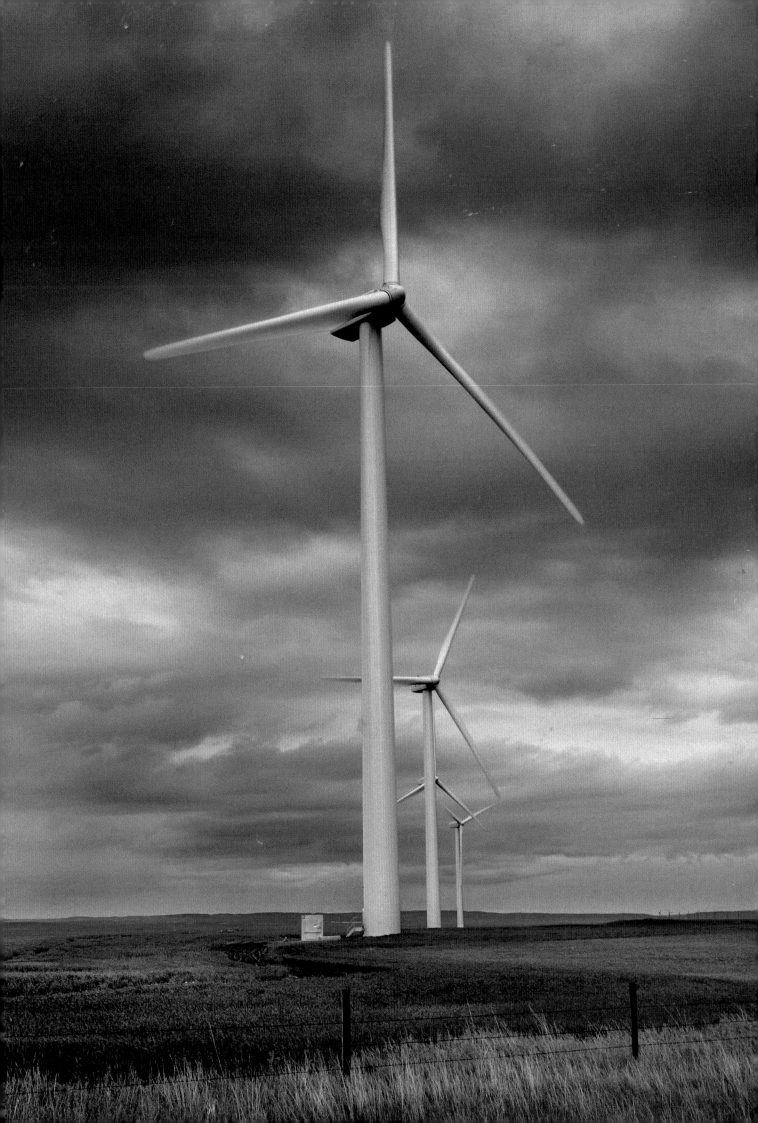

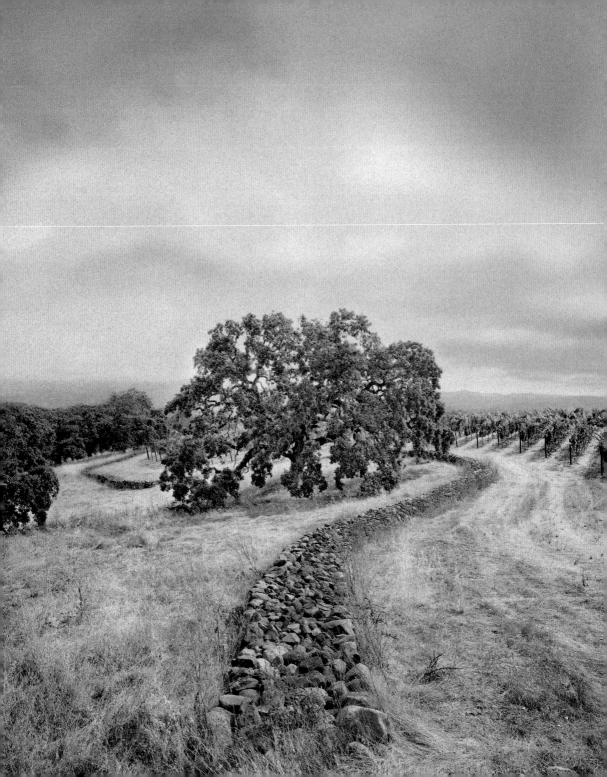

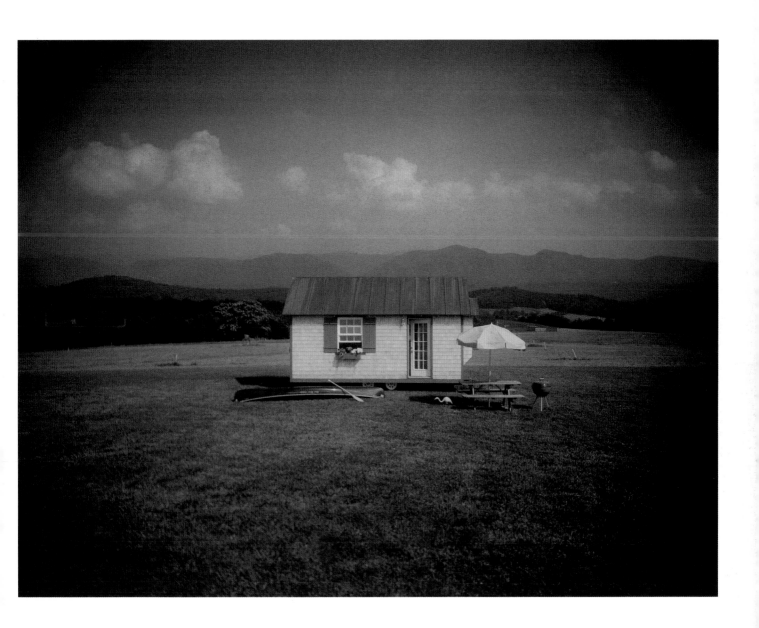

John Henley

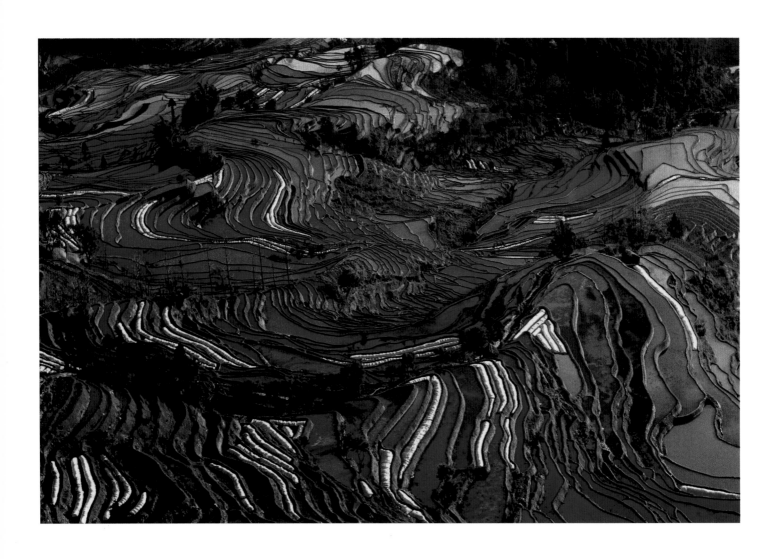

Wu Jianguo

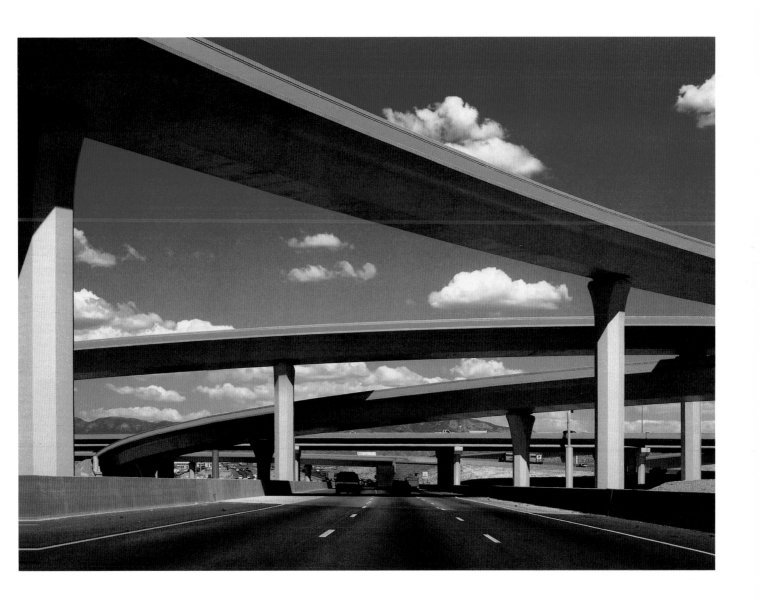

I. David Gross

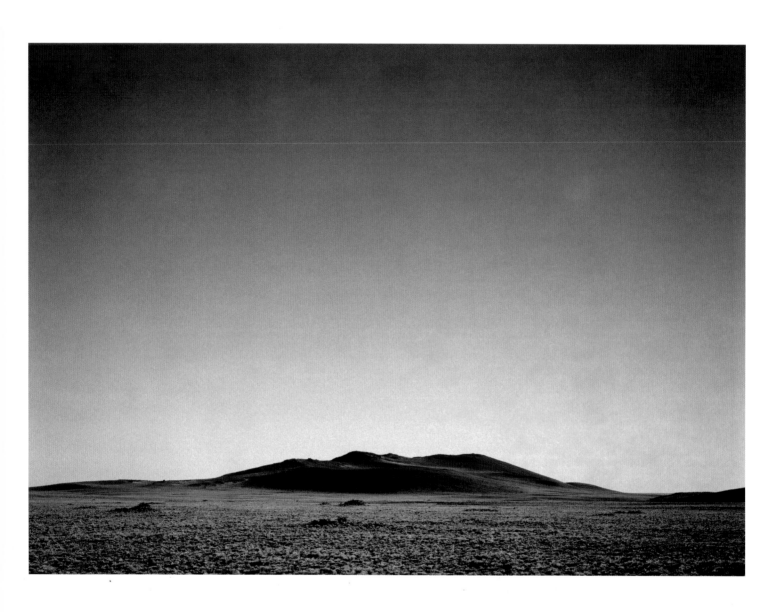

Andy Anderson

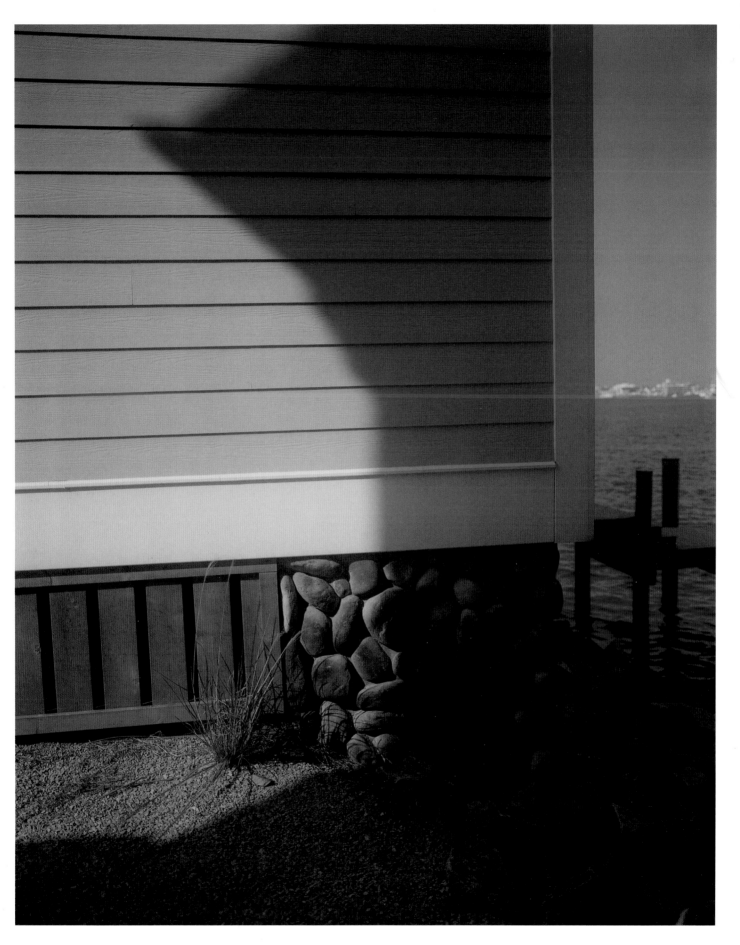

Theo Morrison

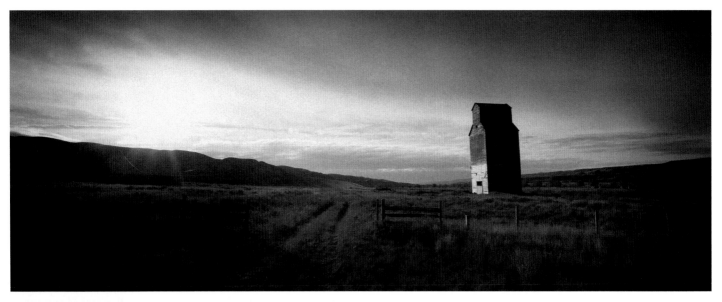

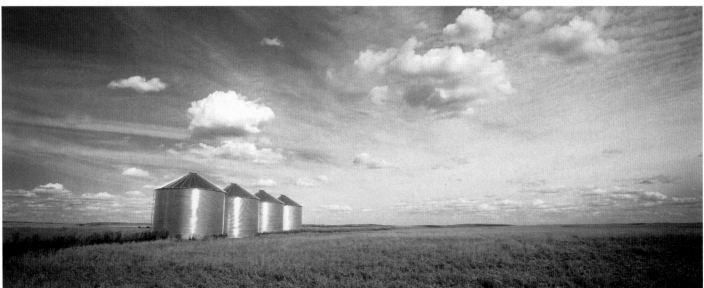

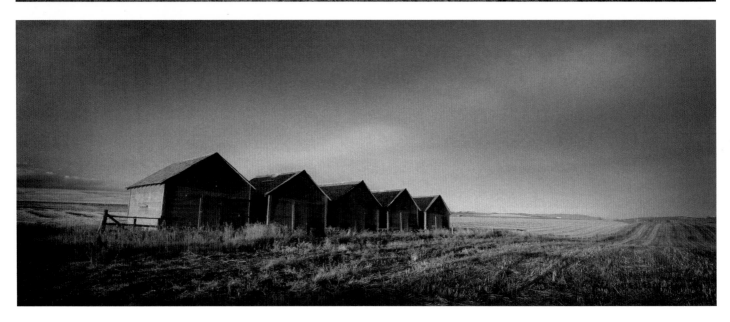

Chris Gordaneer

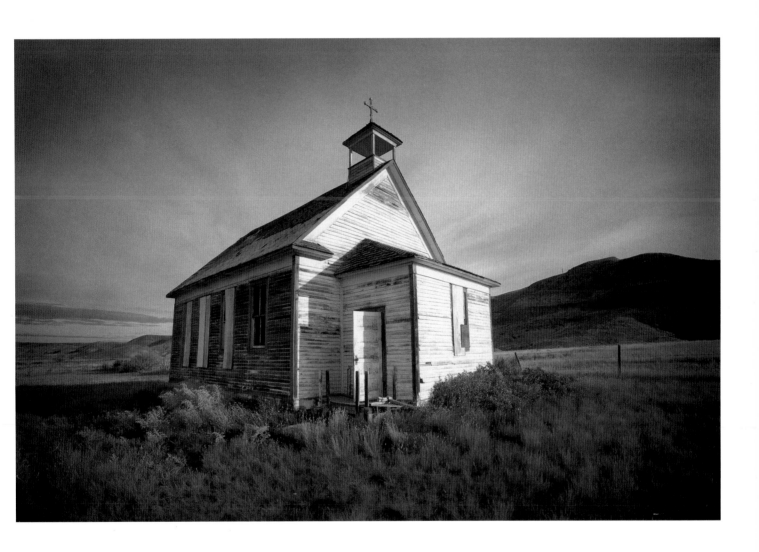

Chris Gordaneer

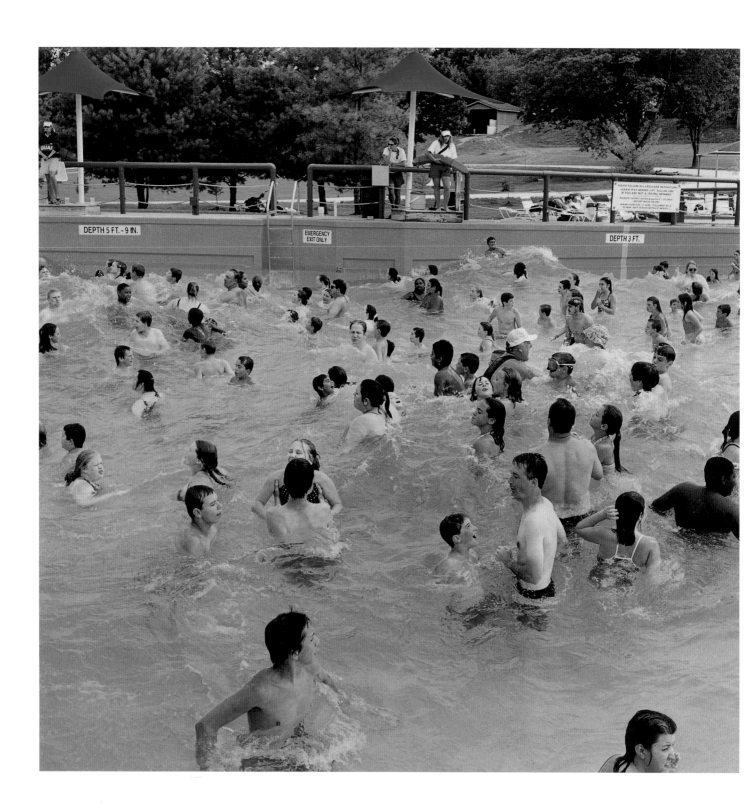

Craig Culter

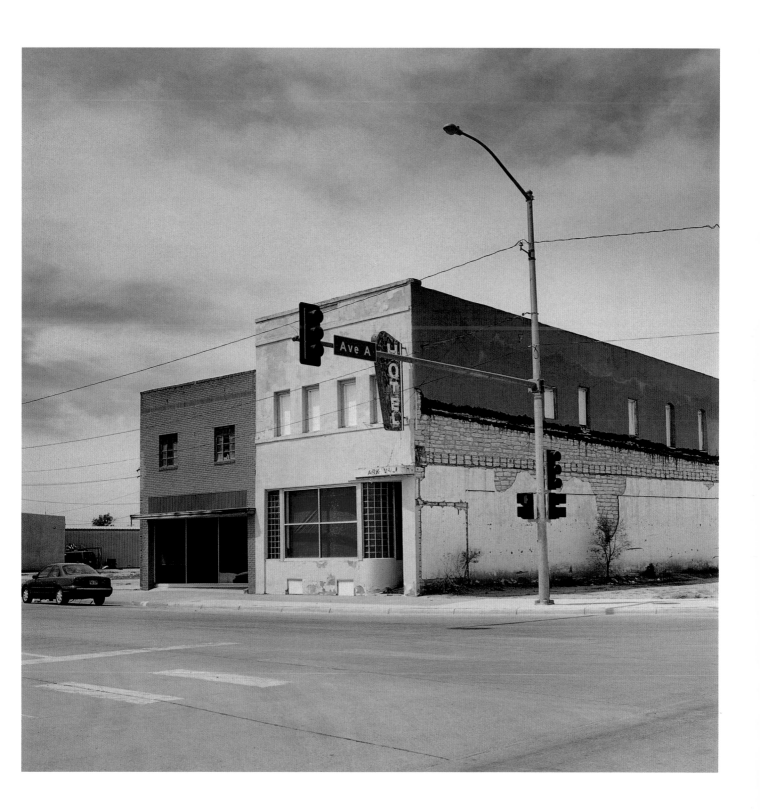

Craig Culter

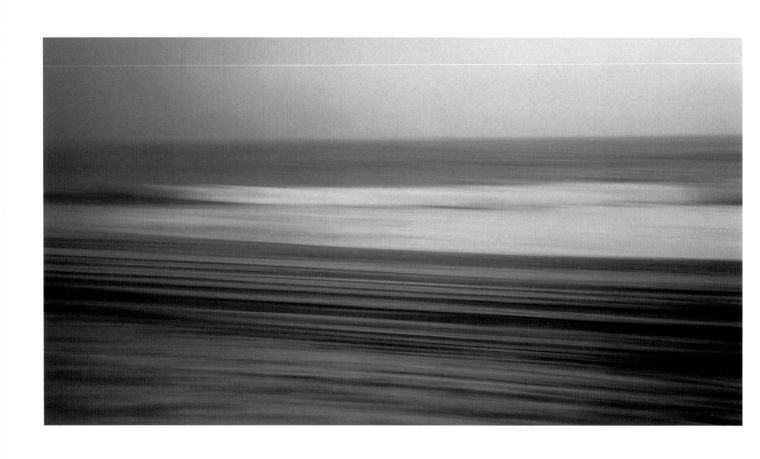

Craig Culter

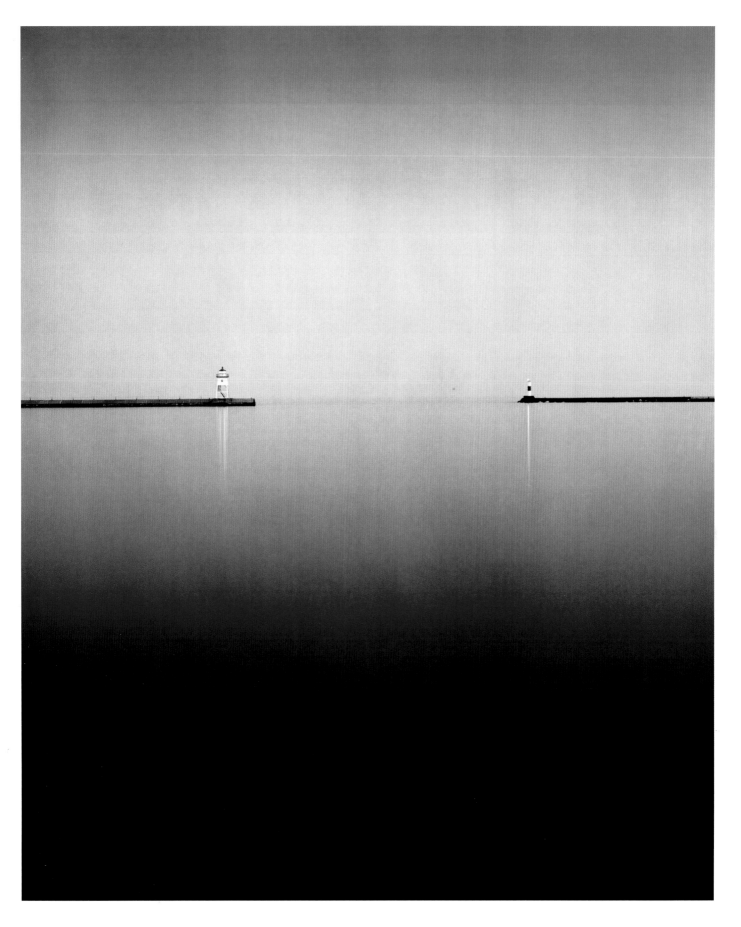

David Bowman

Colin Finlay

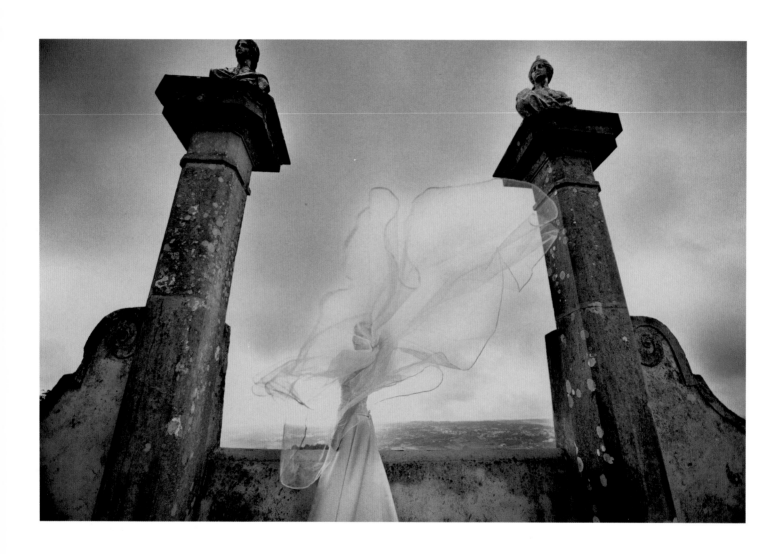

Colin Finlay

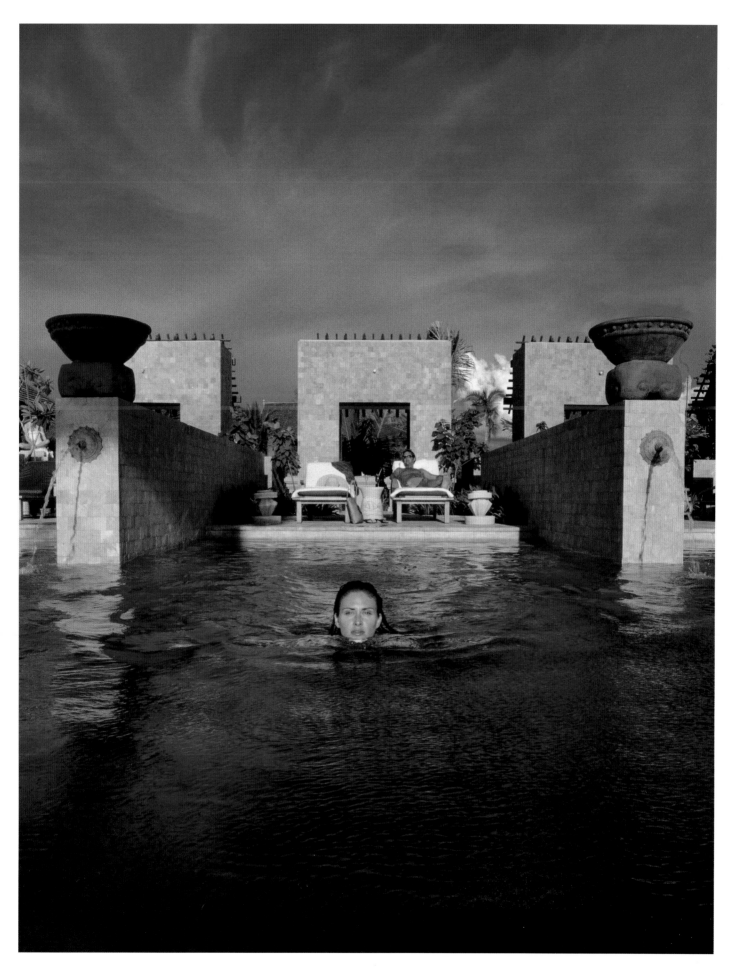

Michele Clement

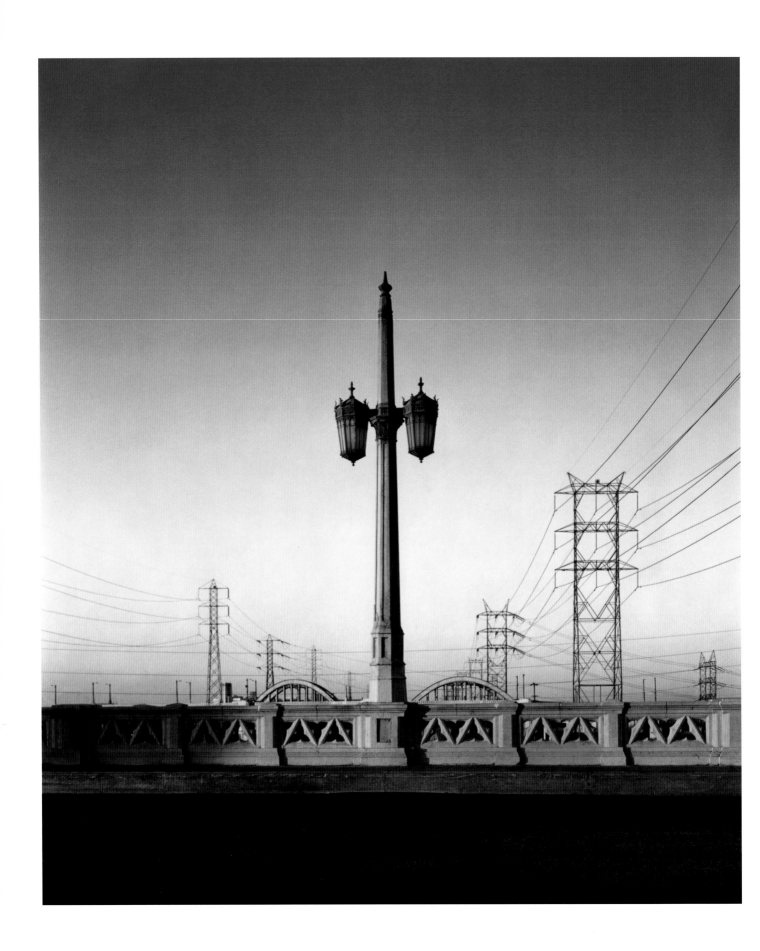

Andy Anderson

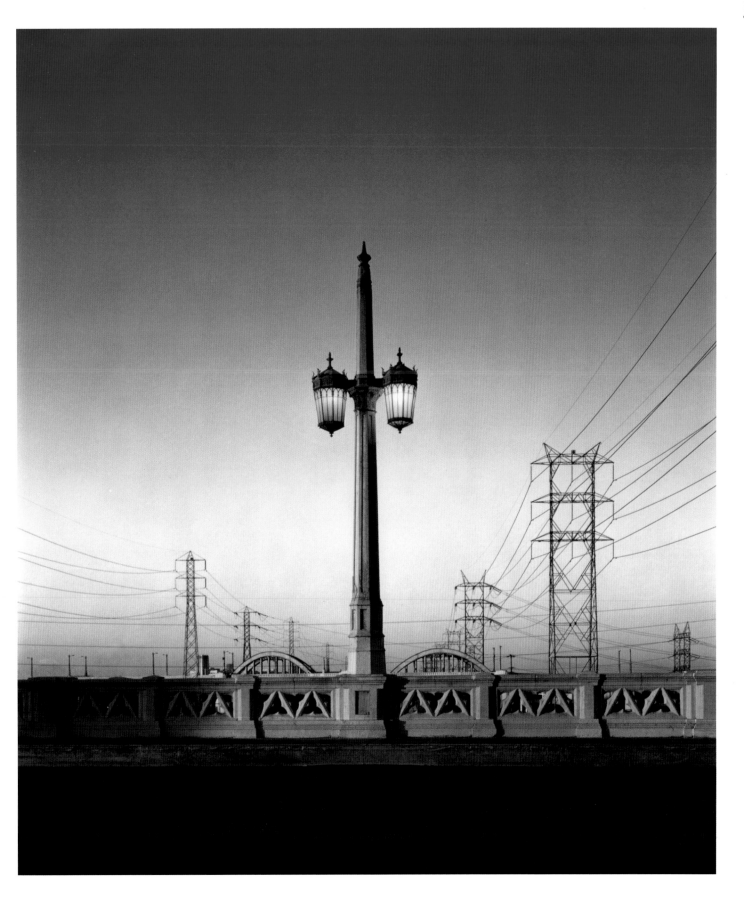

Andy Anderson

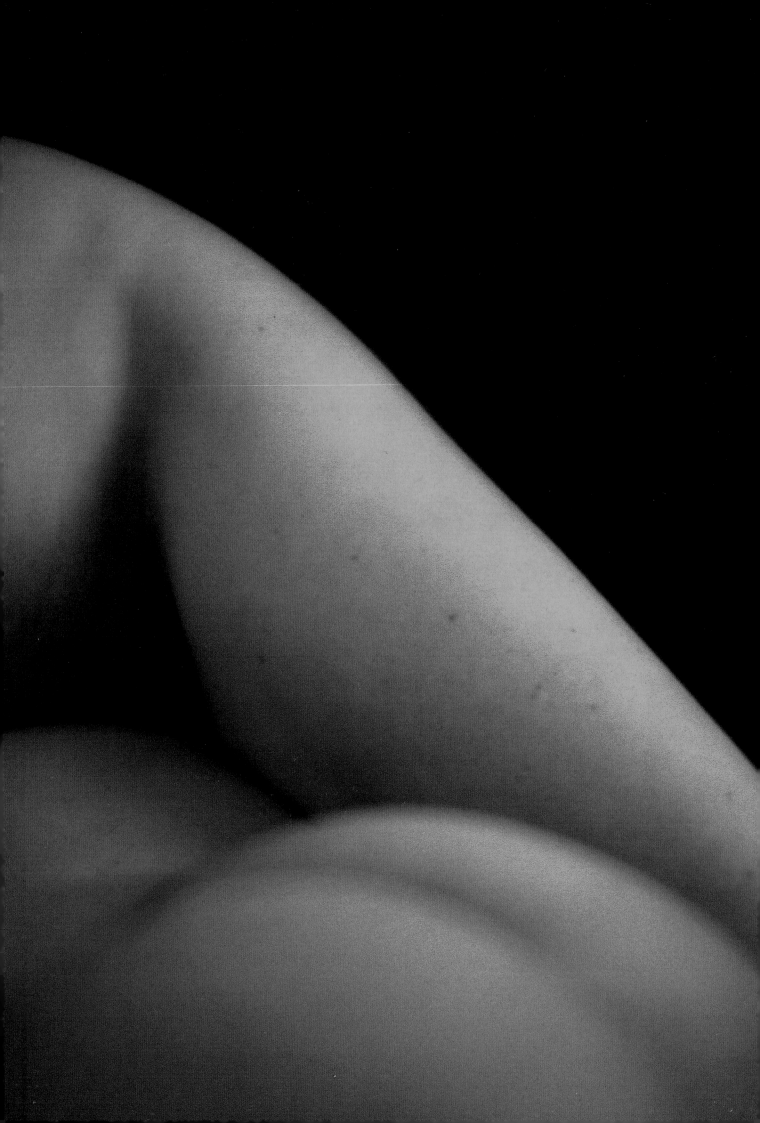

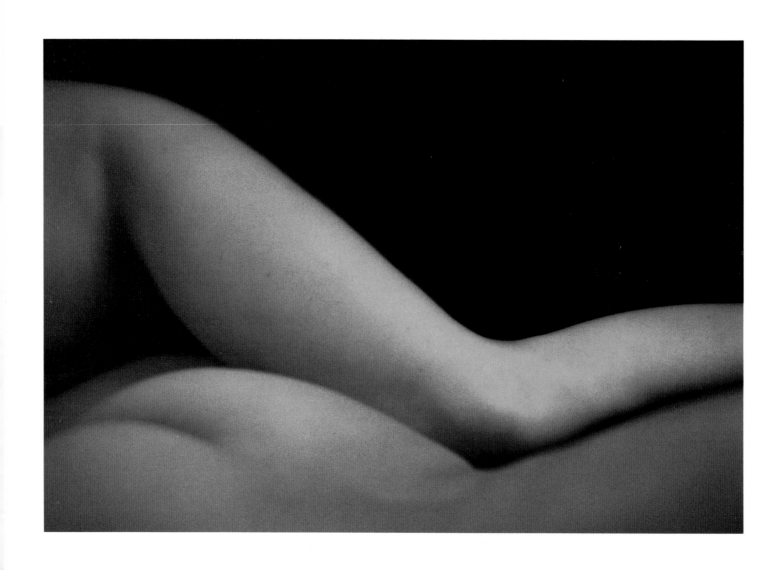

Joseph E. Reid

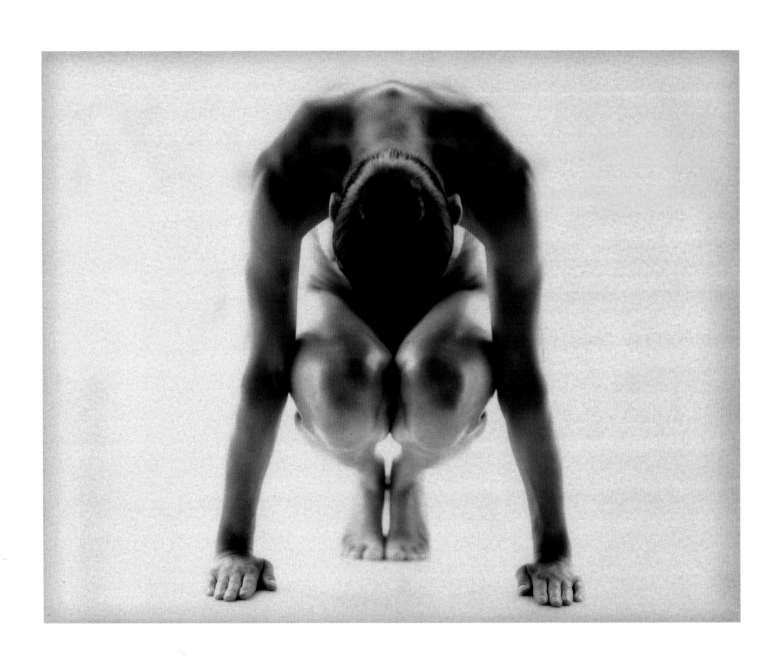

(previous page) Joseph E. Reid (this page) Marcus Swanson

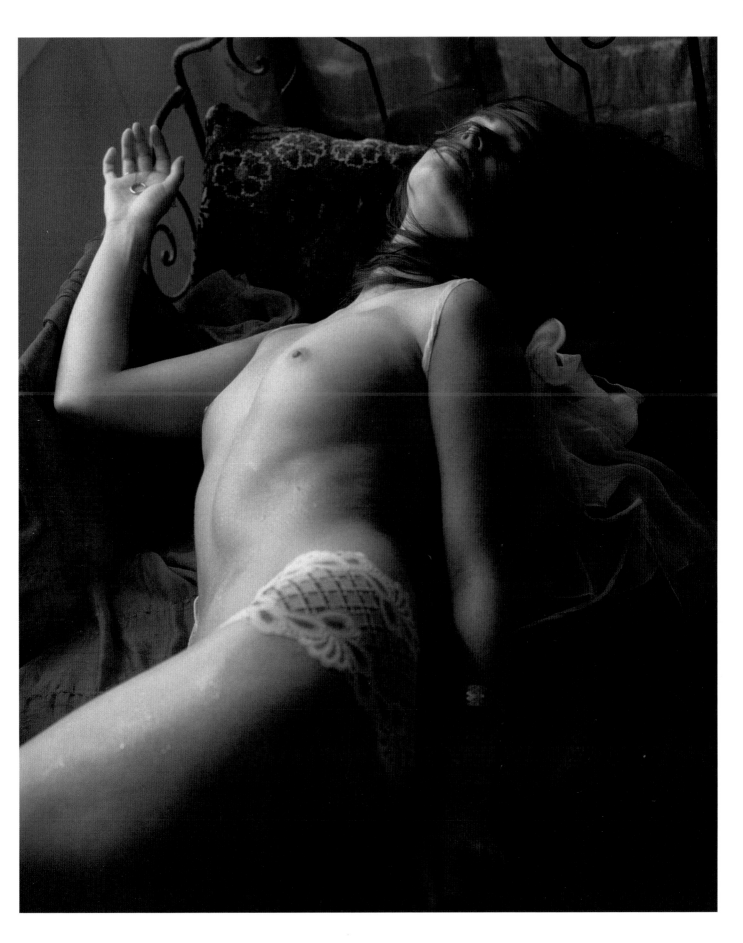

Michele Clement

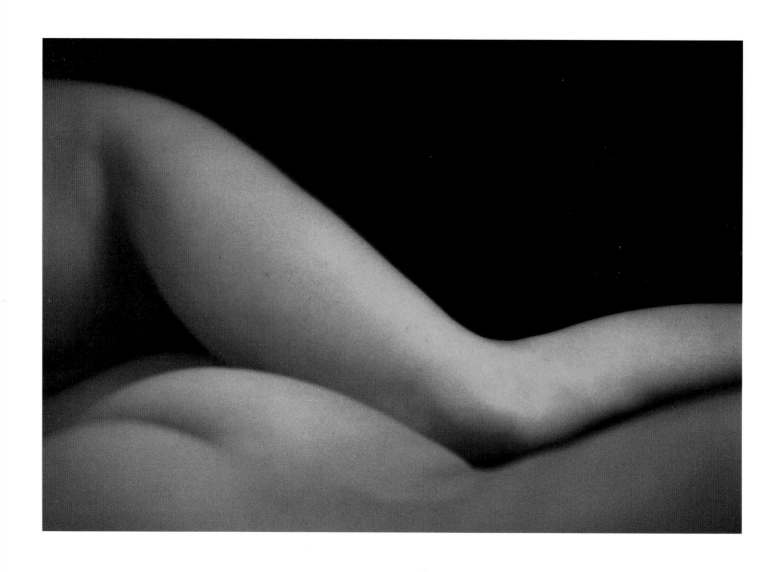

Joseph E. Reid

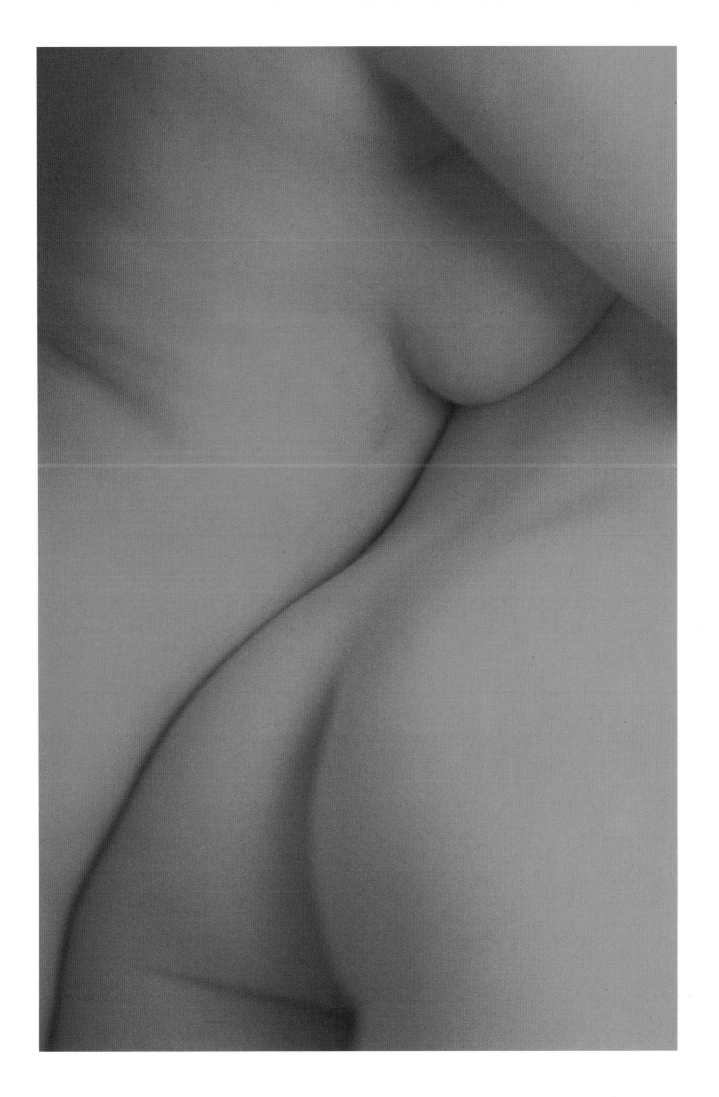

Joseph E. Reid

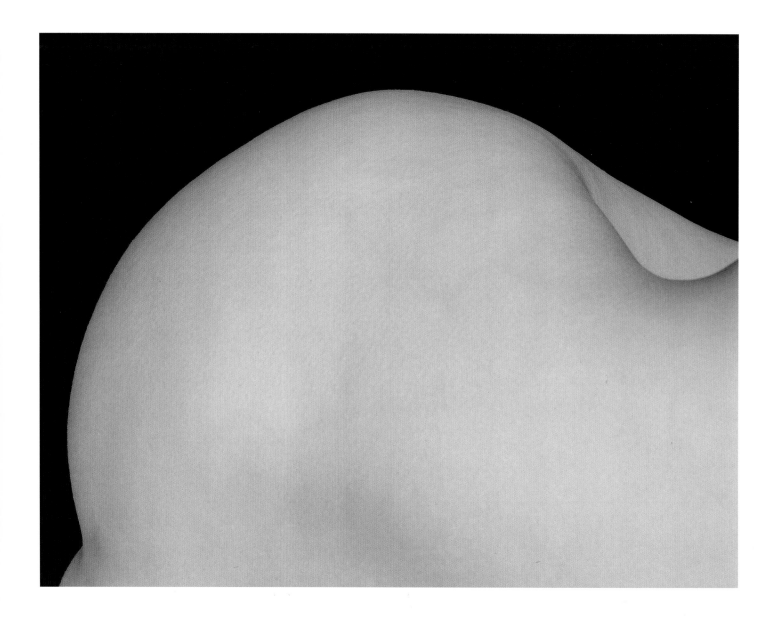

Howard Schatz

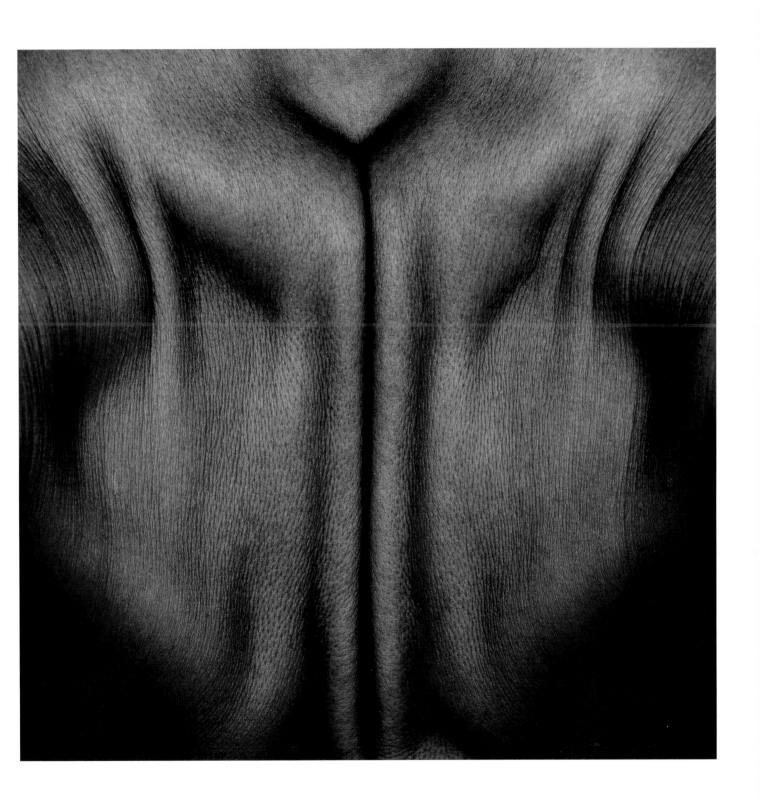

Howard Schatz

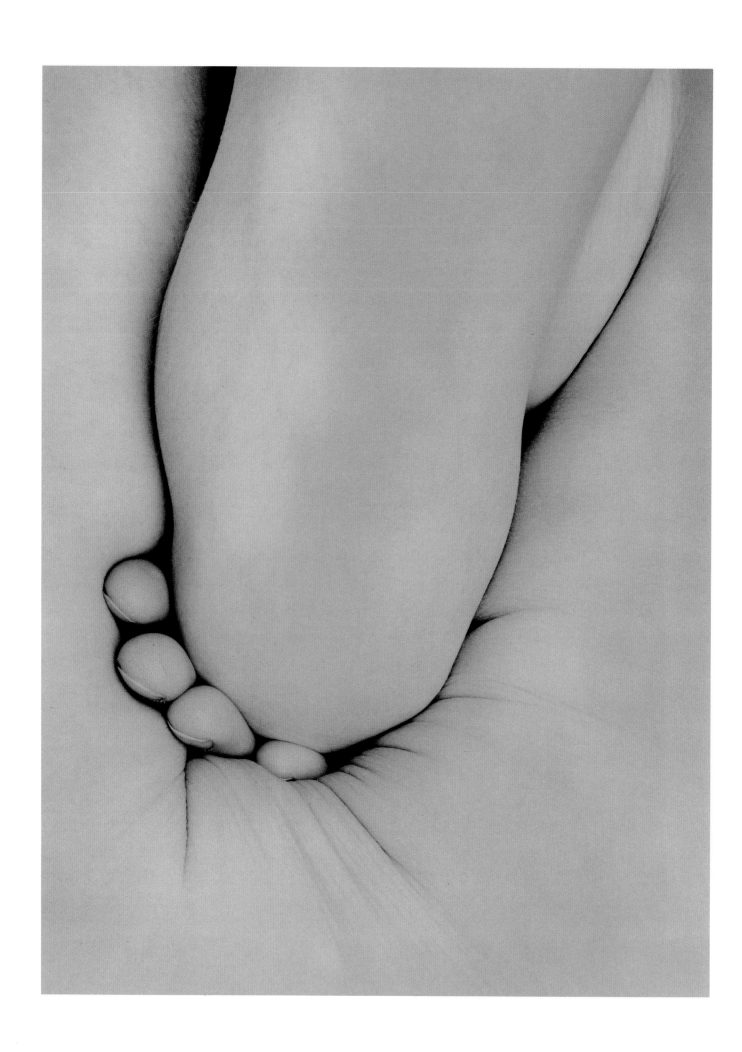

Howard Schatz

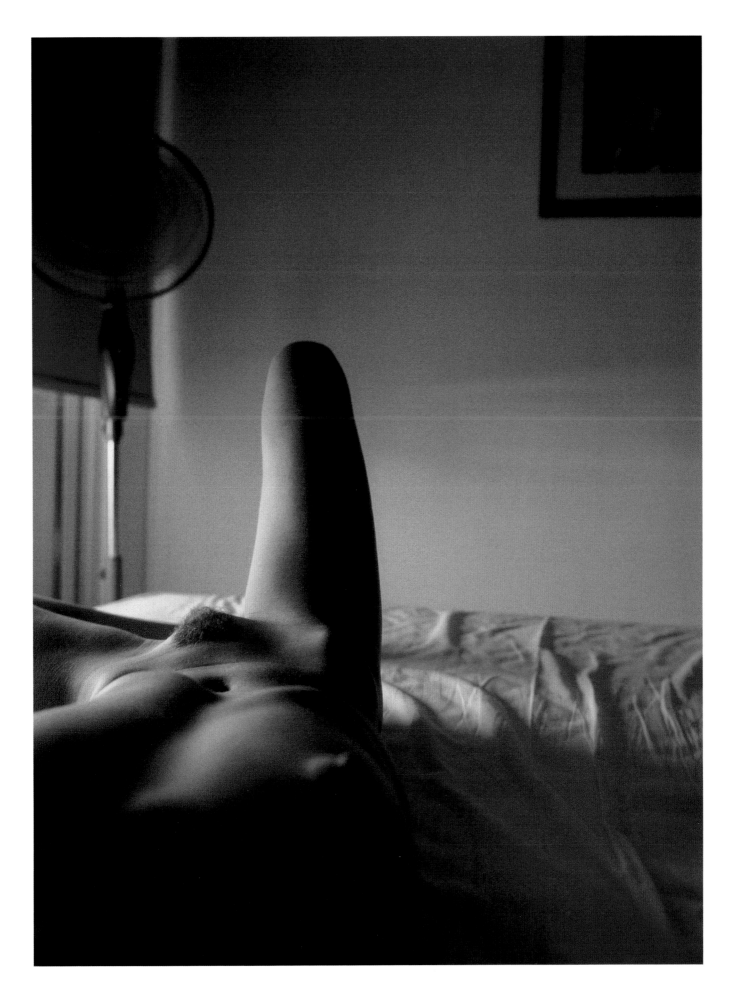

Emy Kat

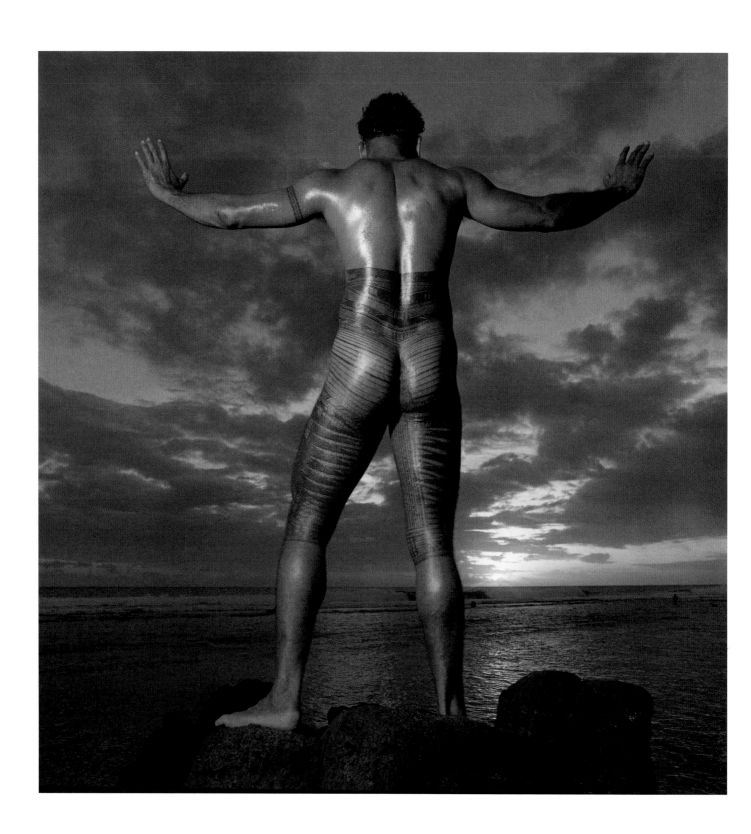

Chris Rainier

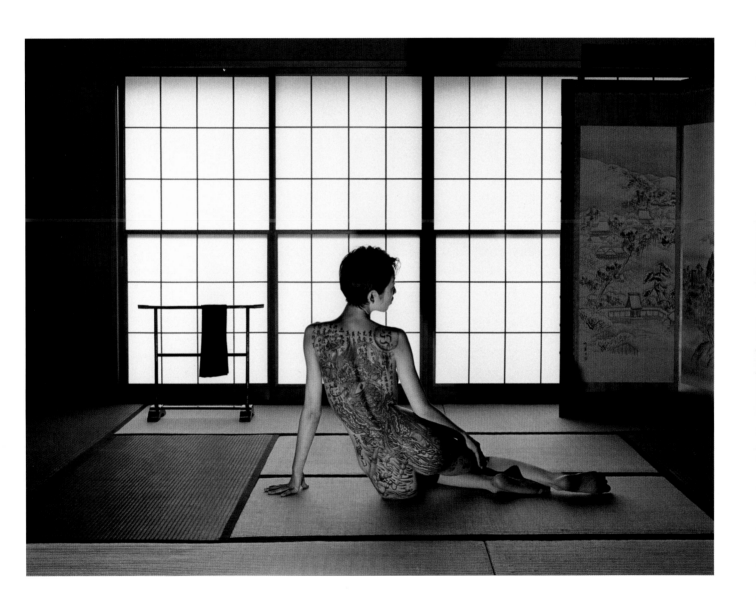

Chris Rainier

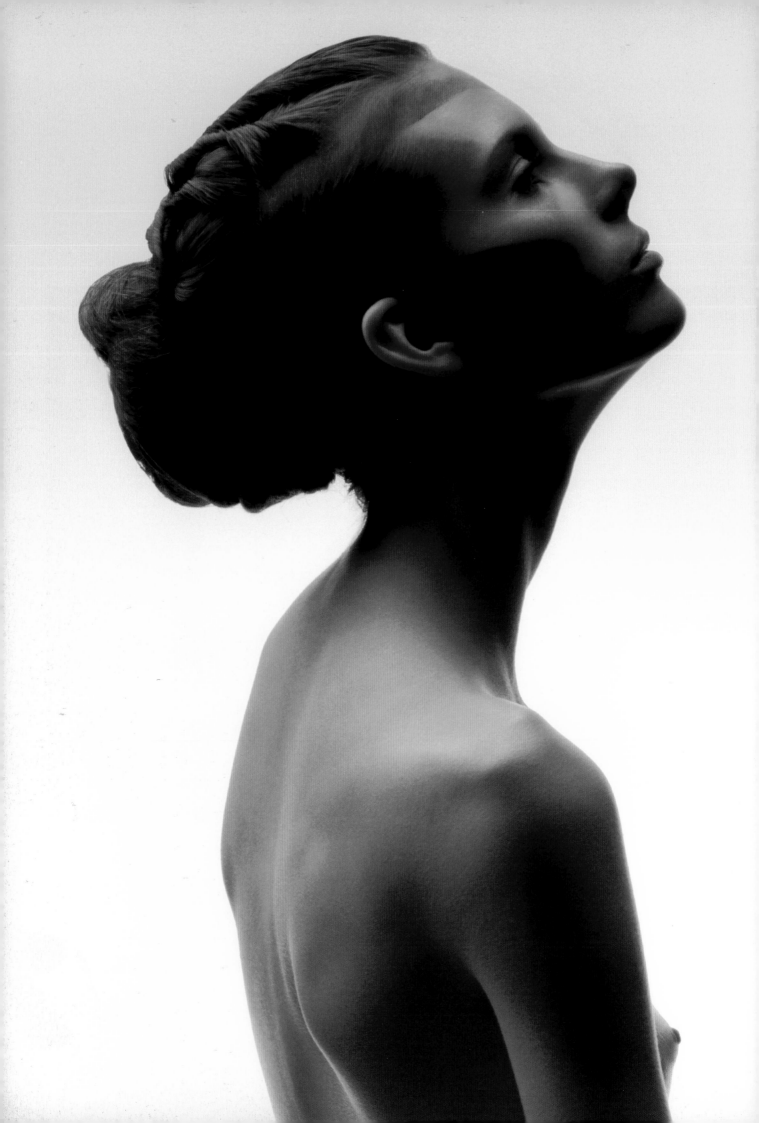

Portraits

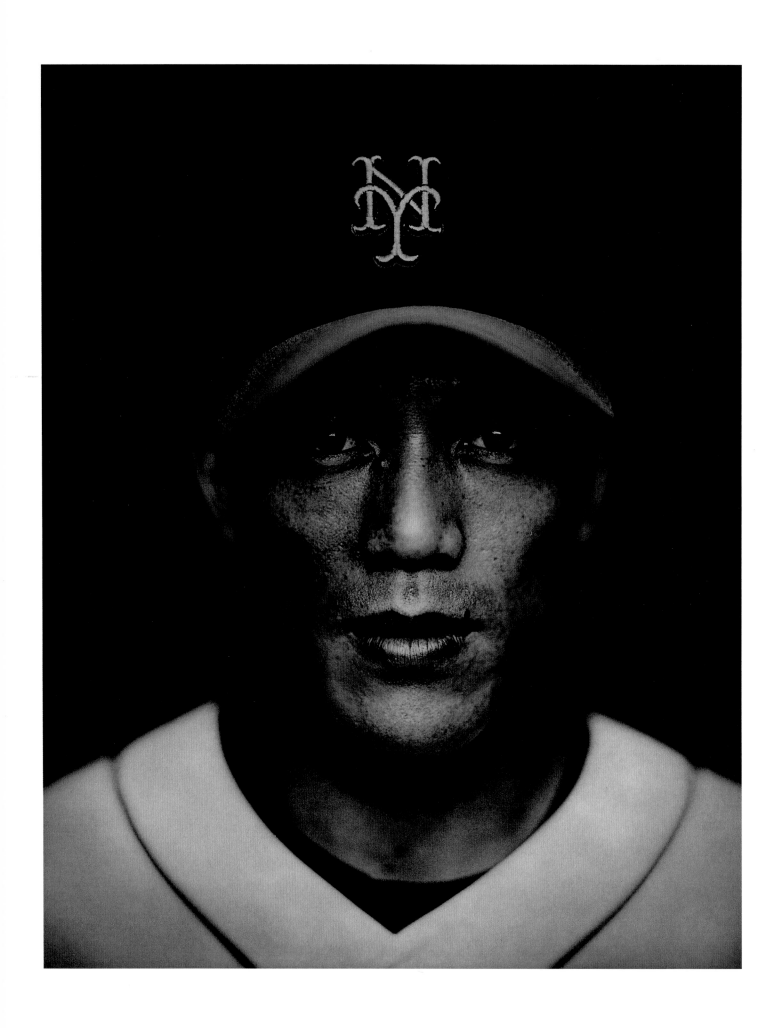

(previous page) Frank Wartenberg (this page) Marcus Swanson

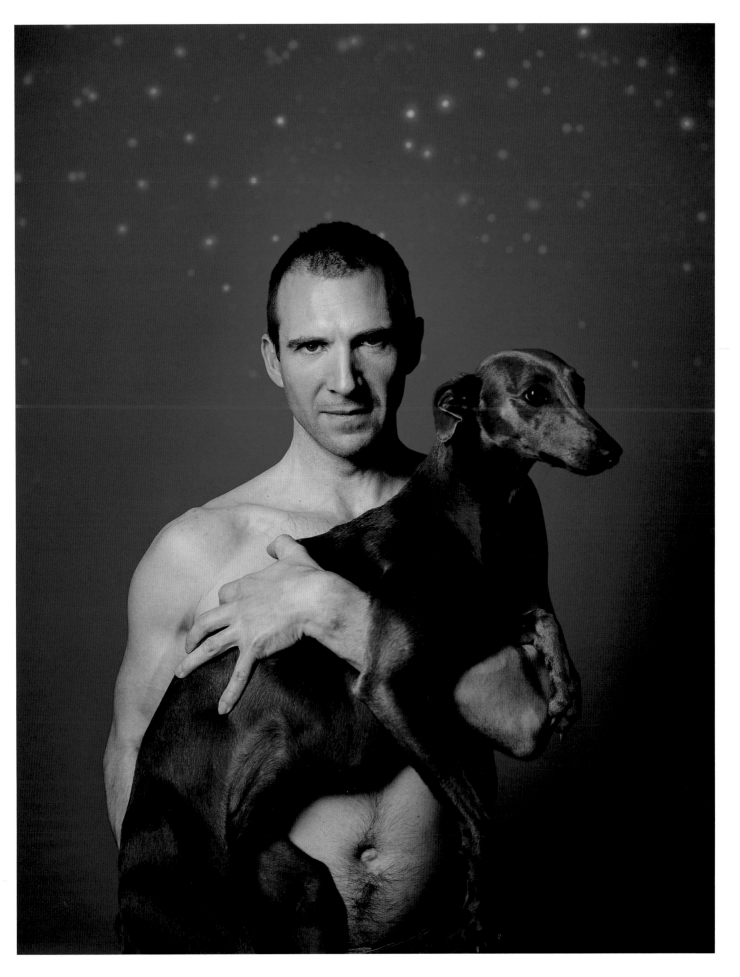

Alessandra Petlin

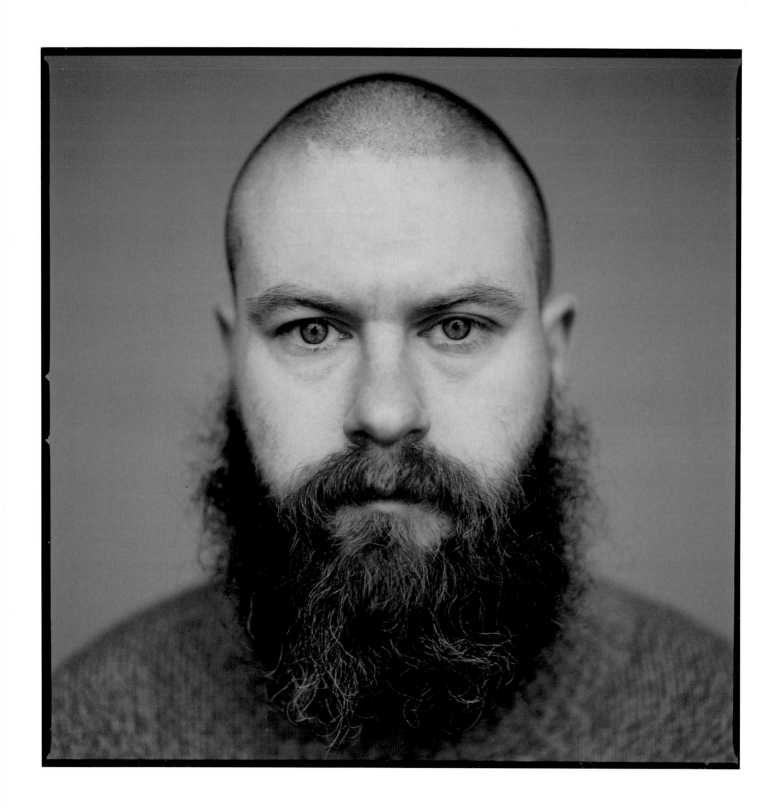

Paul Elledge

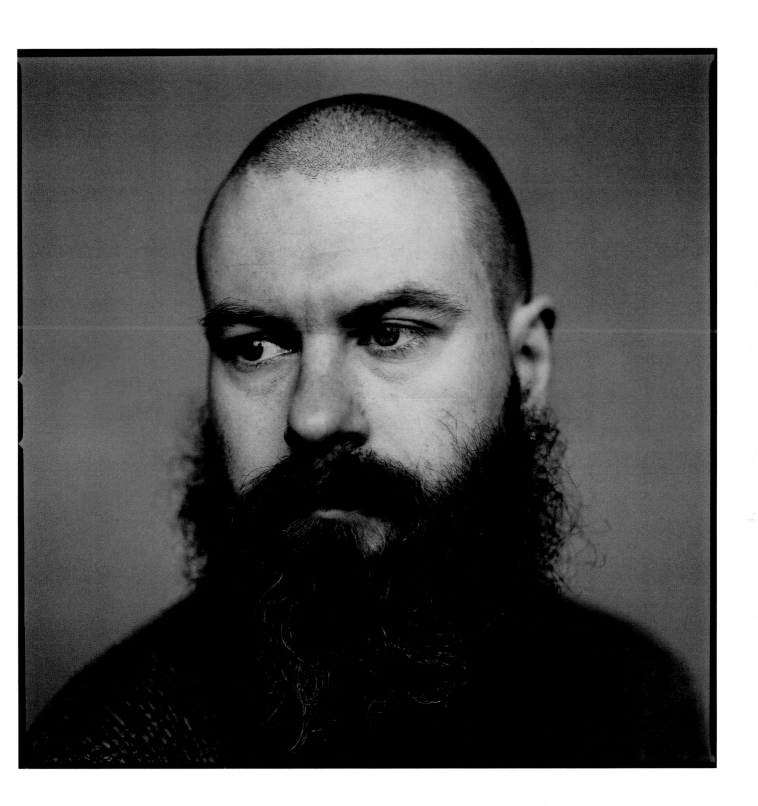

Paul Elledge

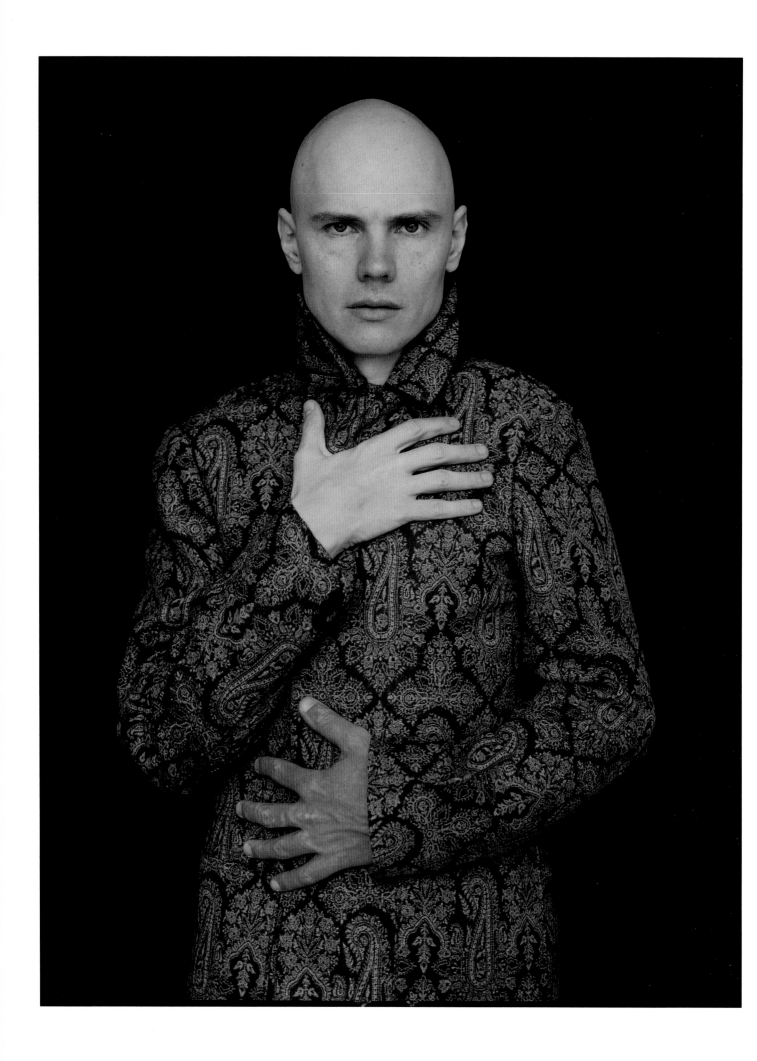

Paul Elledge

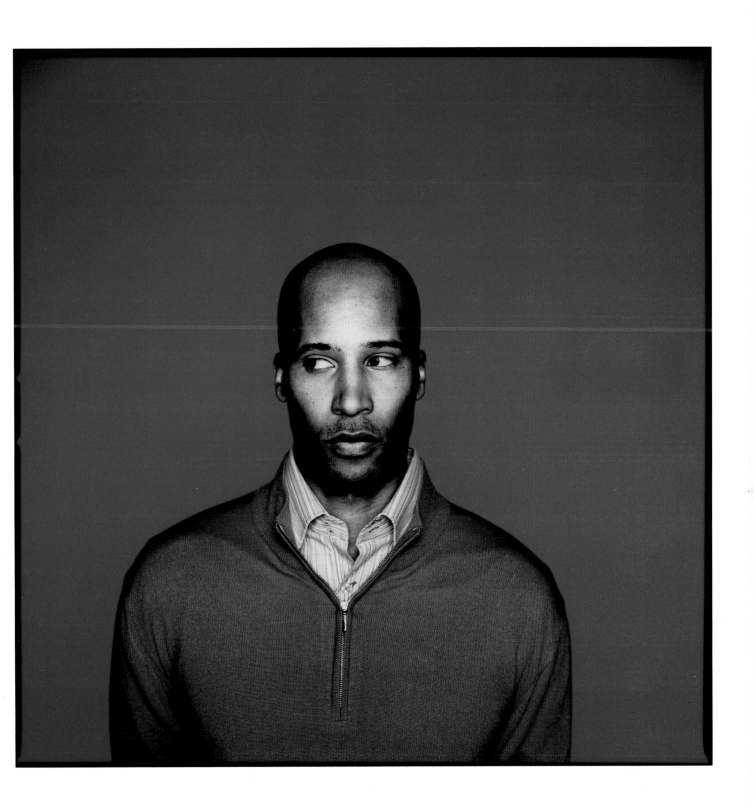

Paul Elledge

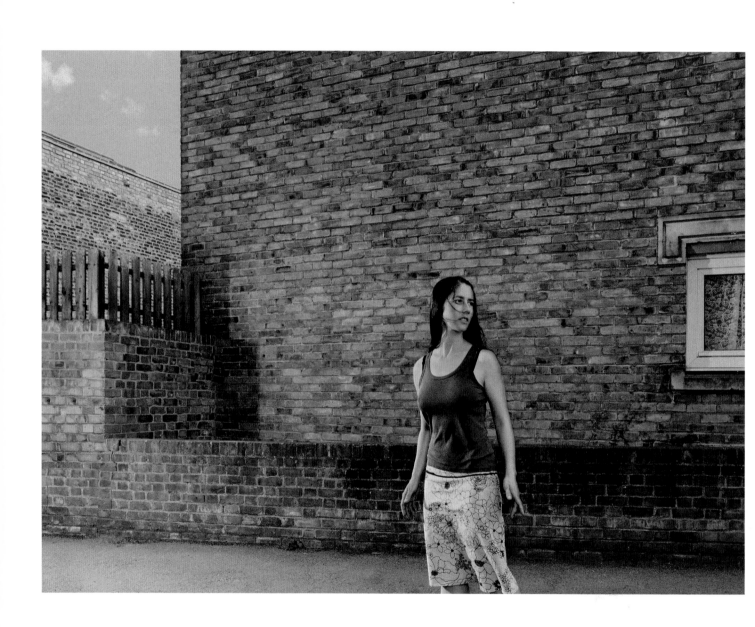

Gabriel Jones

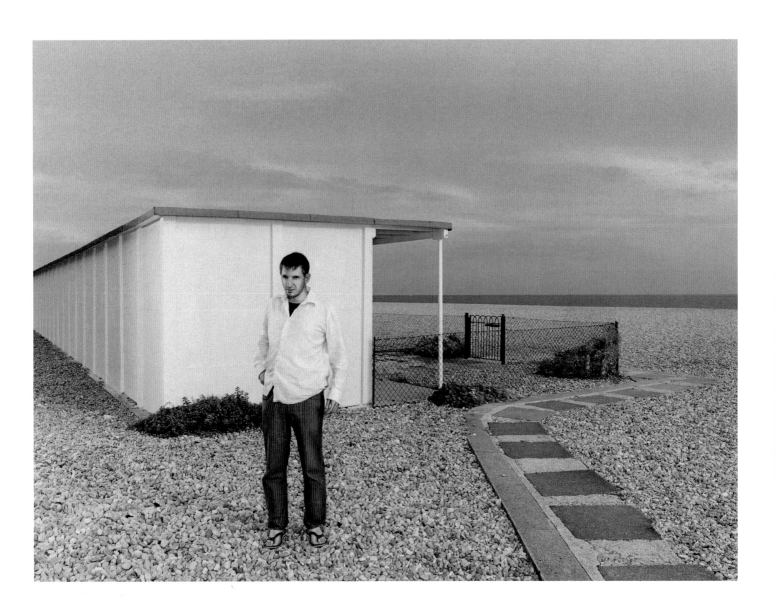

Gabriel Jones

Gabriel Jones

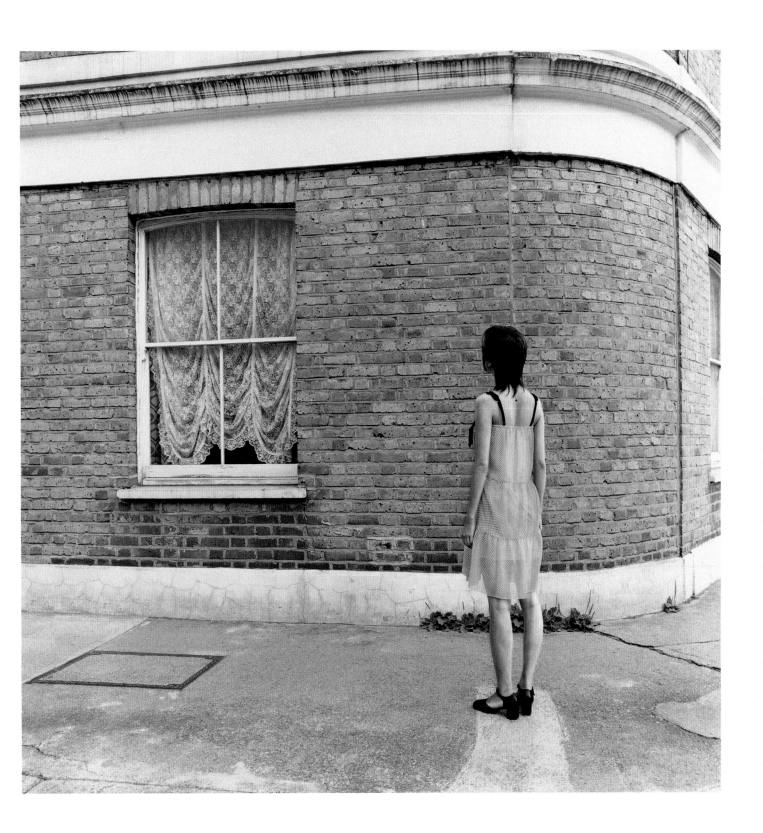

Gabriel Jones

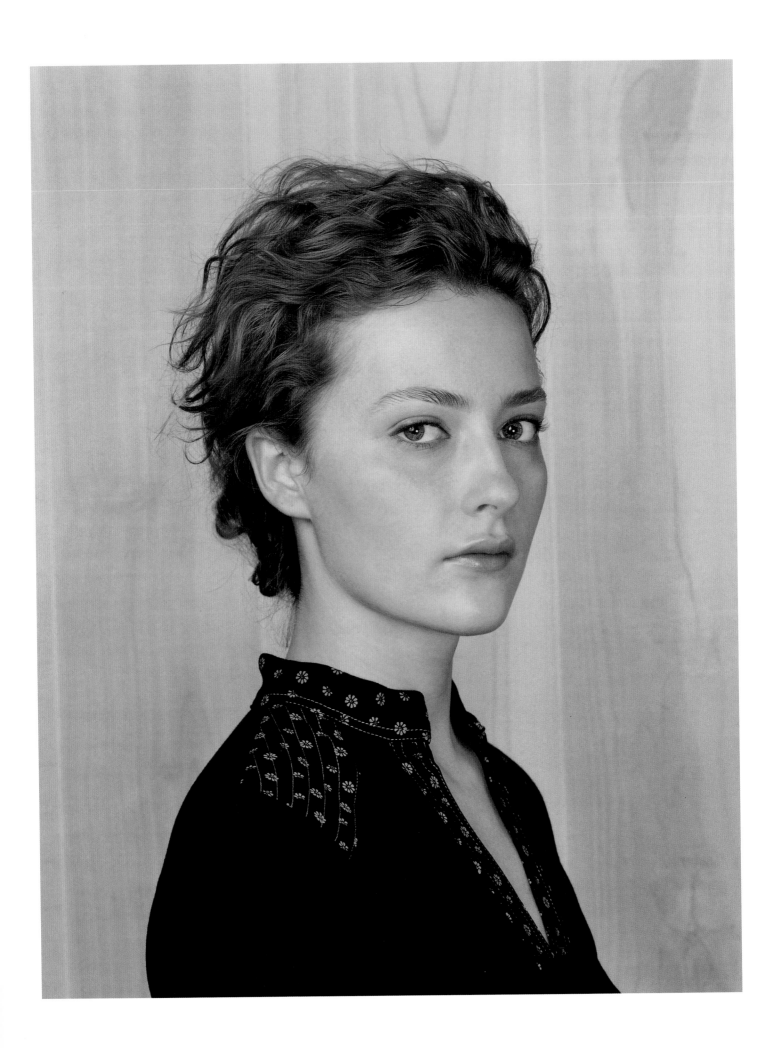

Craig Cutler

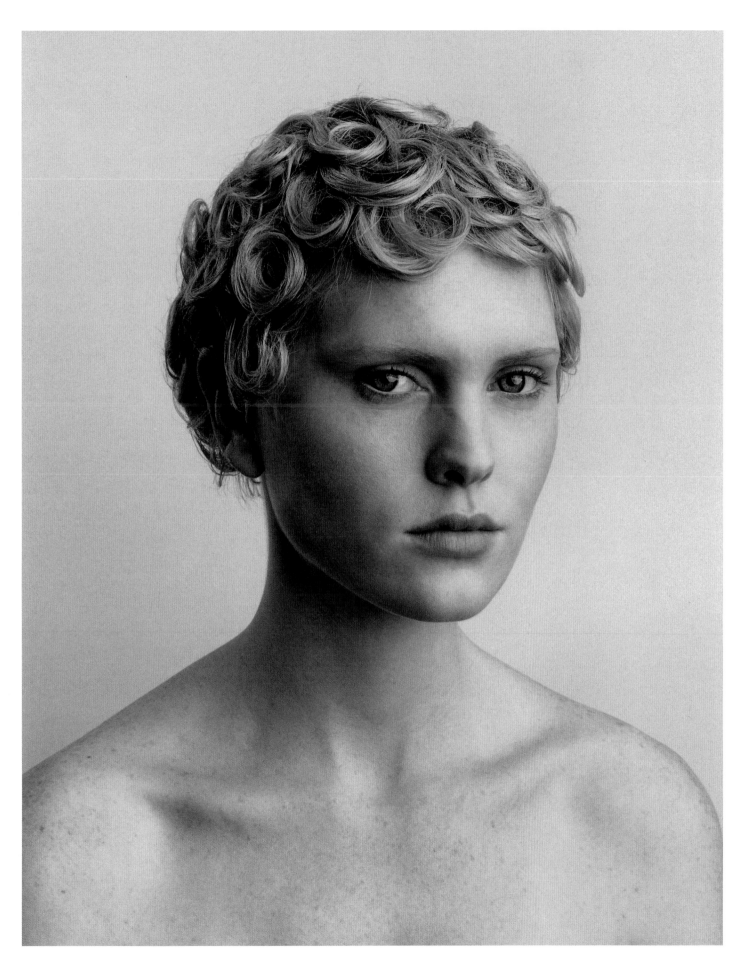

Craig Cutler

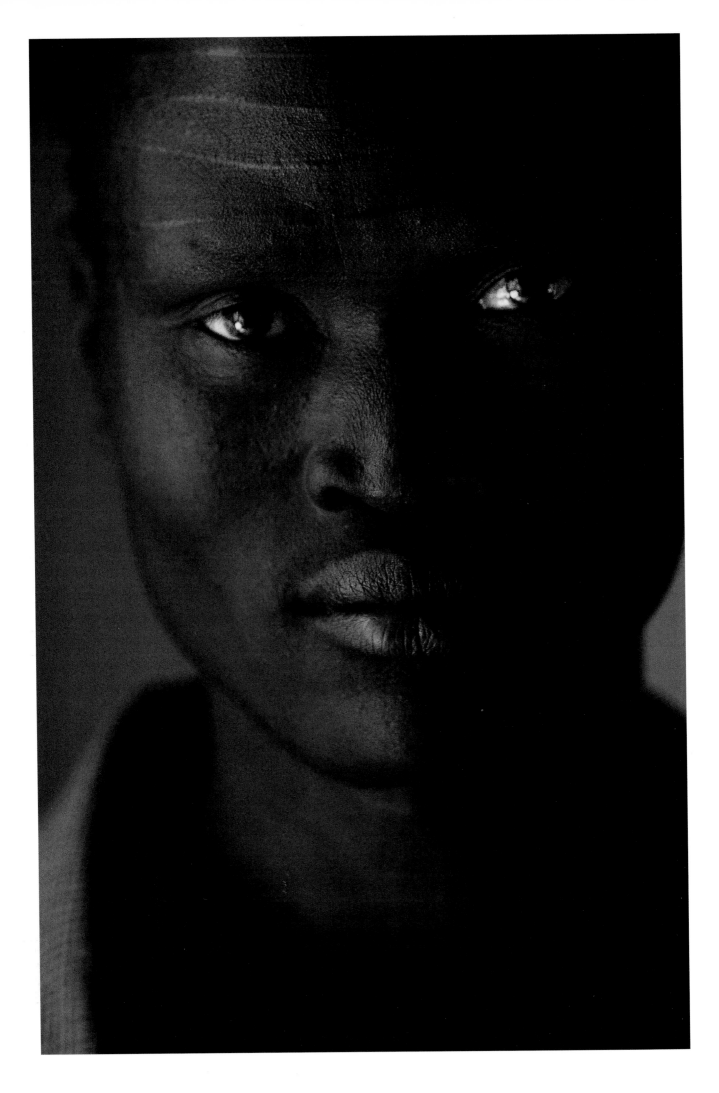

Sean Kernan

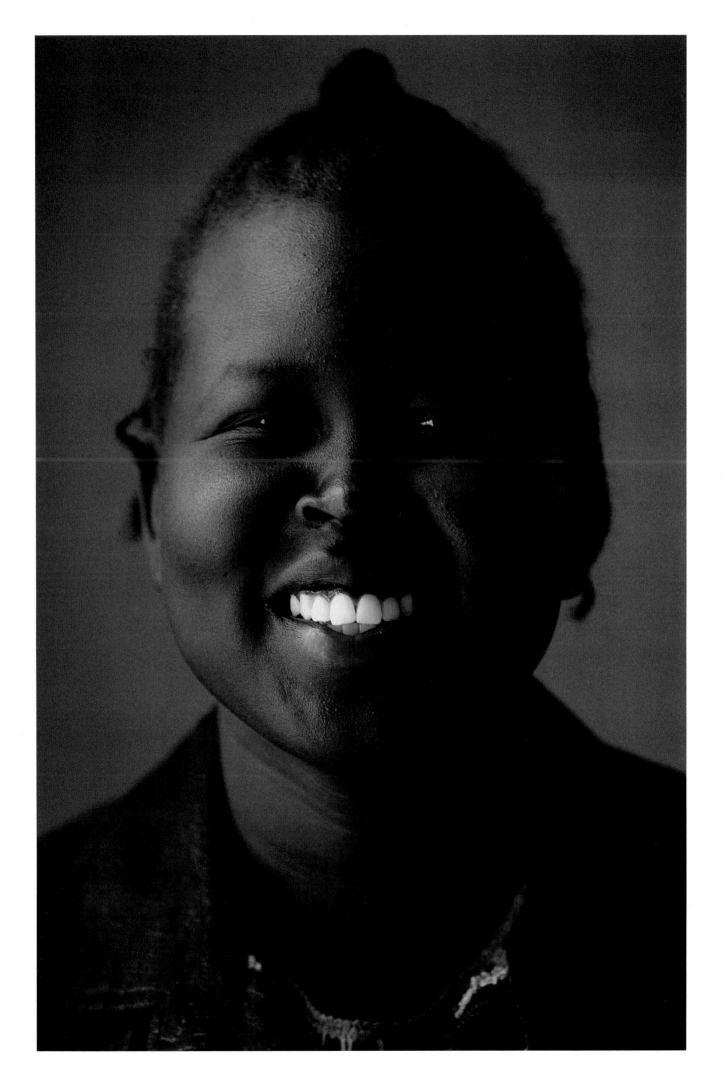

Sean Kernan

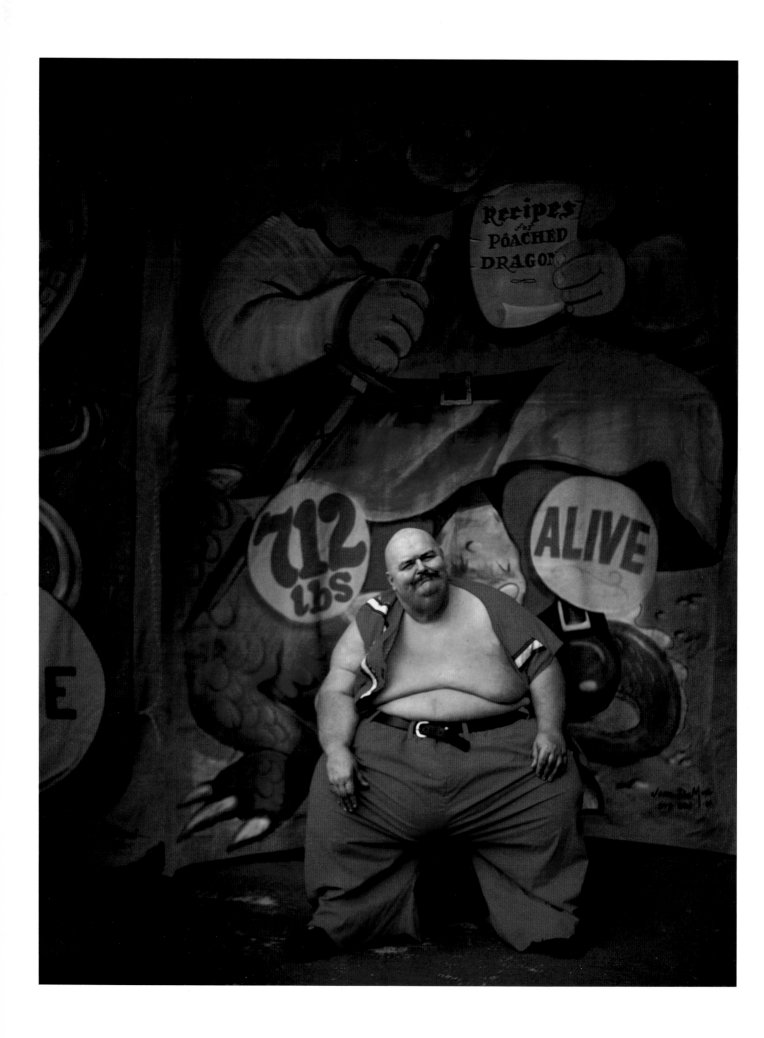

Andy Anderson

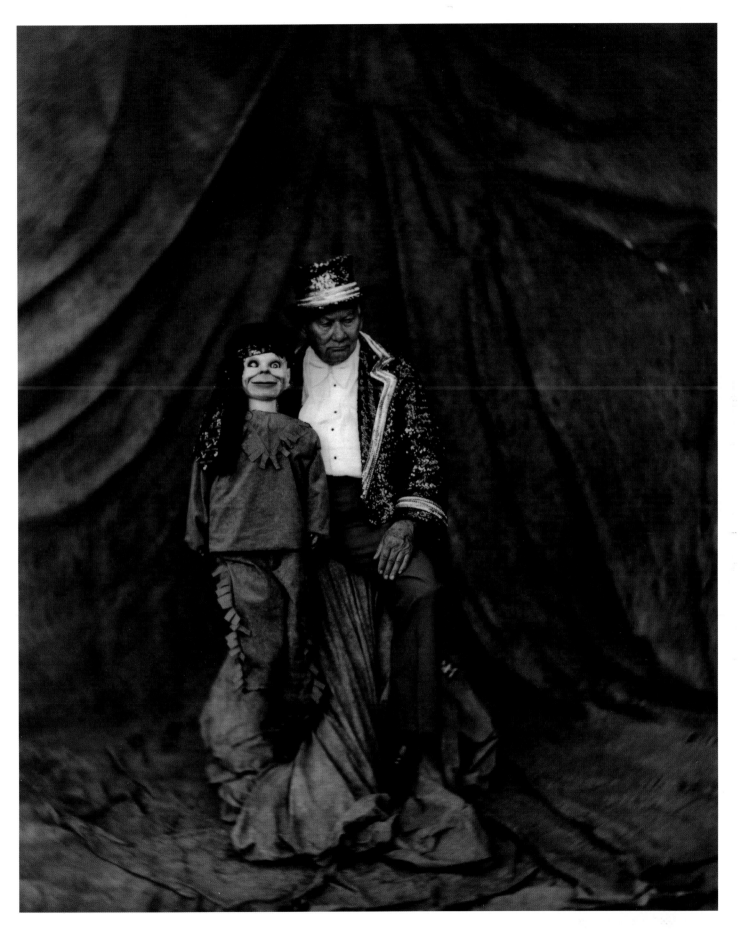

Andy Anderson

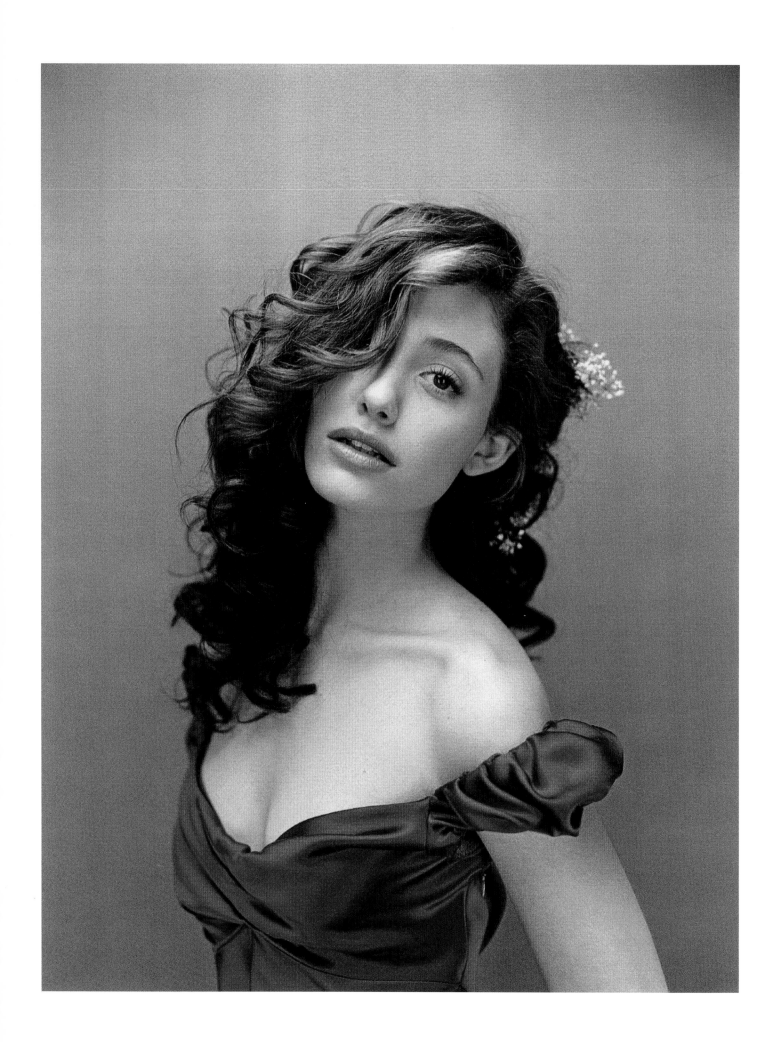

Robert Maxwell

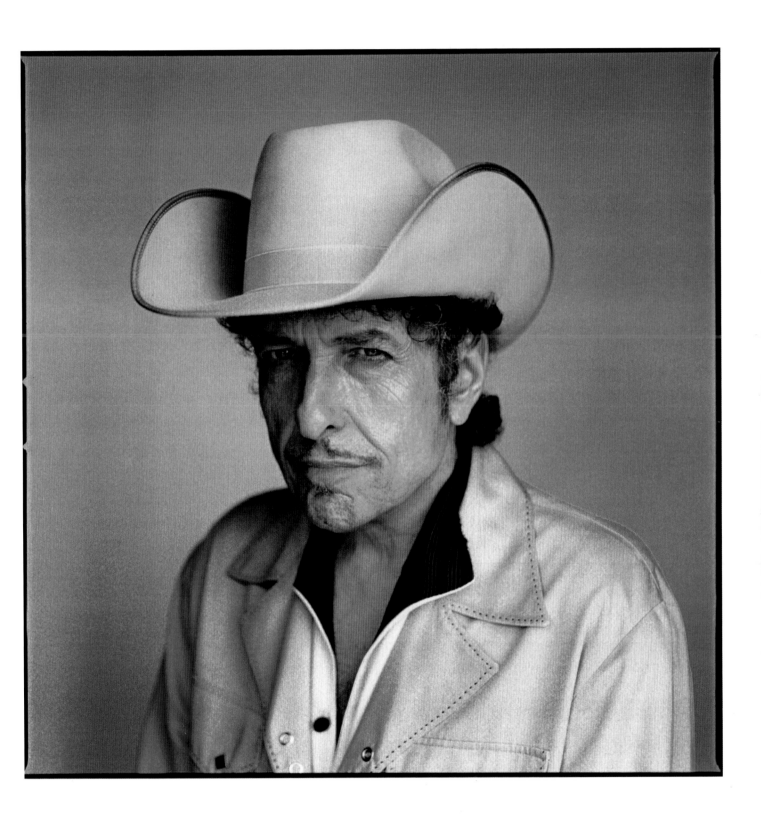

Brigitte Lacombe

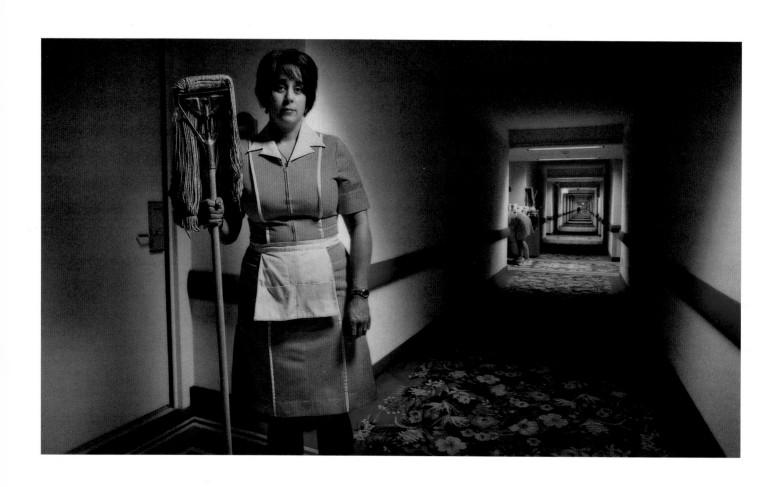

George Simhoni

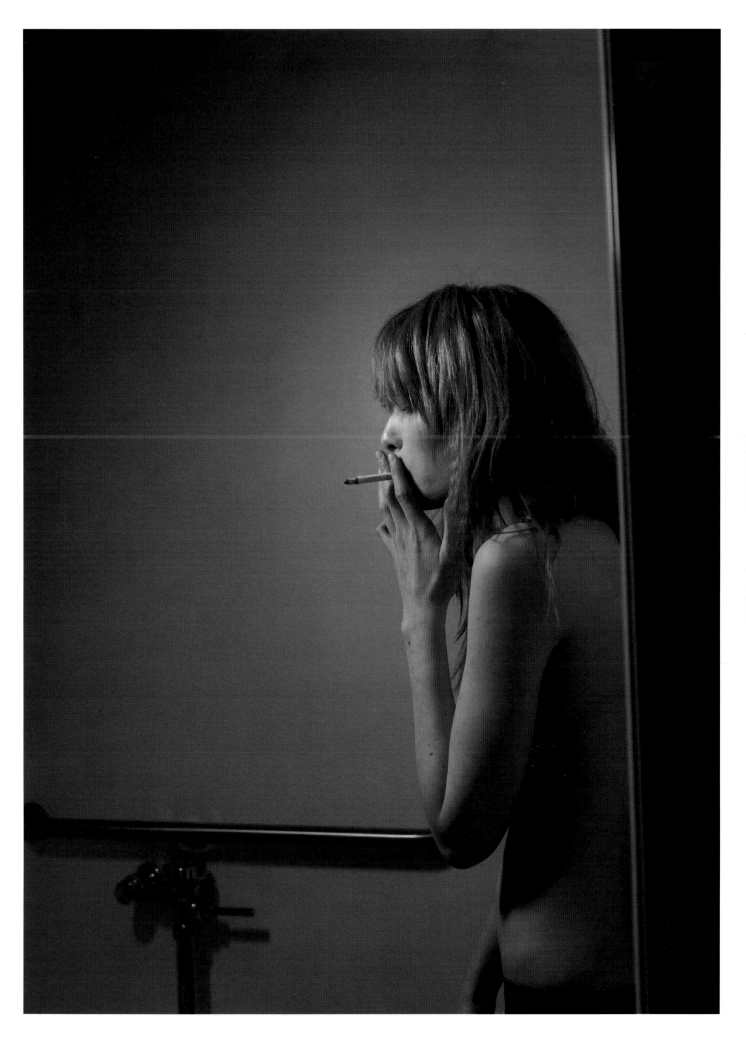

Bill Diodato

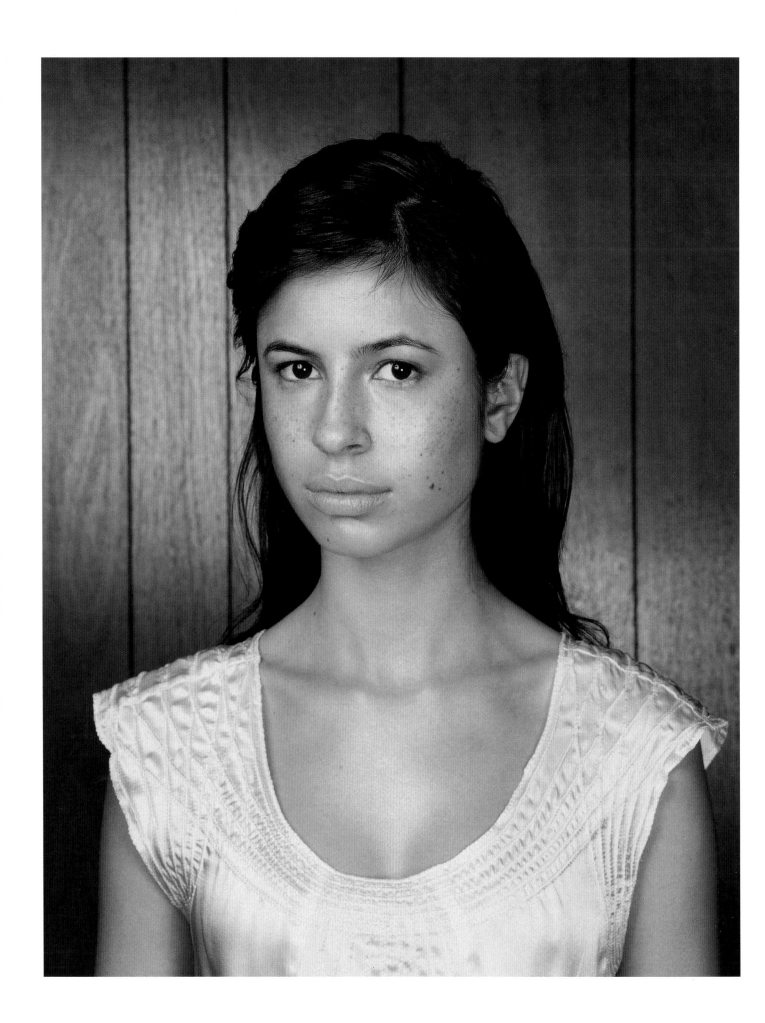

Craig Cutler

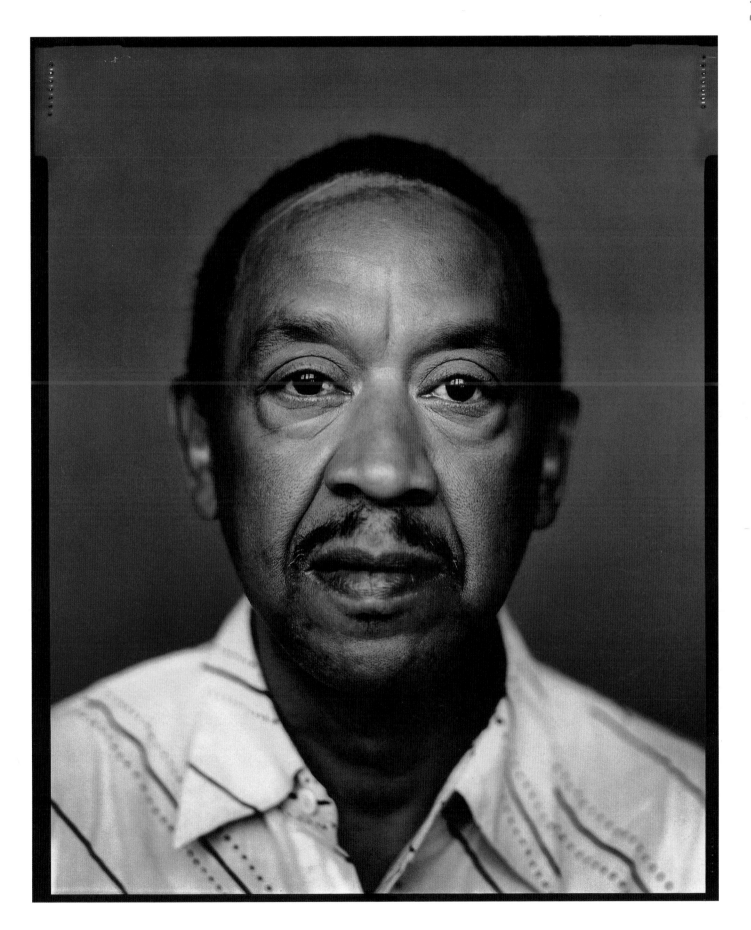

Patrick Molnar

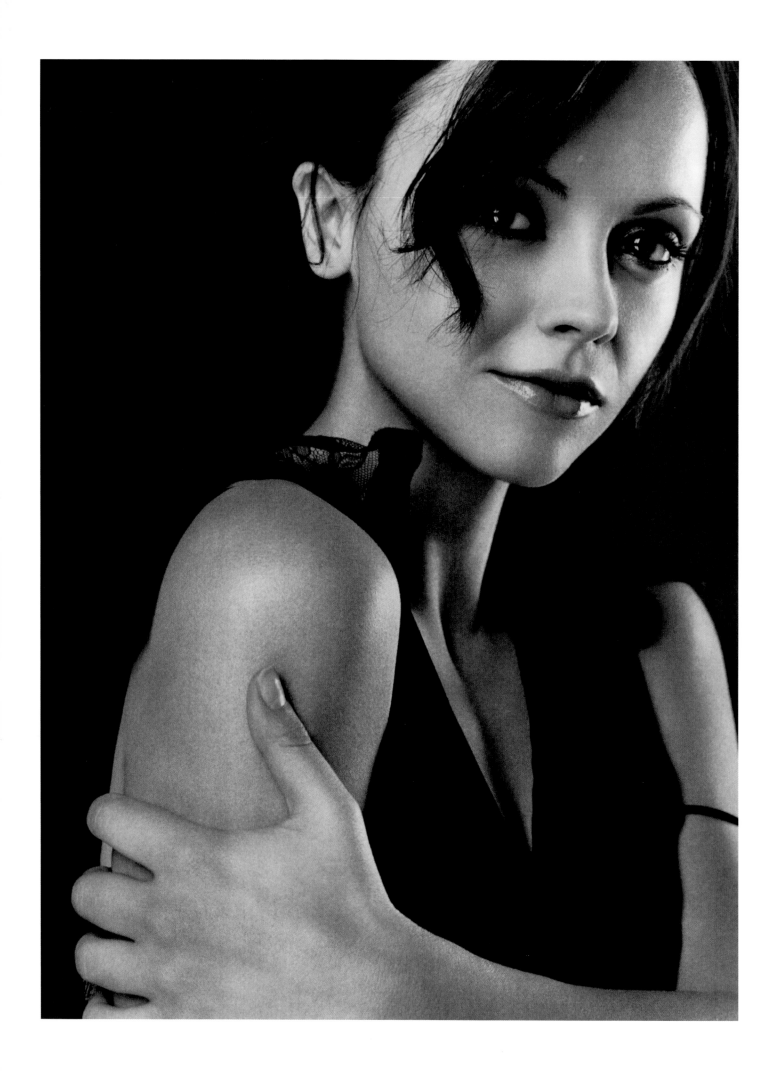

Nigel Perry

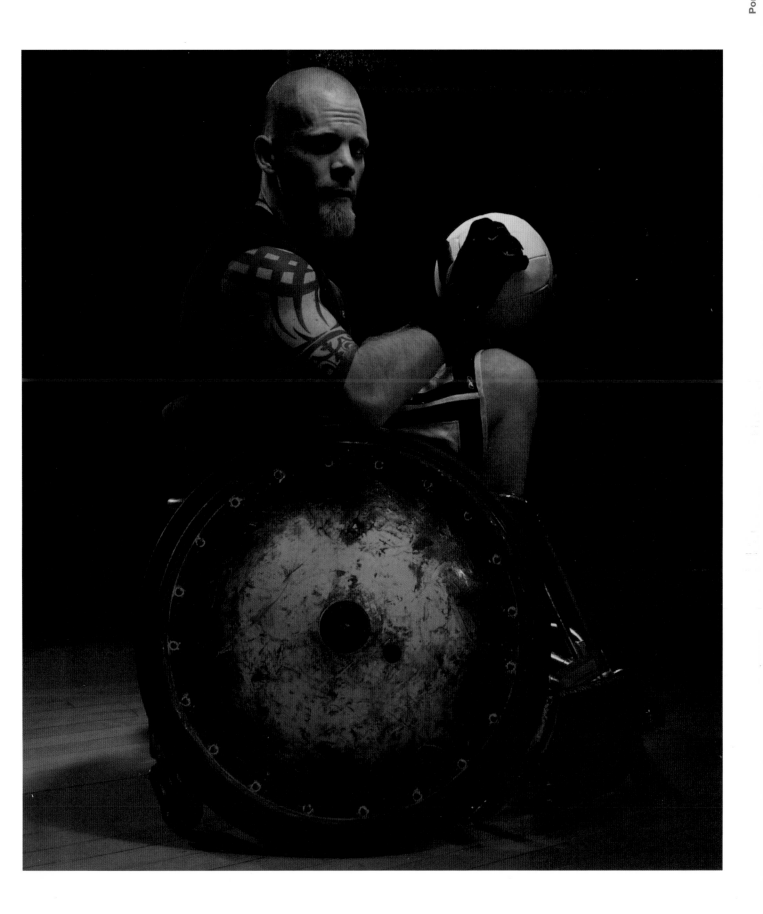

Gary Land

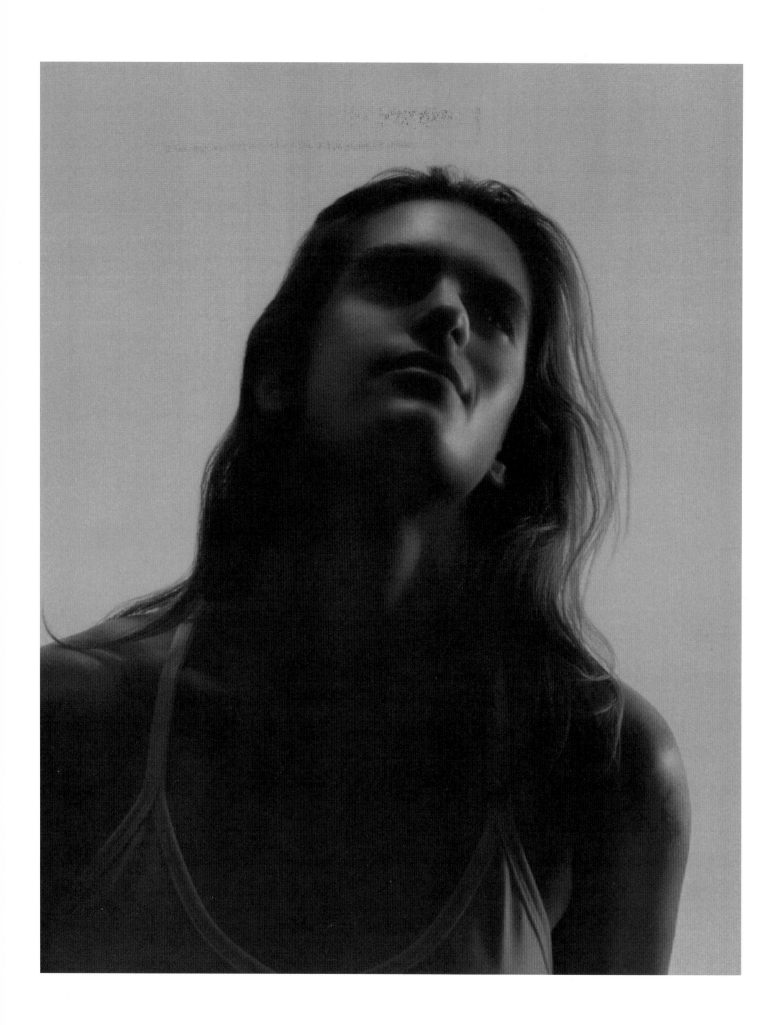

Nadav Kander

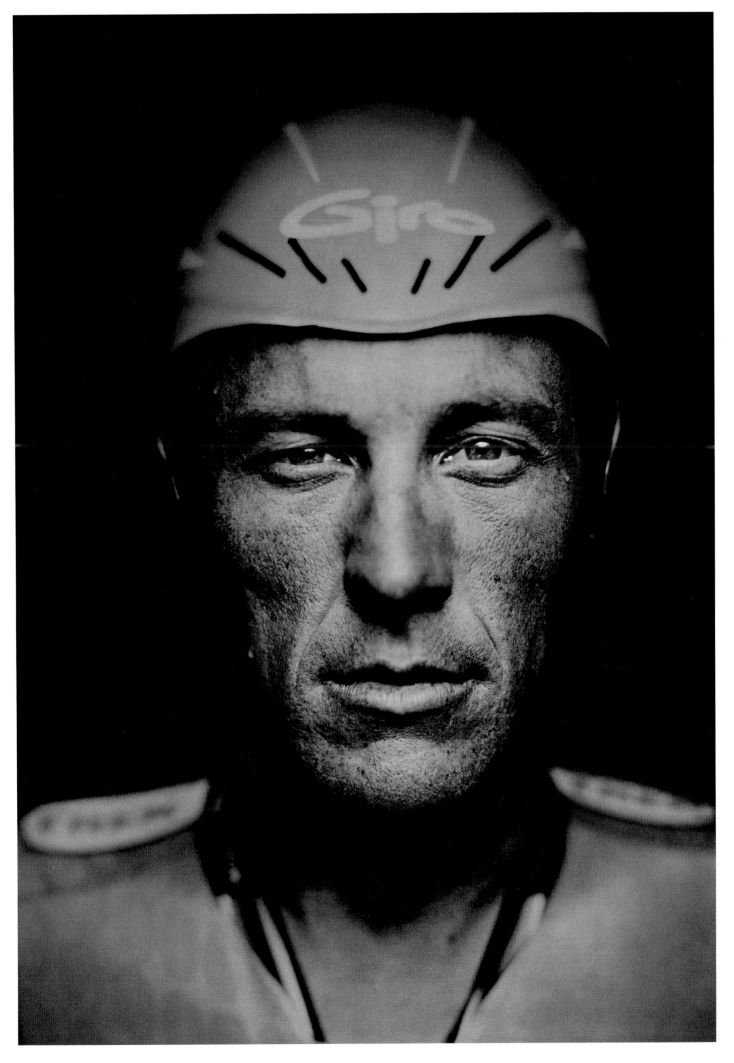

Marcus Swanson

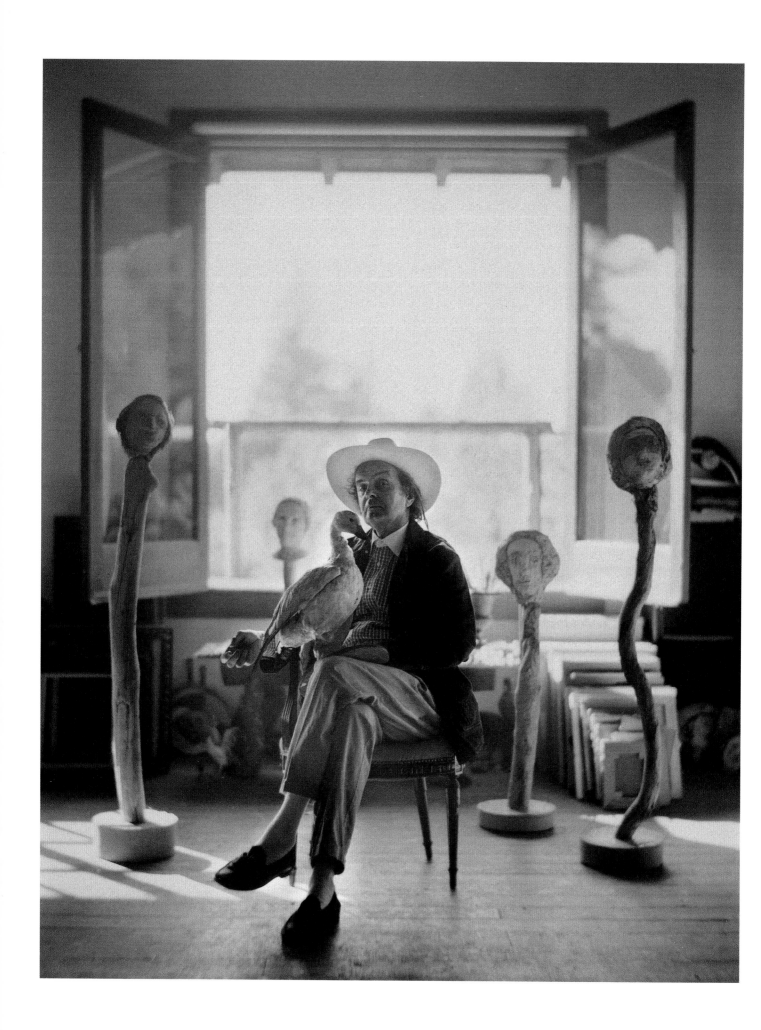

Olaf Beckmann

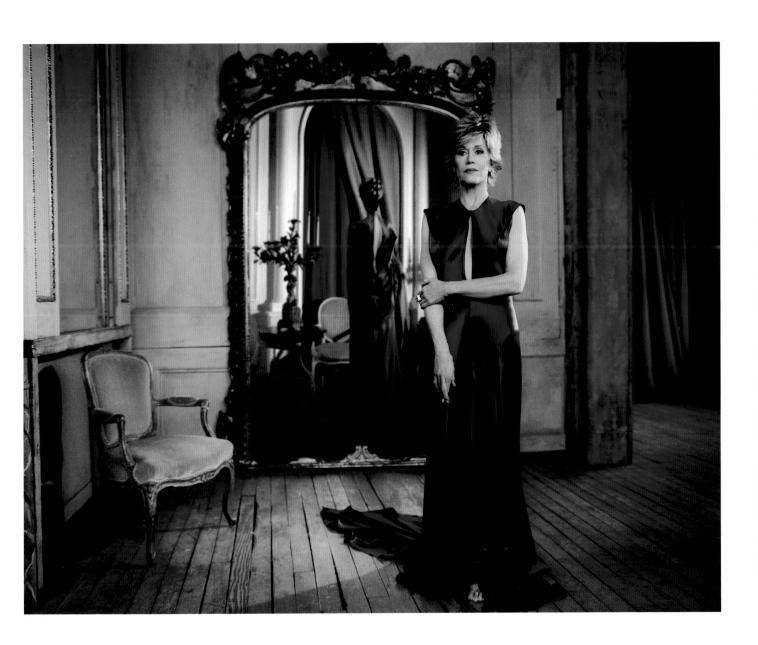

Alessandra Petlin

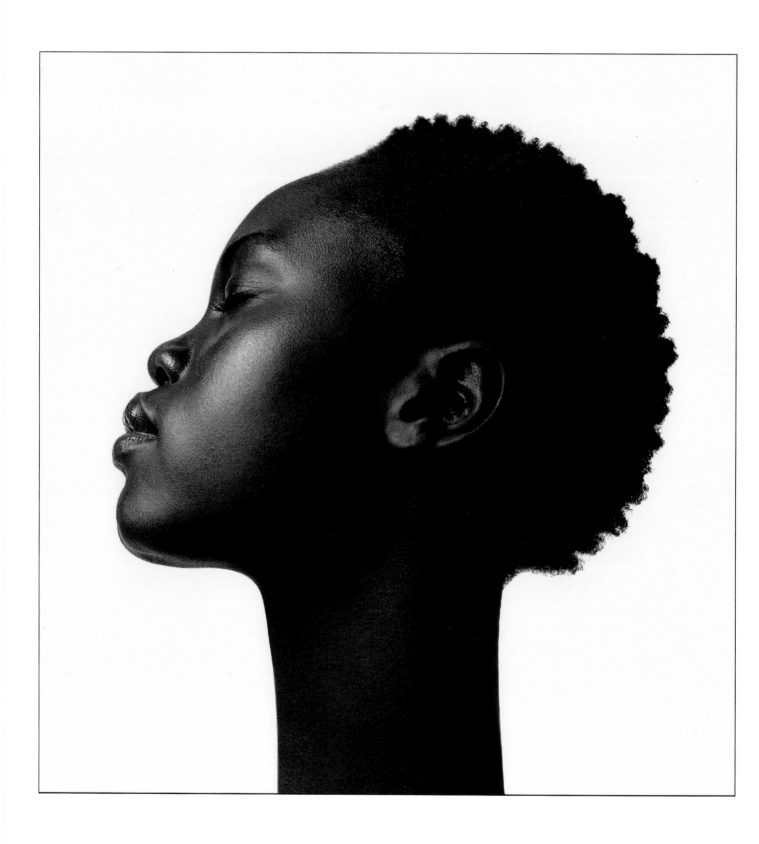

David Allen Brandt

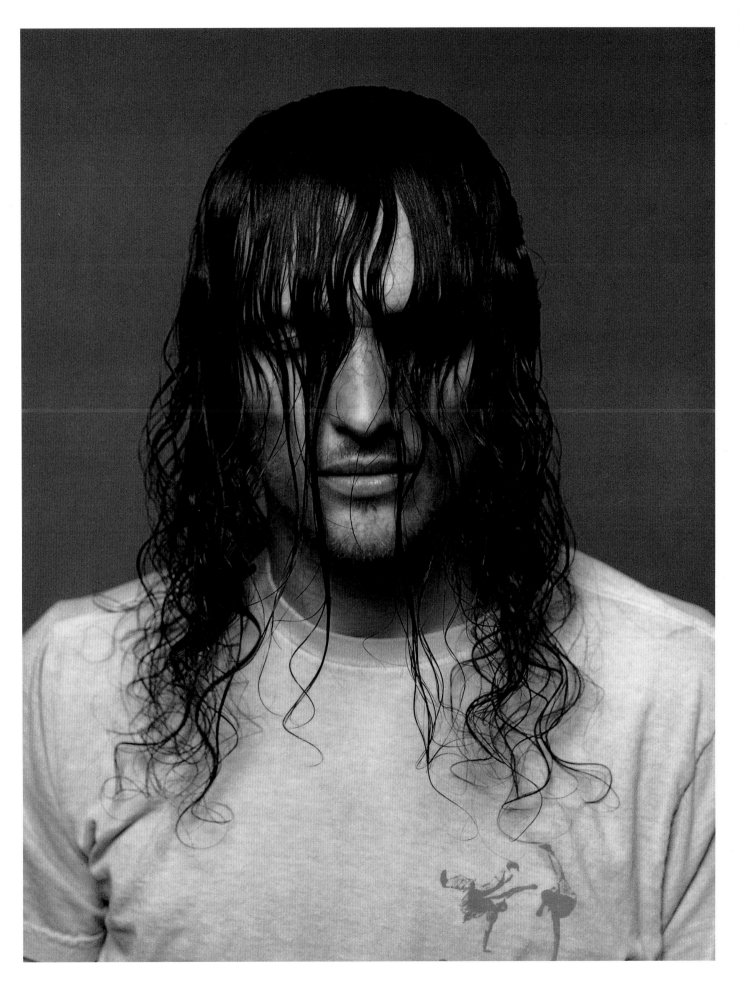

Simon Harsent

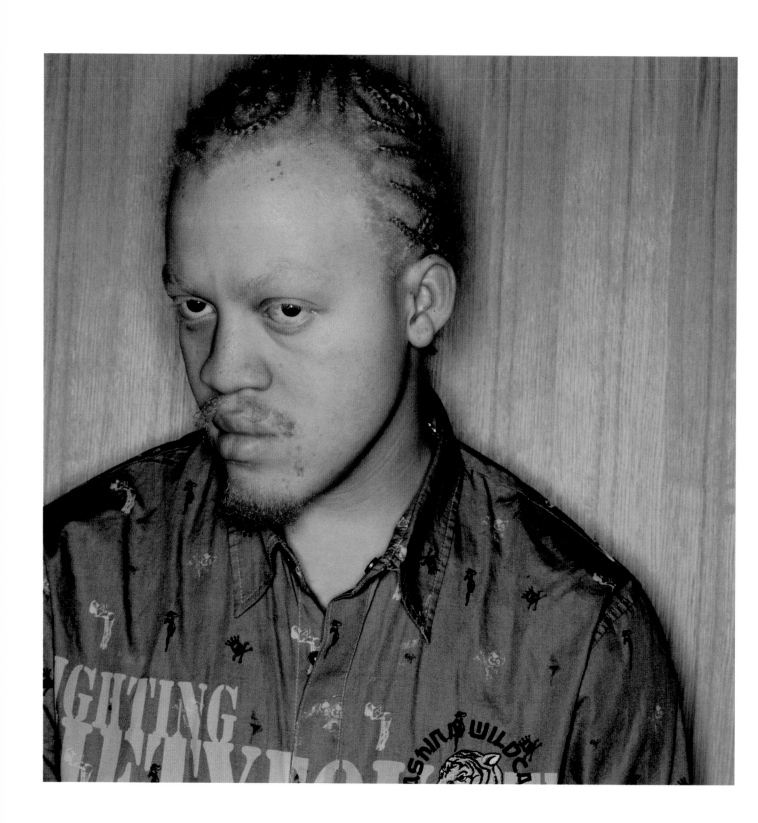

Dazeley

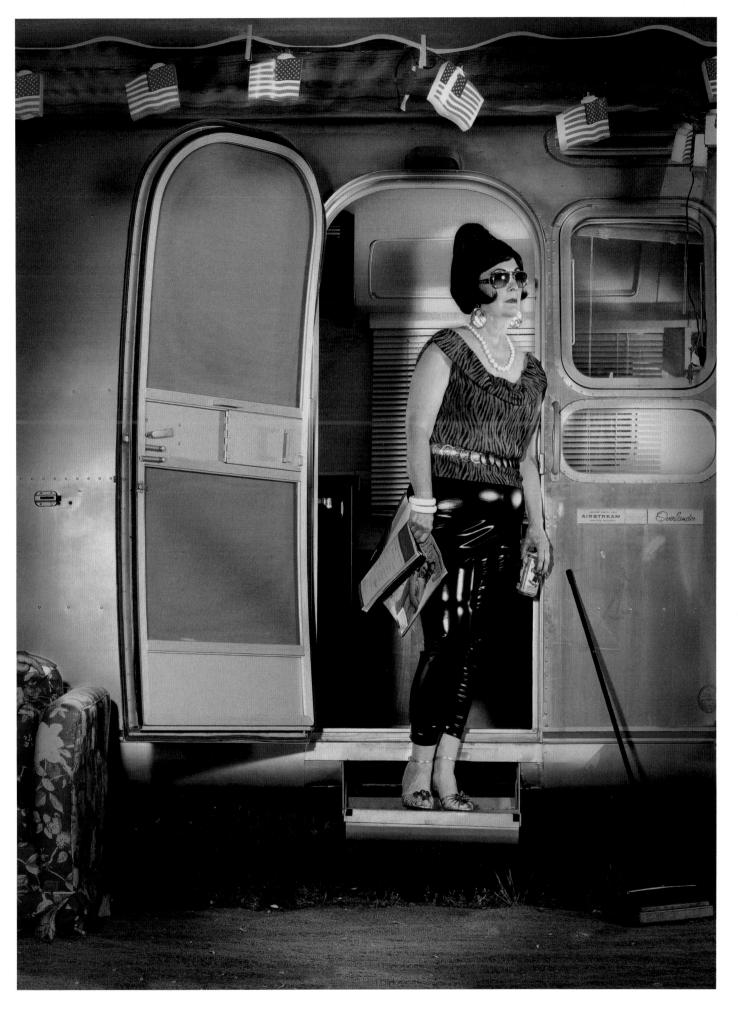

Troye Fox

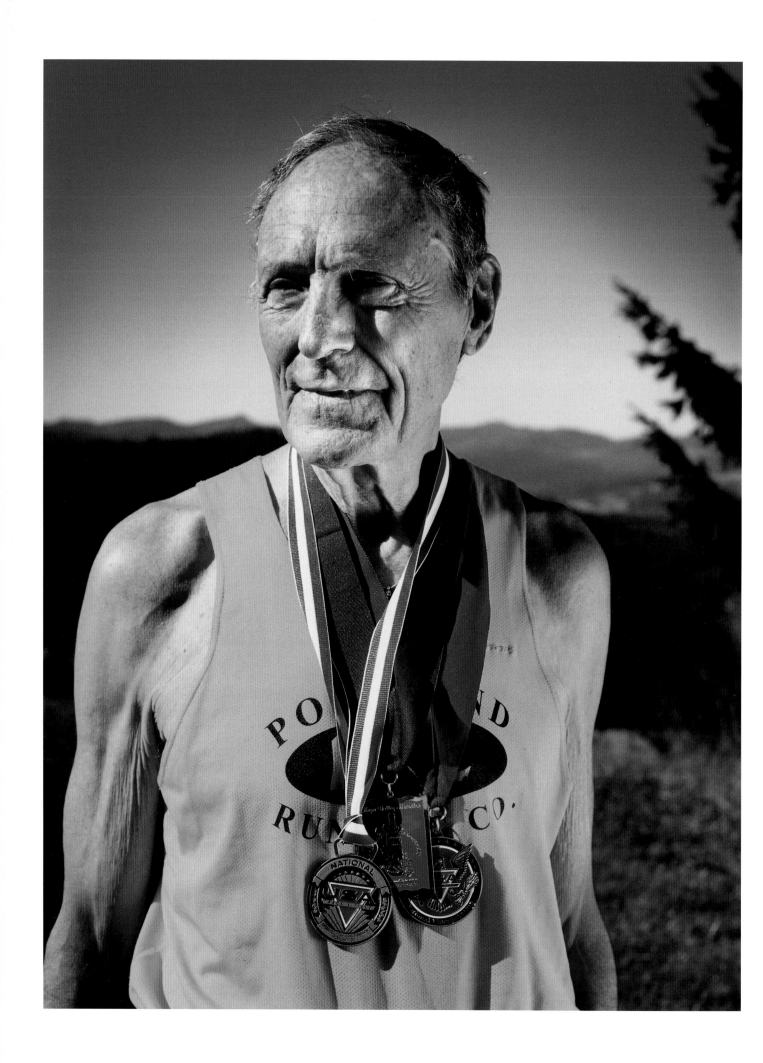

David Emmite

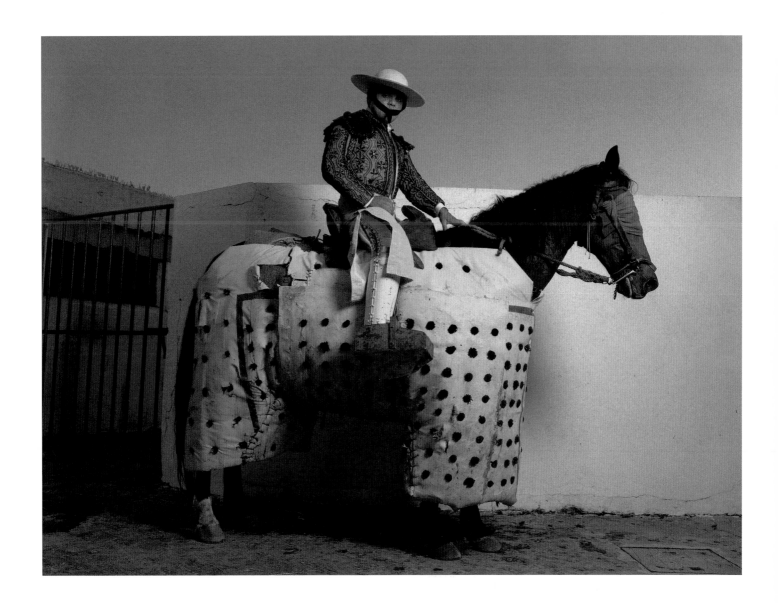

James Salzano

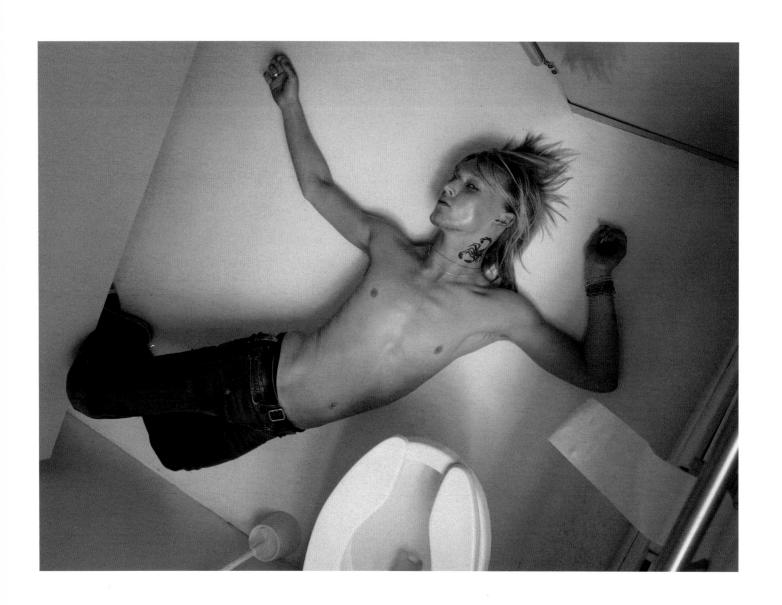

Bill Diodato

joSon

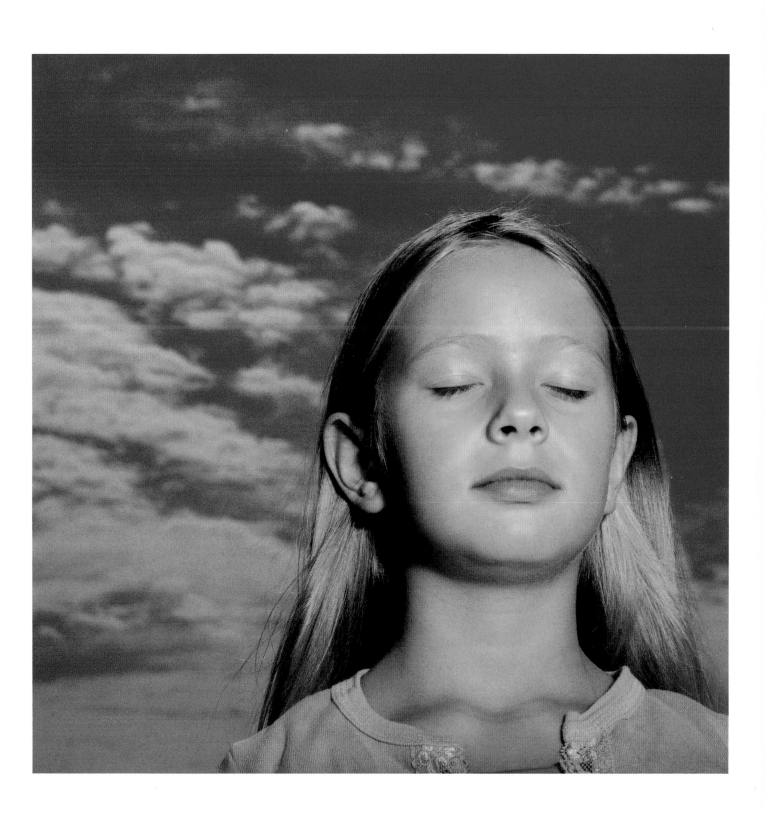

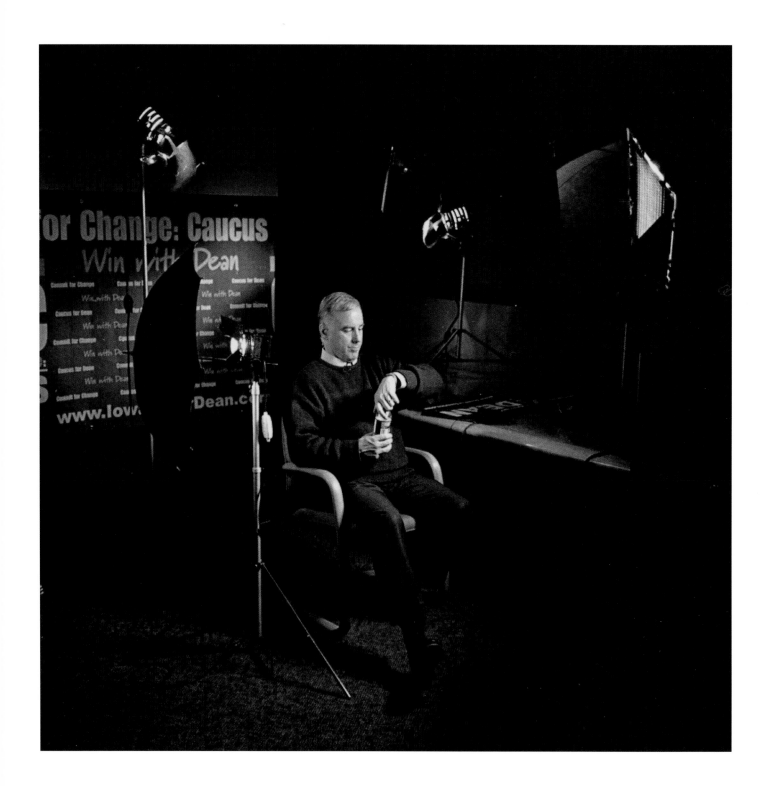

Charles Ommanney

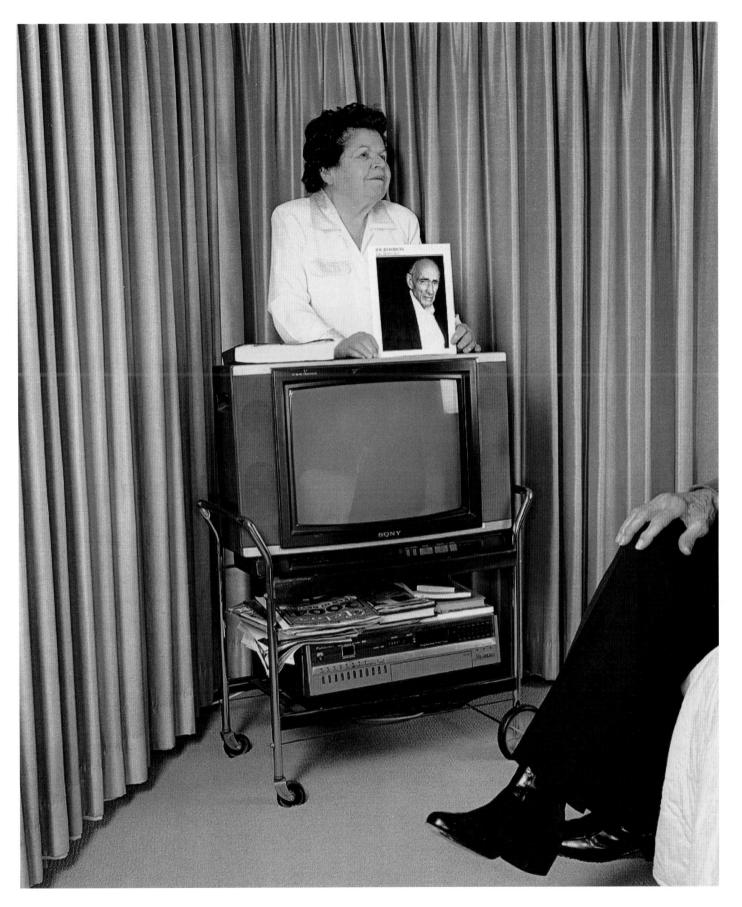

Gregg Segal

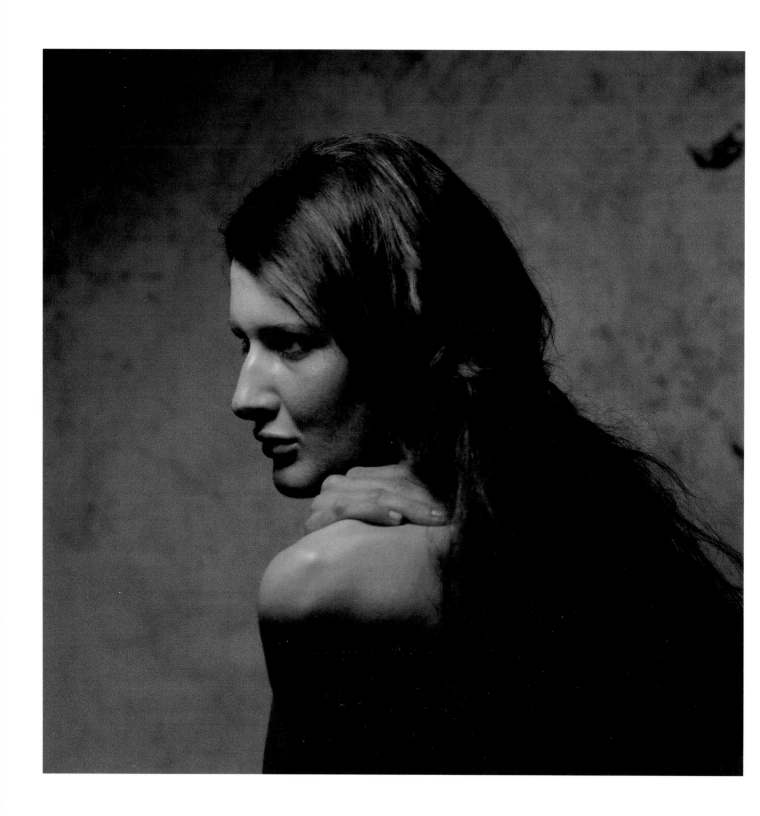

Janez Vlachy

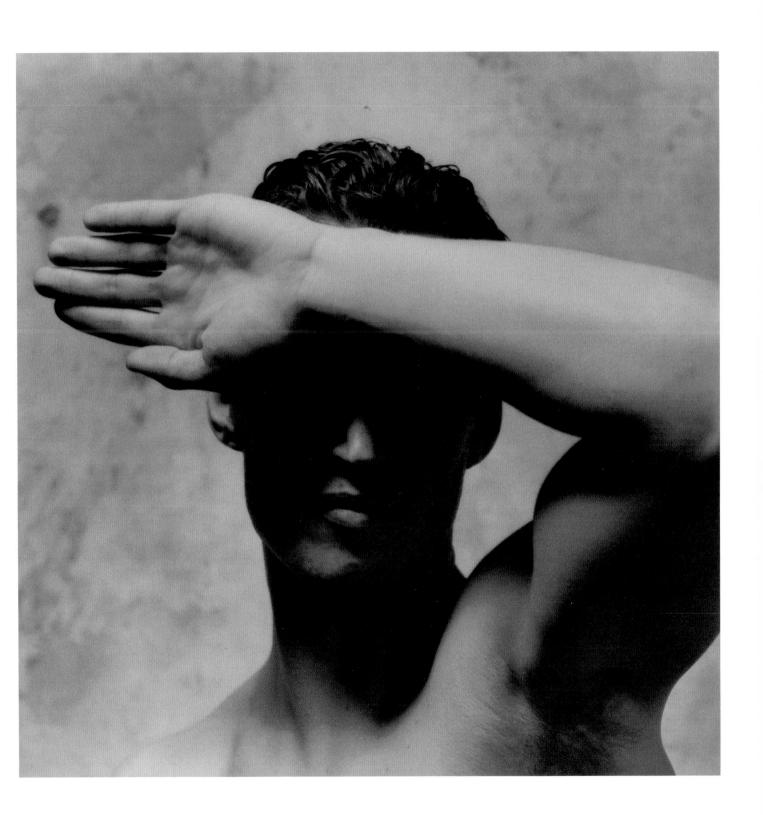

Janez Vlachy

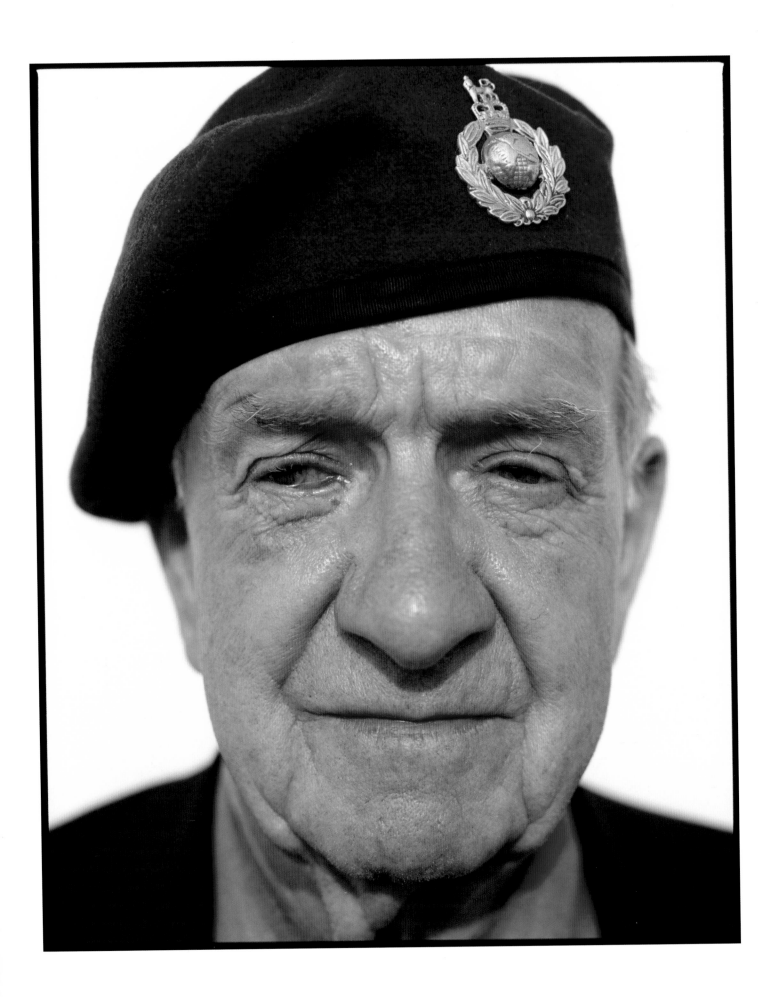

Hans Kwiotek

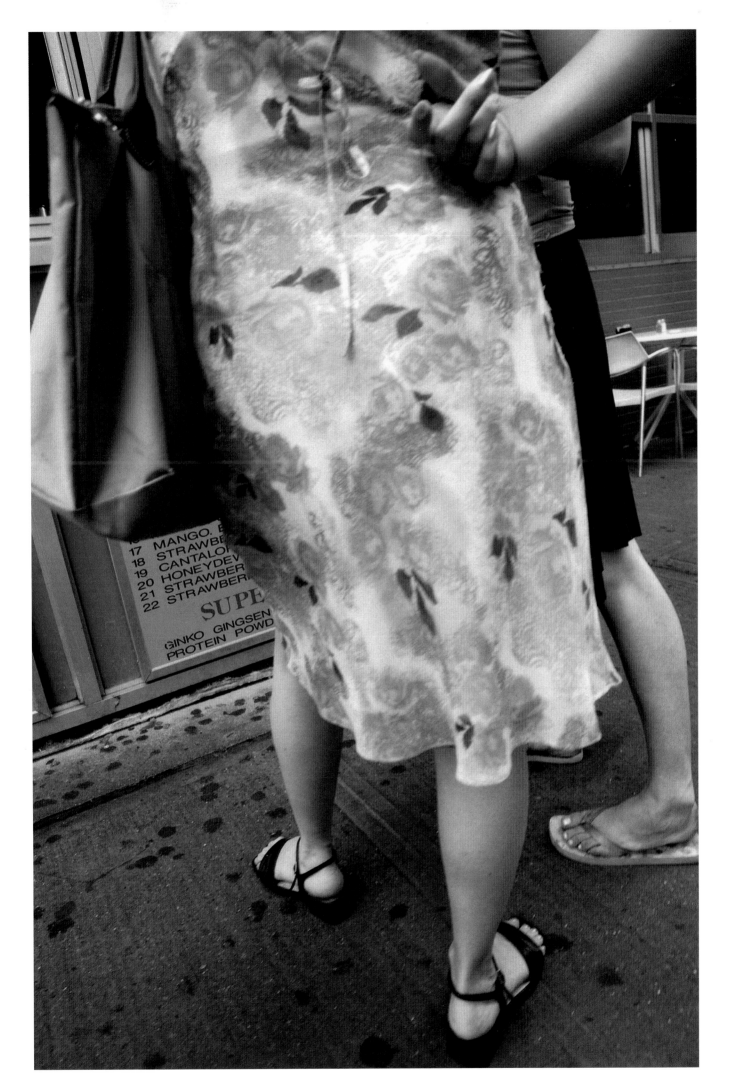

David Zimmerman

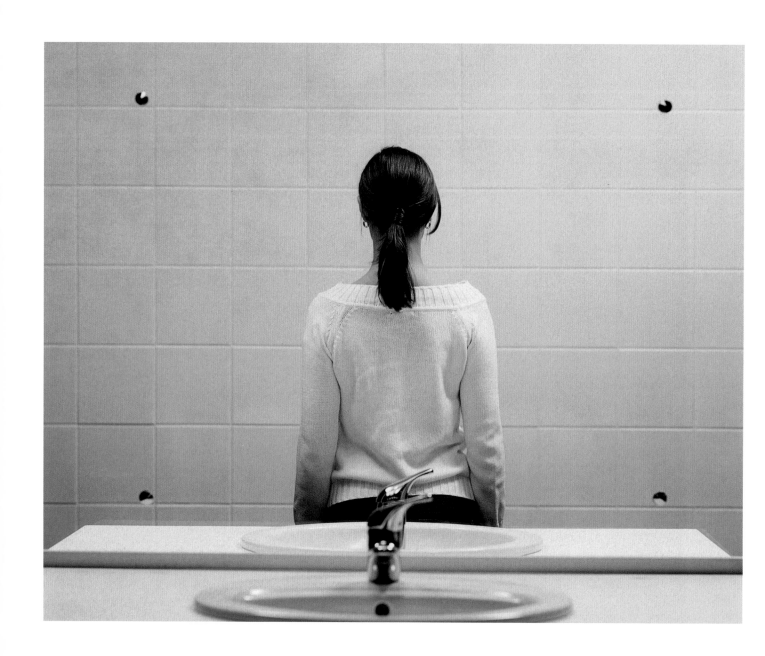

Mike Carsley

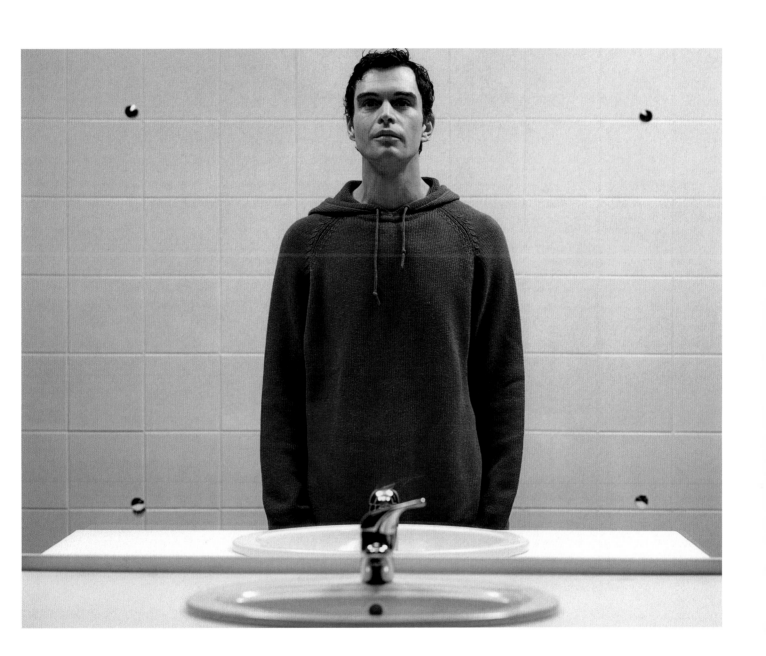

Mike Carsley

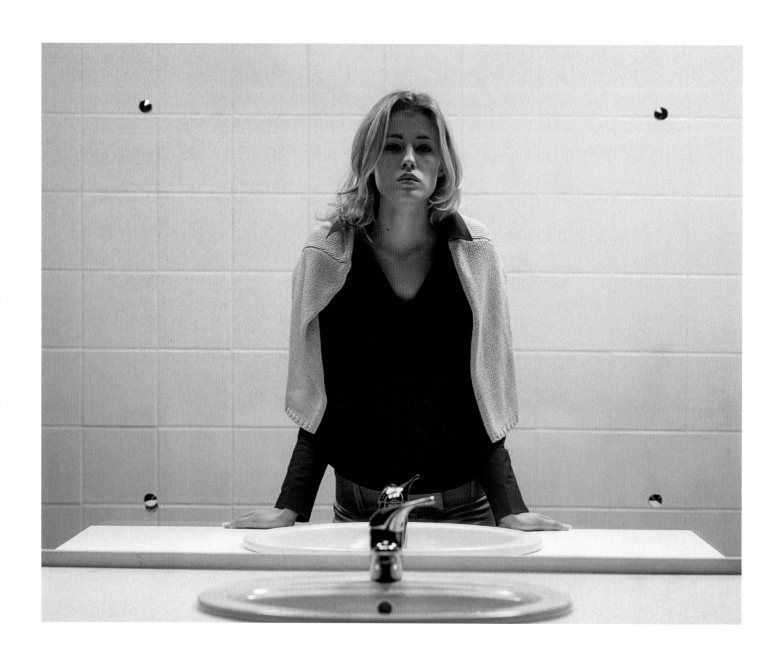

Mike Carsley

Mike Carsley

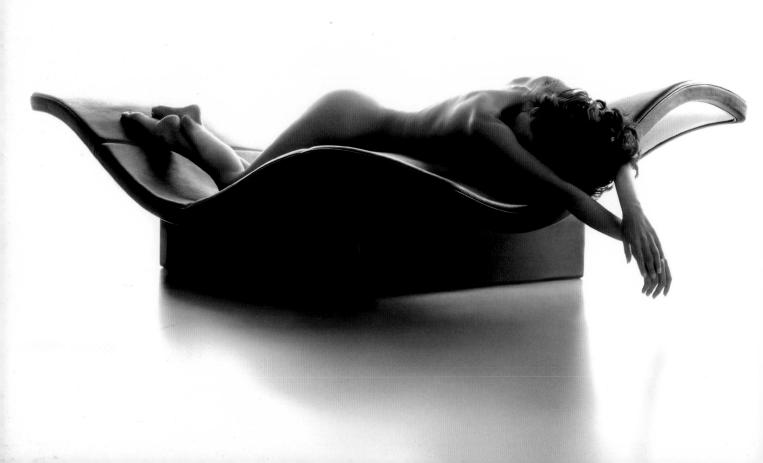

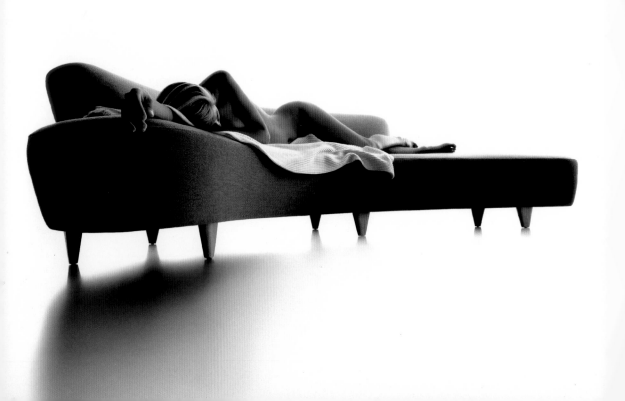

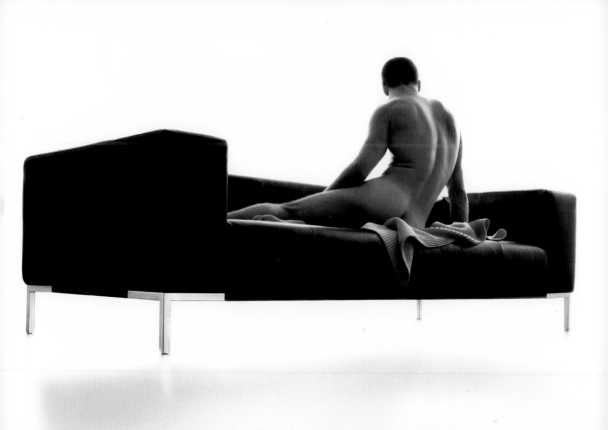

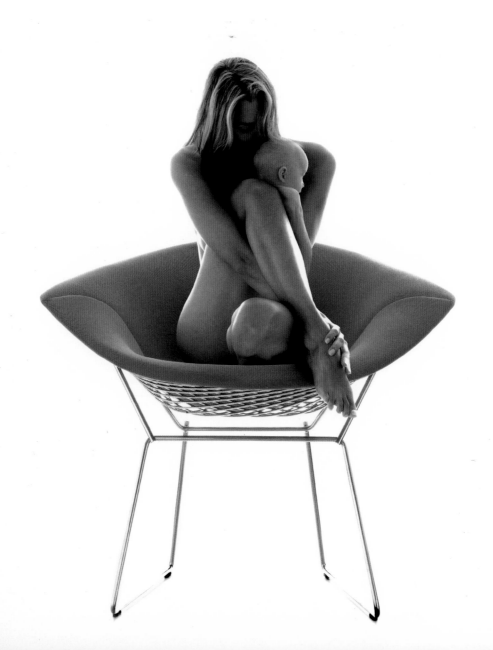

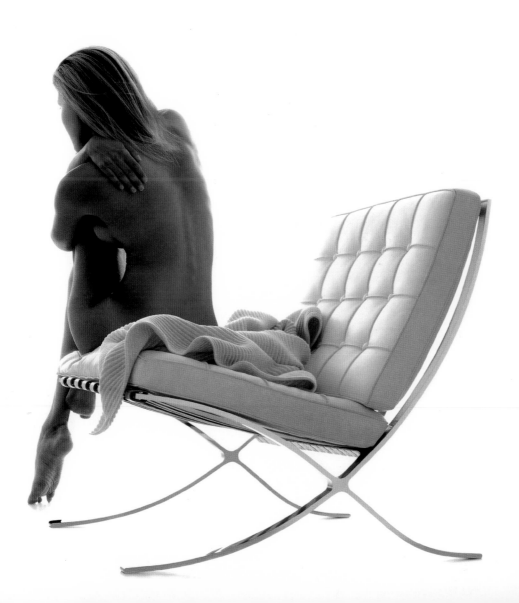

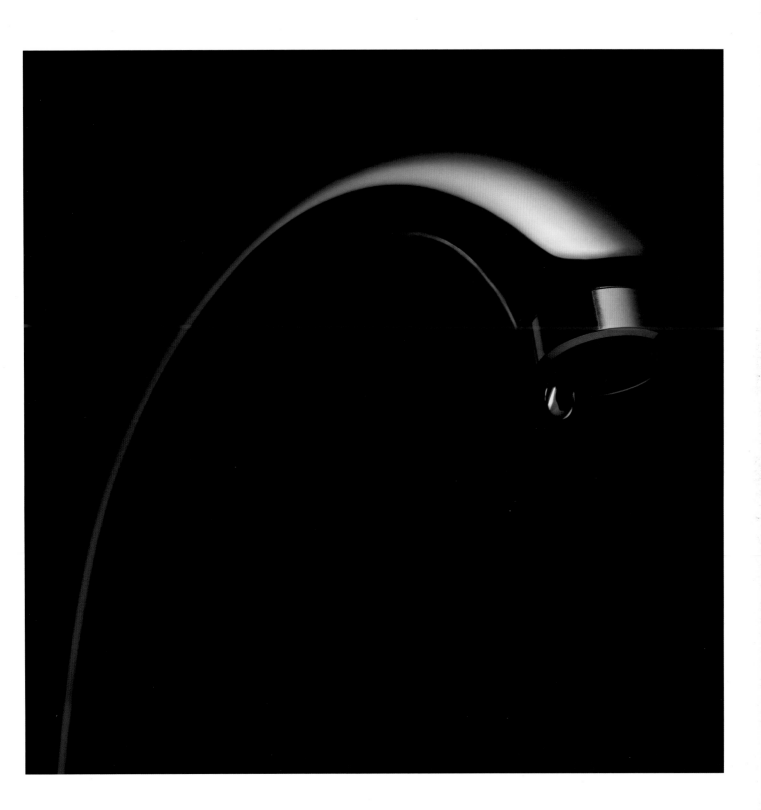

Dick Baker

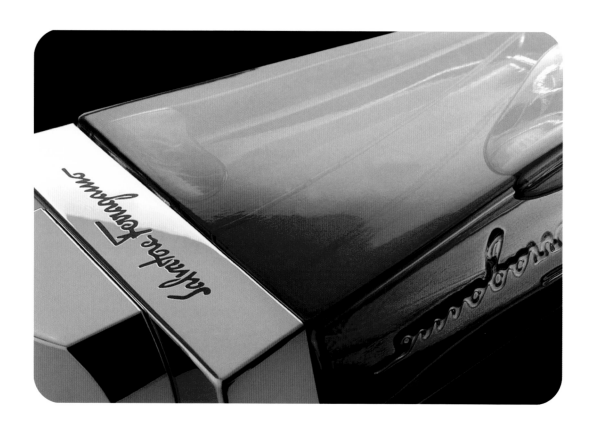

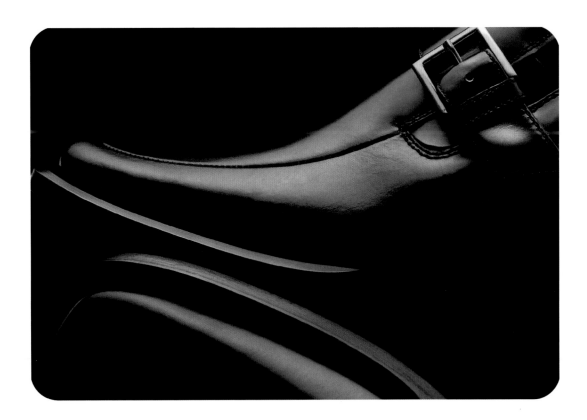

Luis Ernesto Santana

Craig Cutler

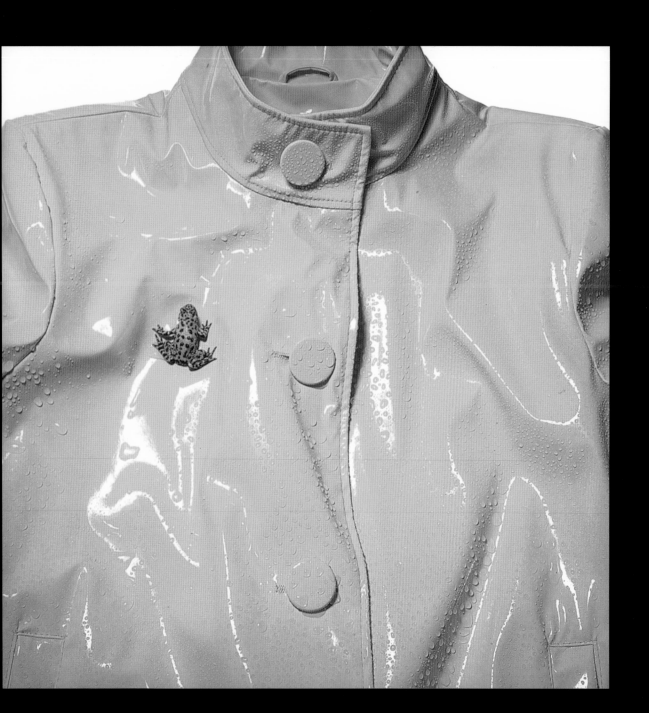

(previous page and this page) Chris Gordaneer

Chris Gordaneer

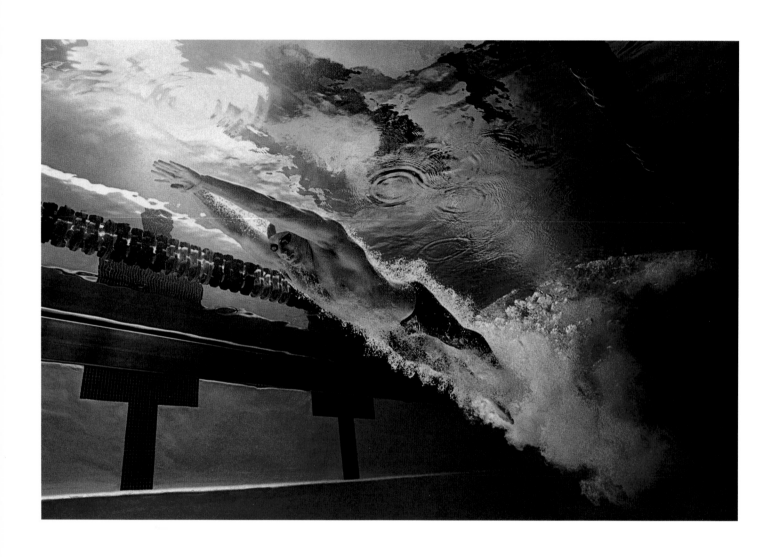

Marcus Swanson

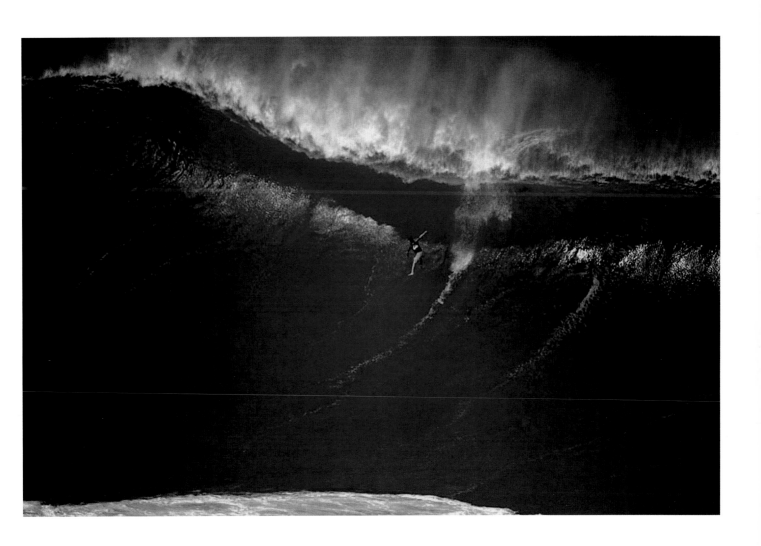

Daren Fentiman

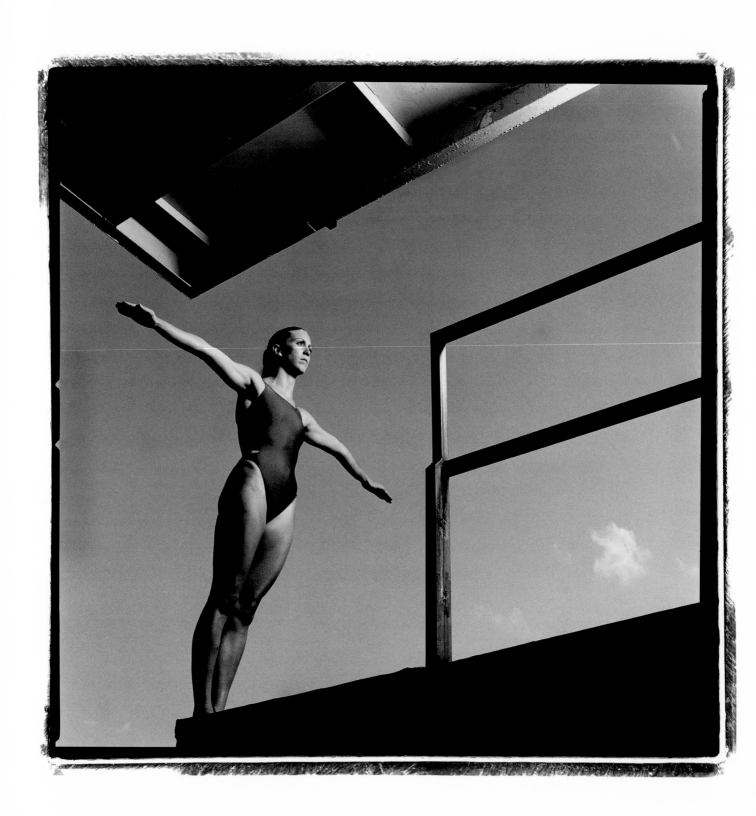

Michael O'Brien

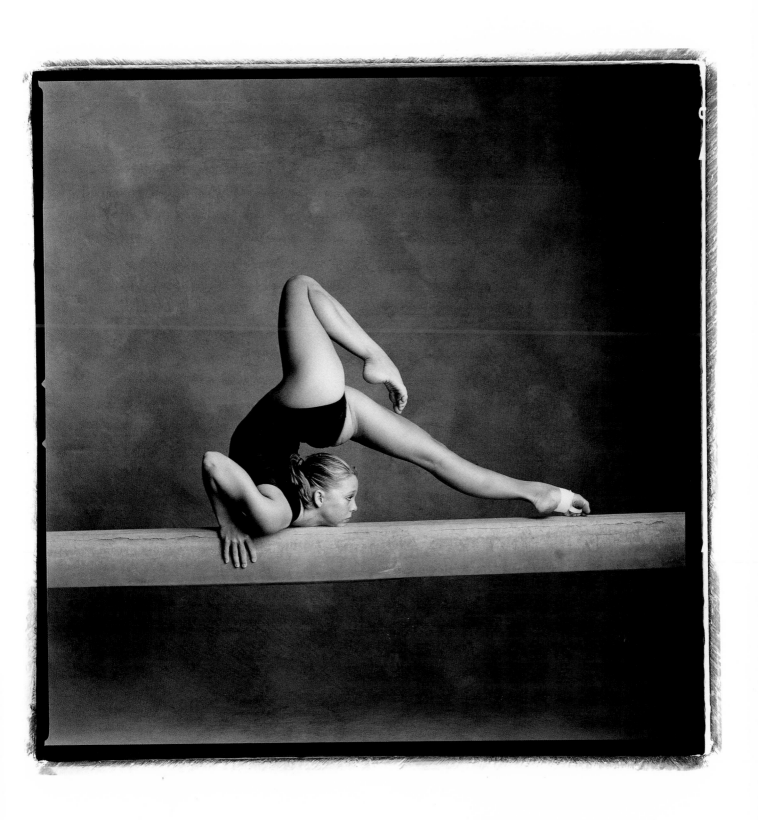

Michael O'Brien

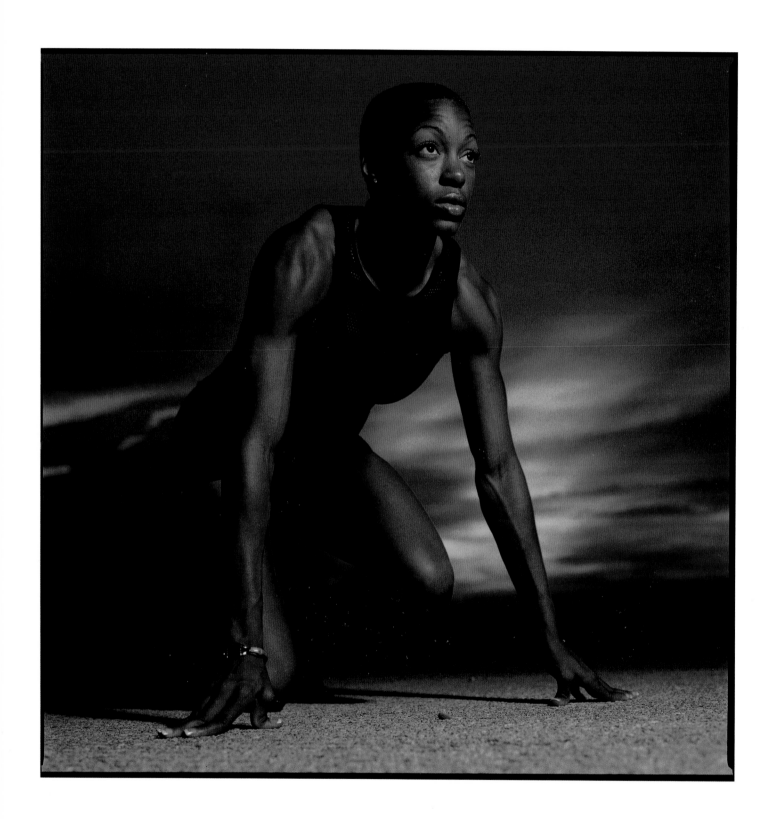

Michael O'Brien

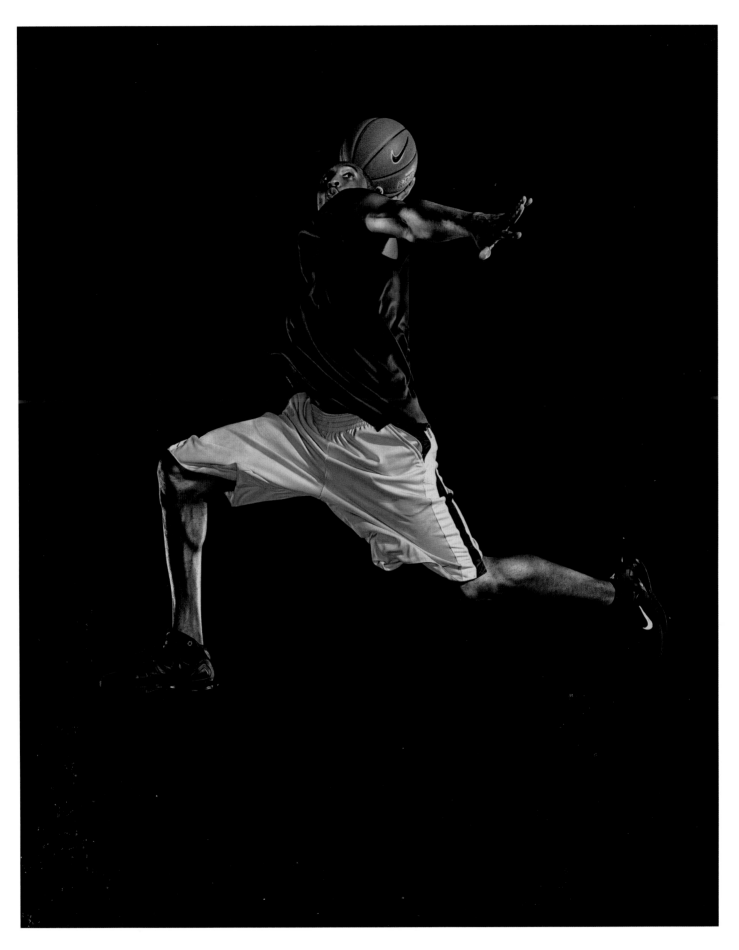

Pier Nicola D'Amico

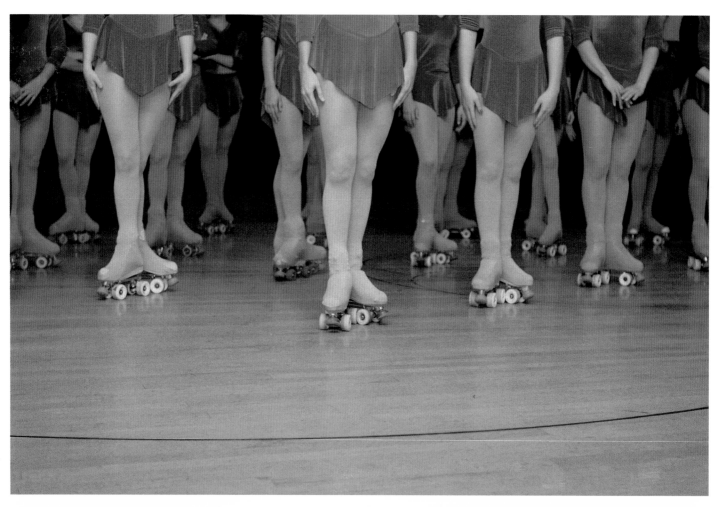

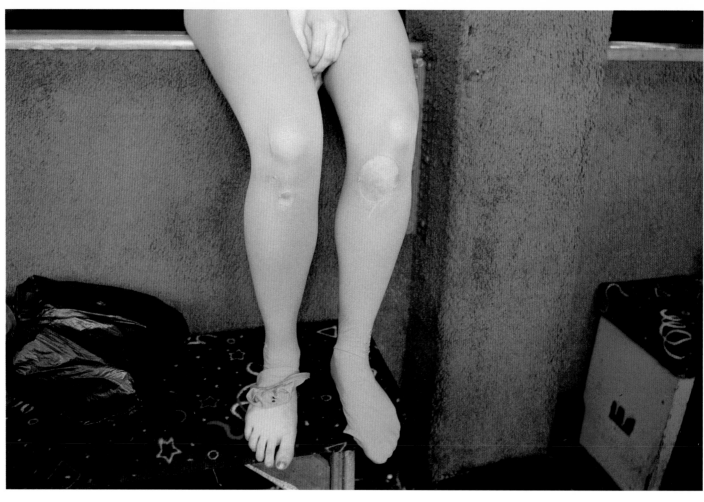

Alexa Miller

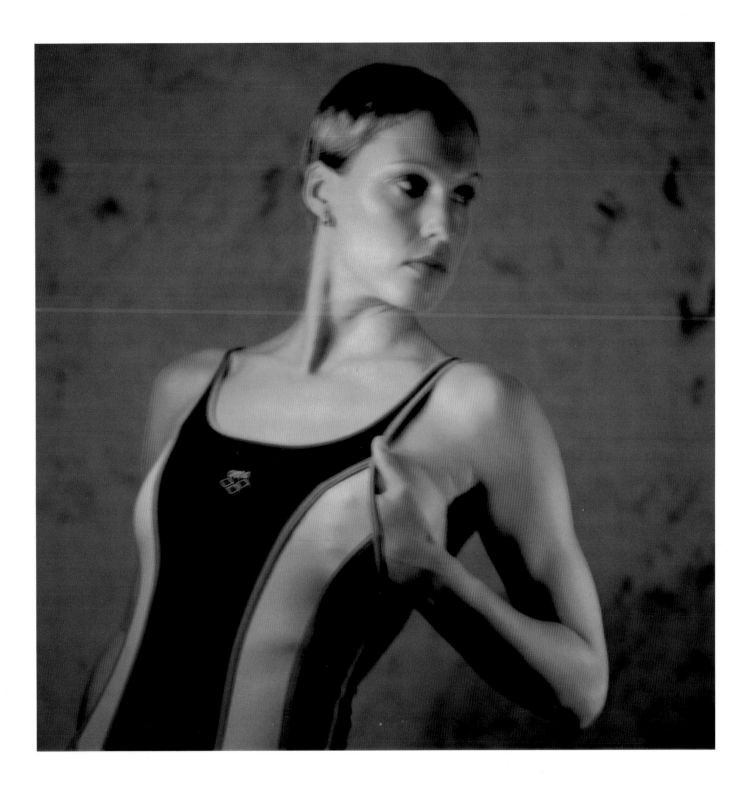

Janez Vlachy

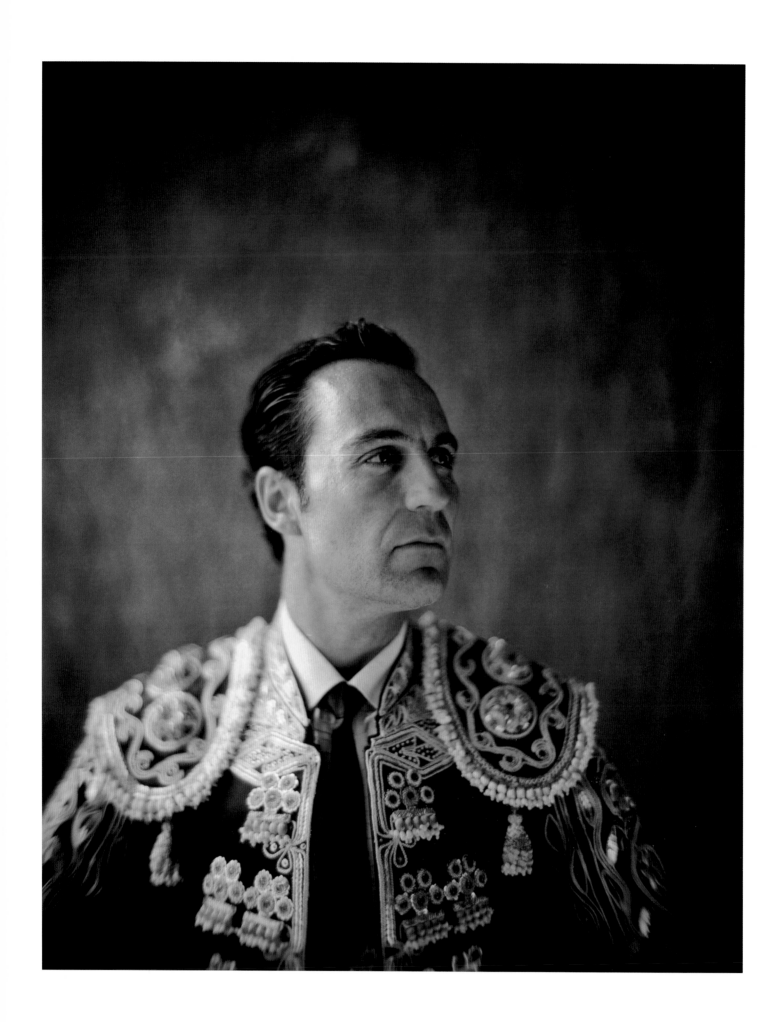

Andy Anderson

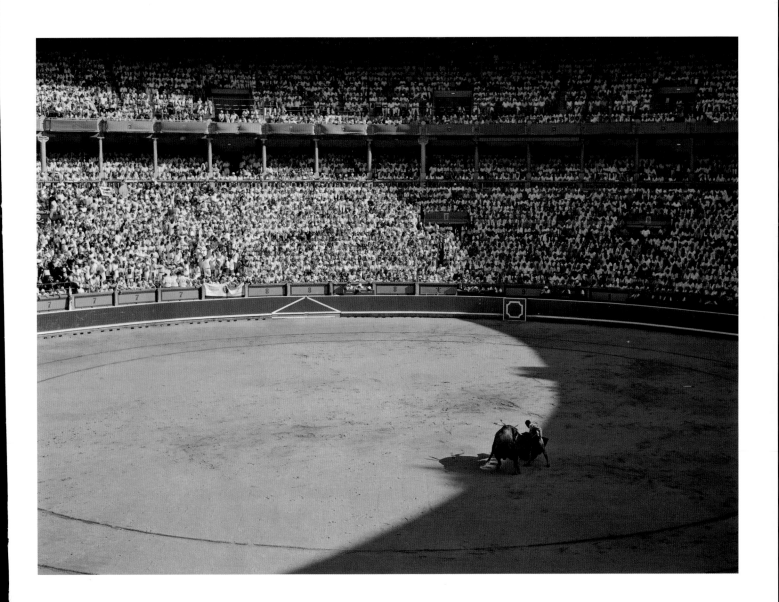

Andy Anderson

Still Life

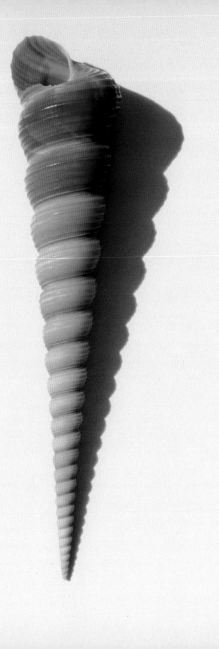

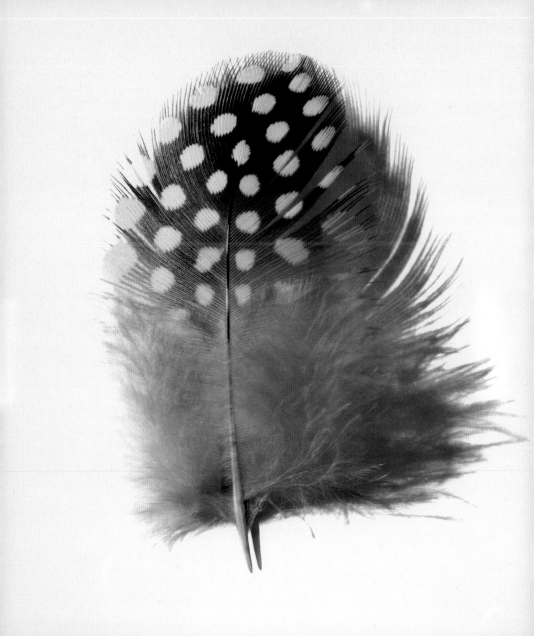

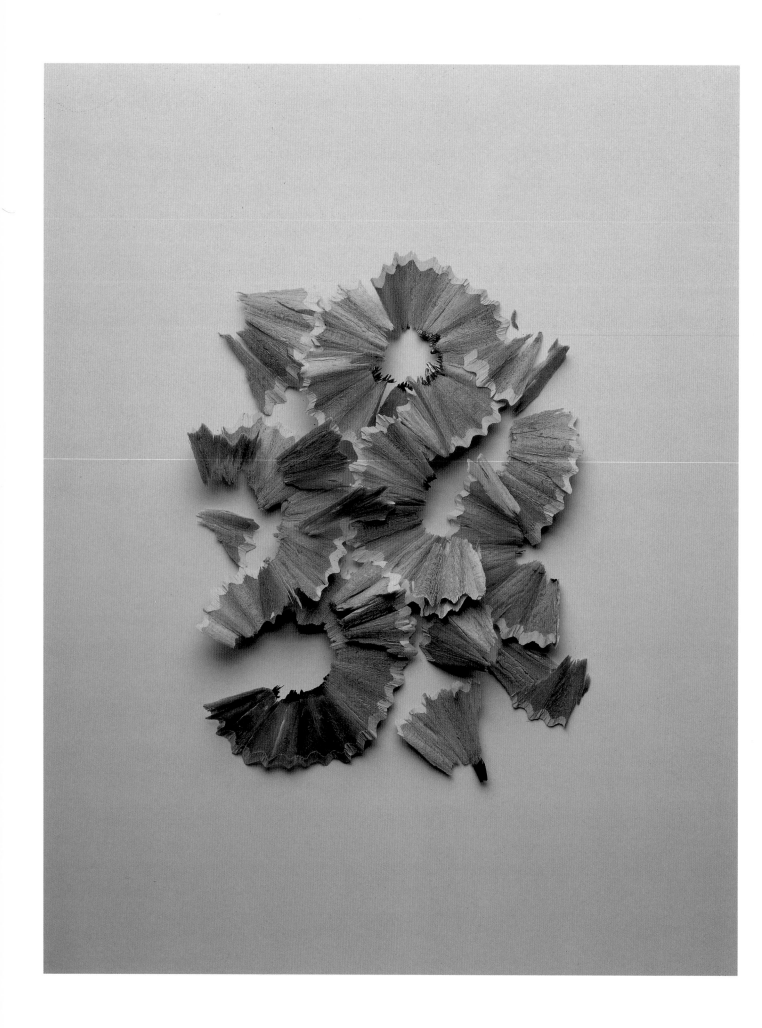

Craig Cutler

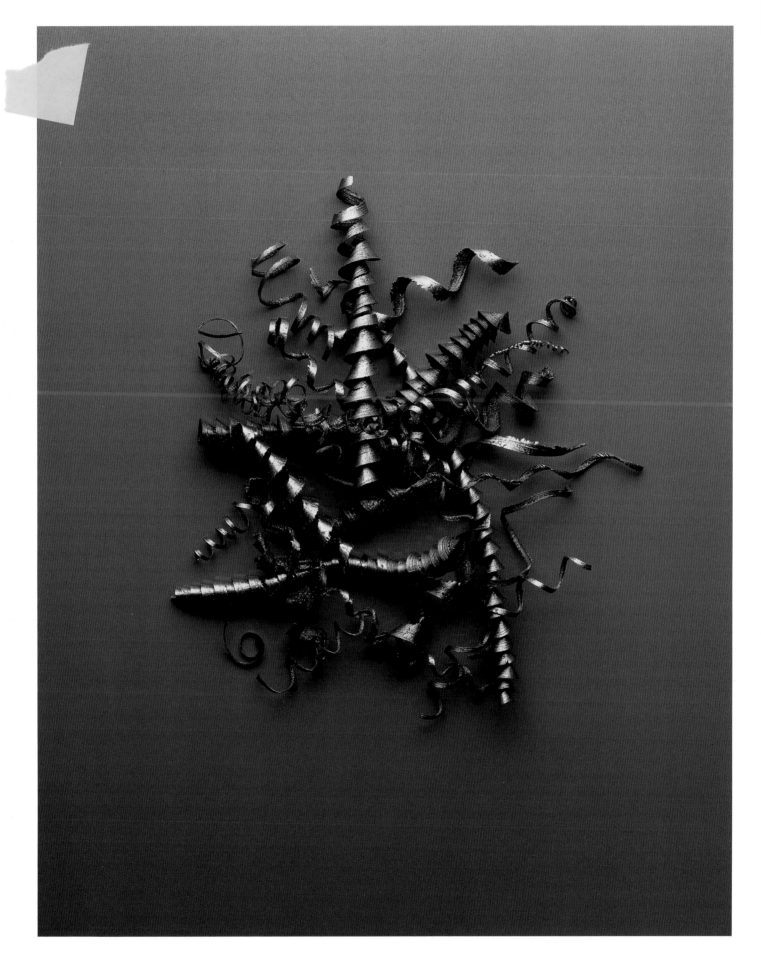

Craig Cutler

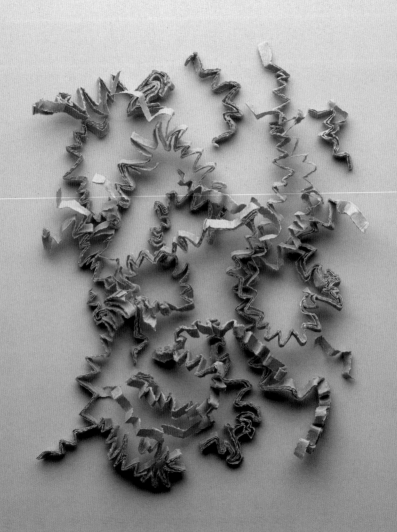

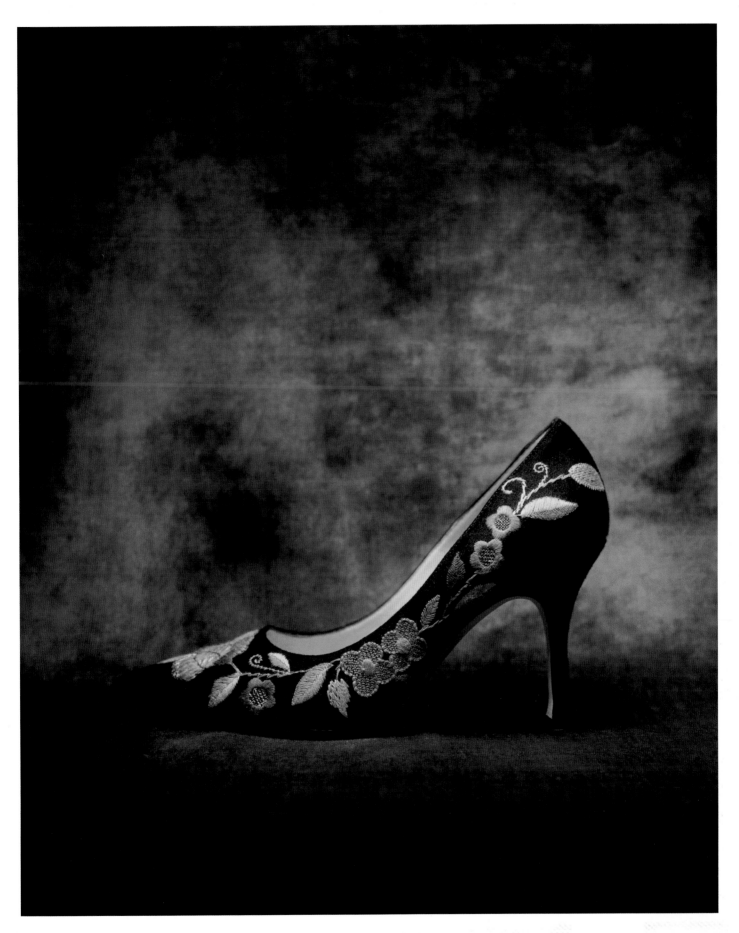

Craig Cutler

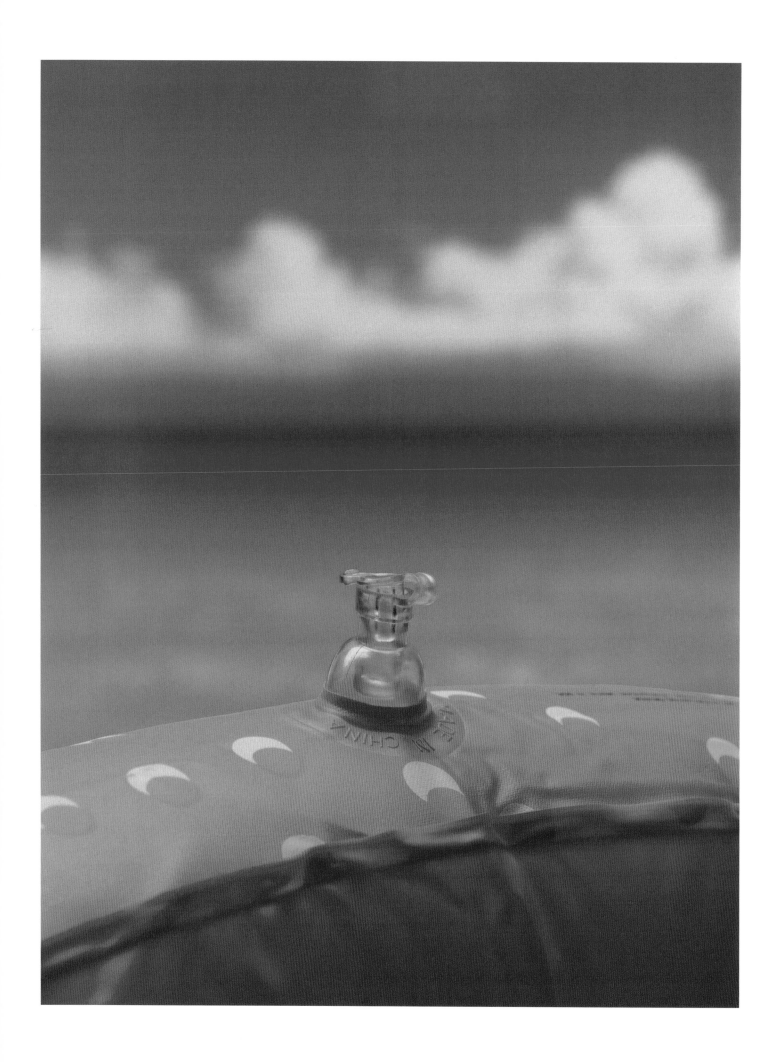

Bill Diodato

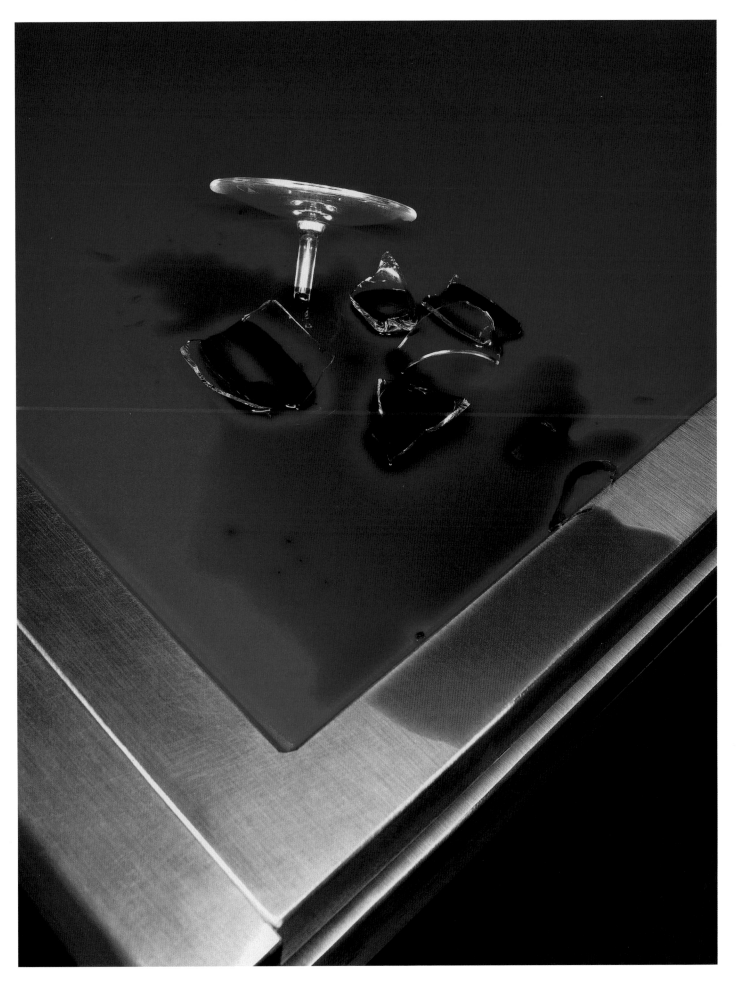

Bill Diodato

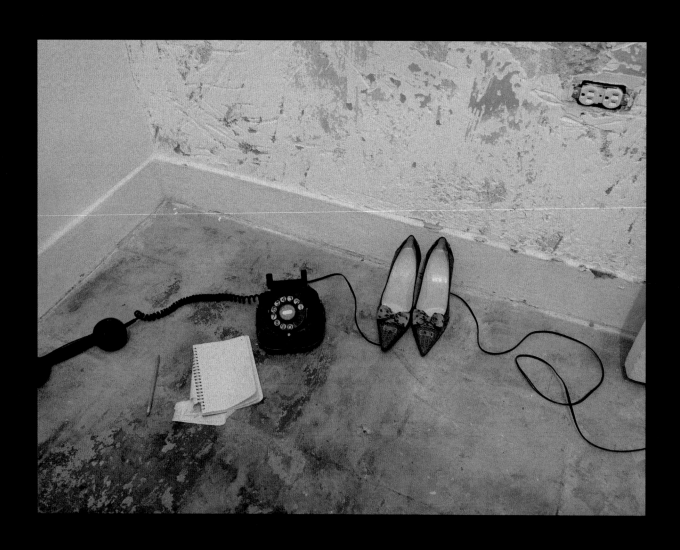

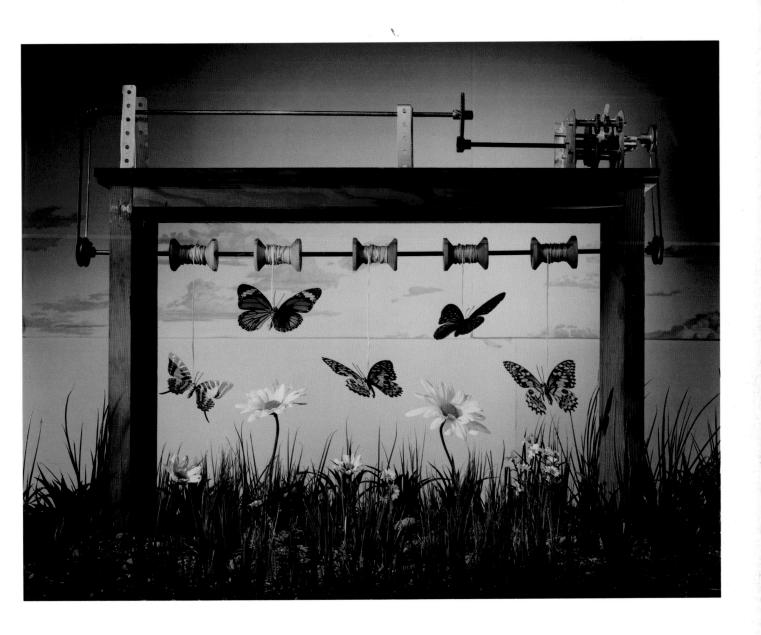

David Emmite

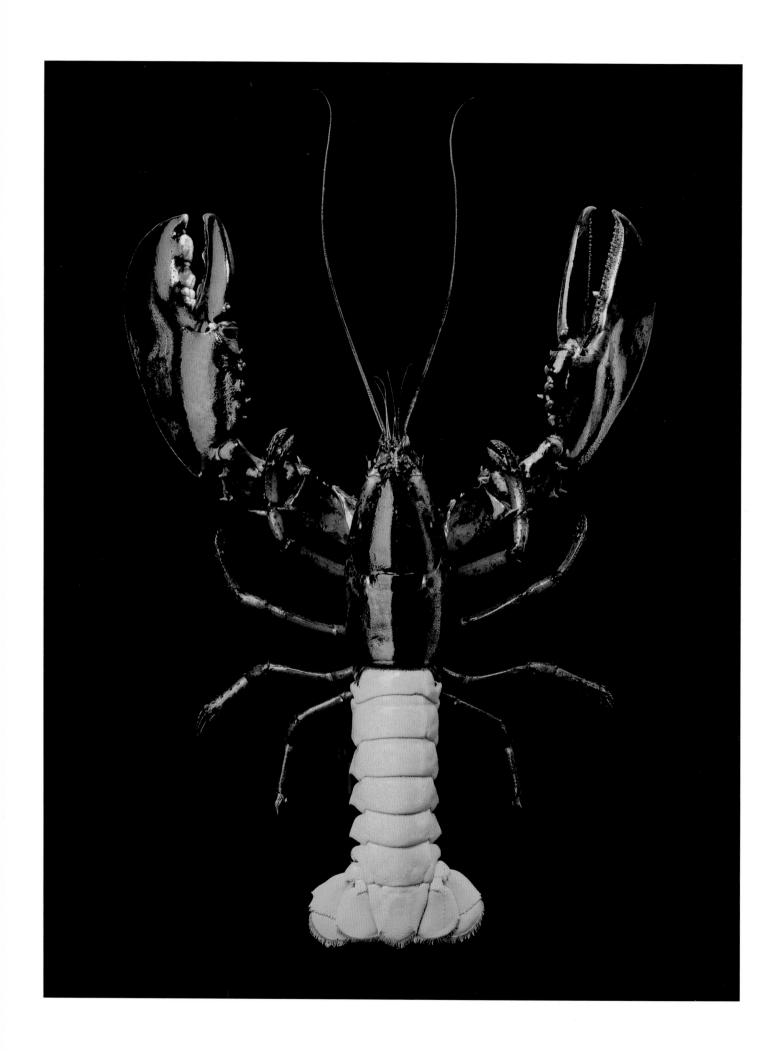

Chris Collins

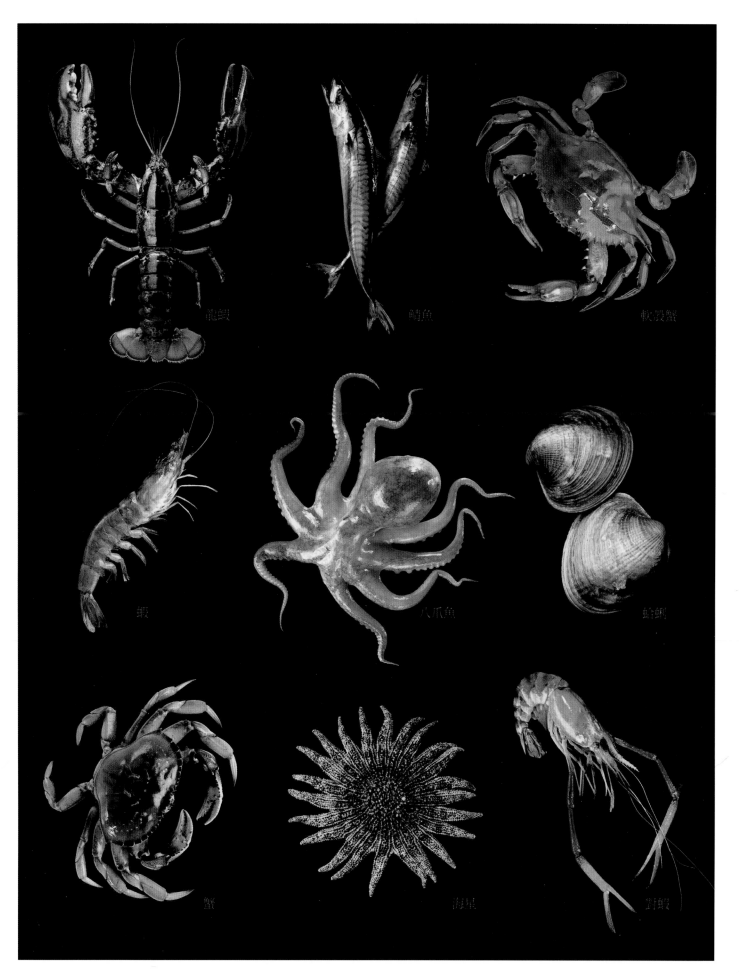

龍蝦　　　　　　　　　鯖魚　　　　　　　　　軟殼蟹

蝦　　　　　　　　　八爪魚　　　　　　　　蛤蜊

蟹　　　　　　　　　海星　　　　　　　　對蝦

Chris Collins

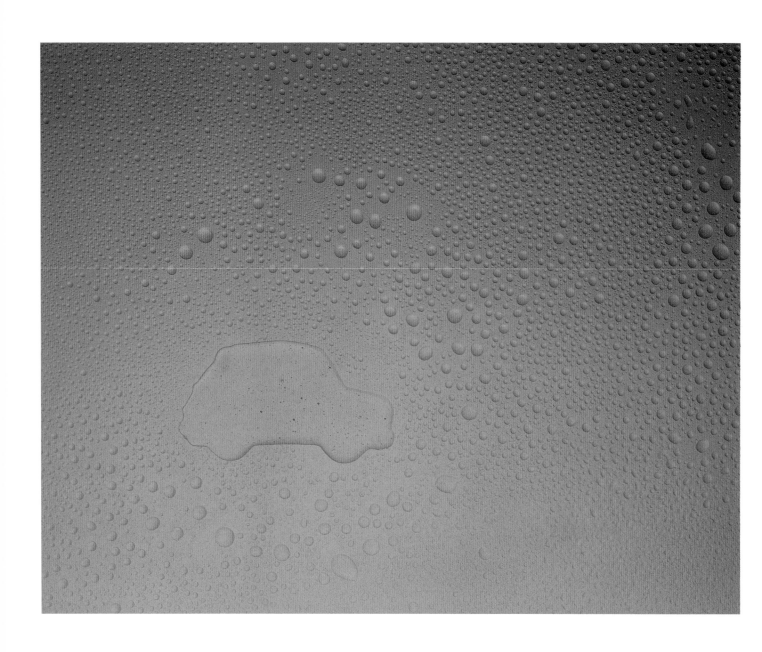

Jonathan Knowles

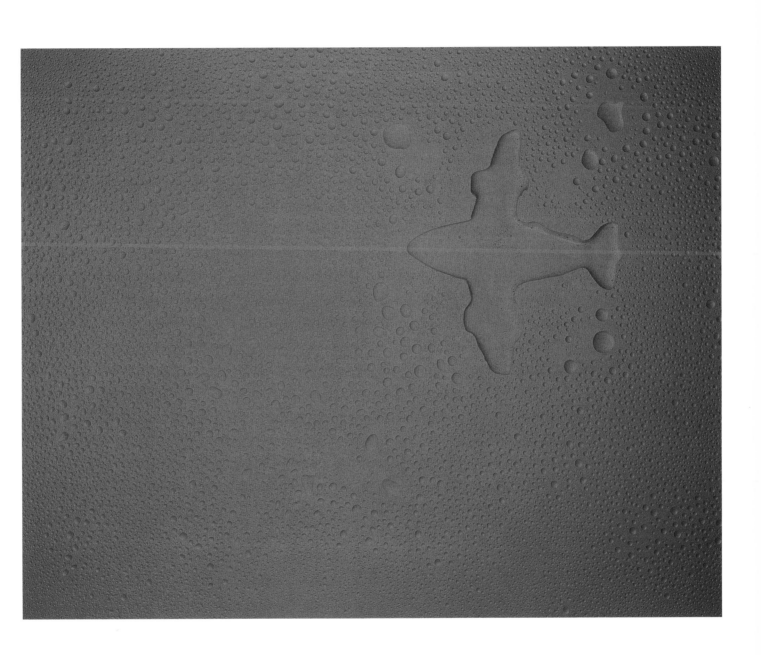

Jonathan Knowles

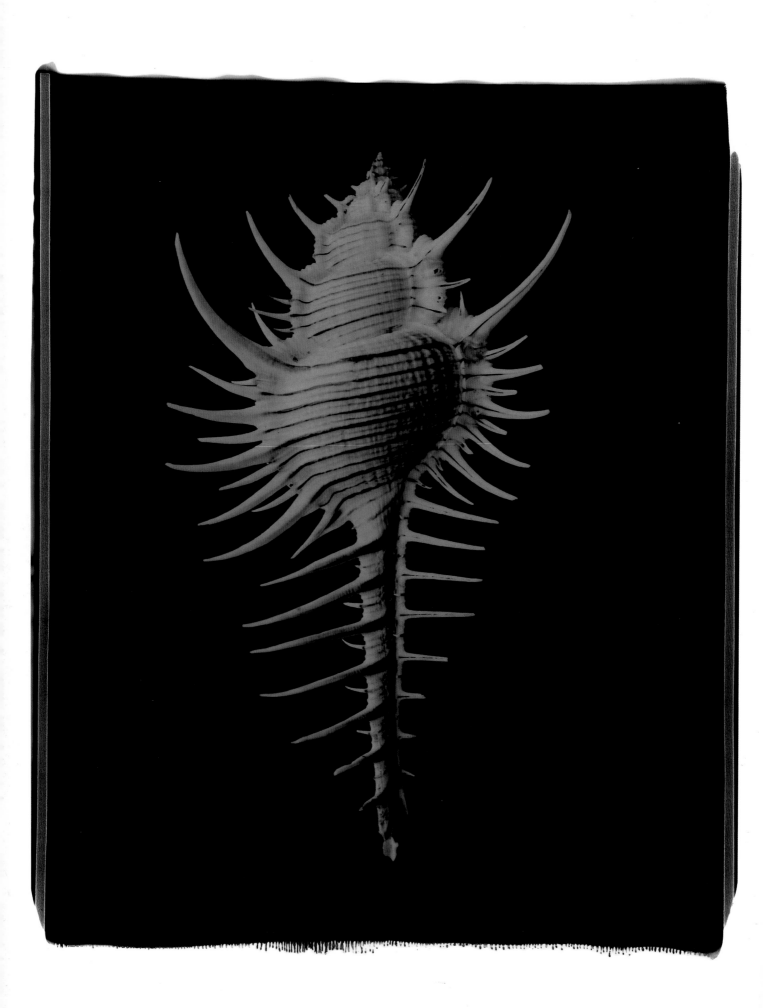

Mark Laita

Dan Saelinger

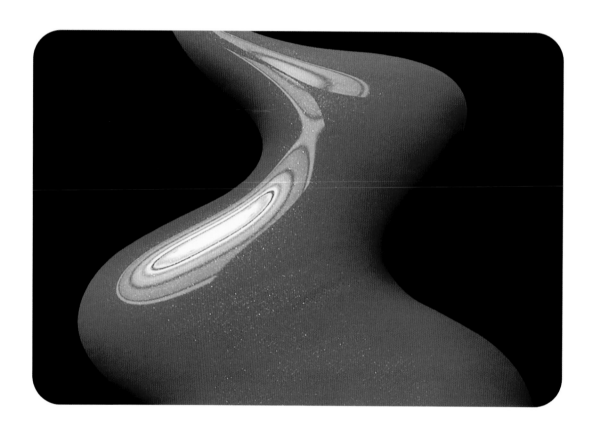

Luis Ernesto Santana

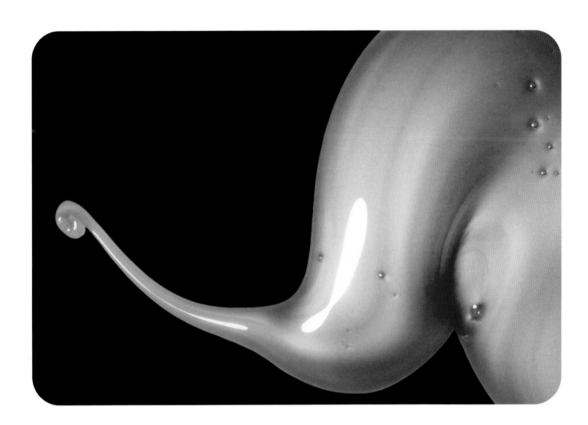

Luis Ernesto Santana

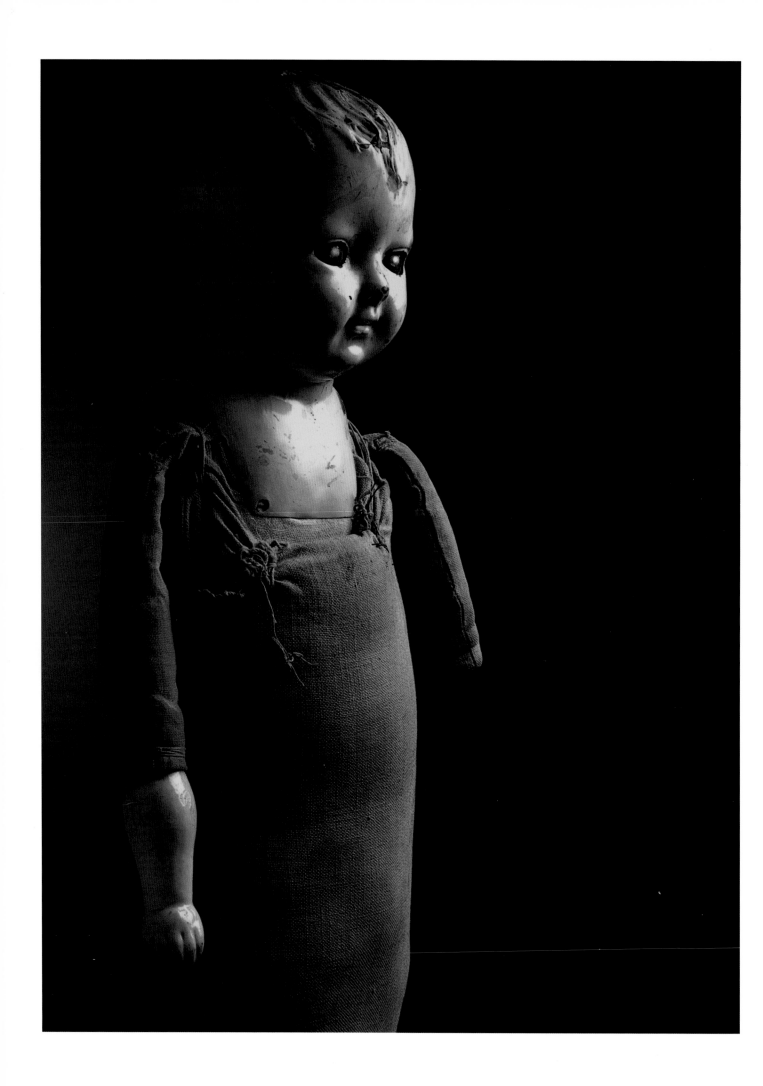

Phil Marco

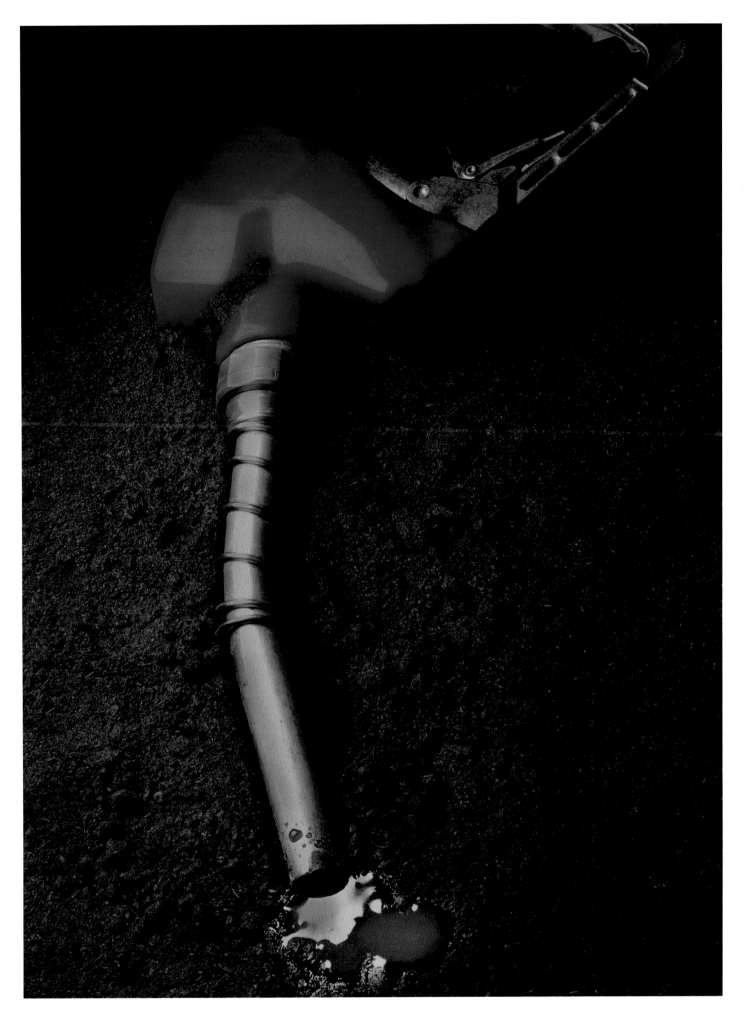

Phil Marco

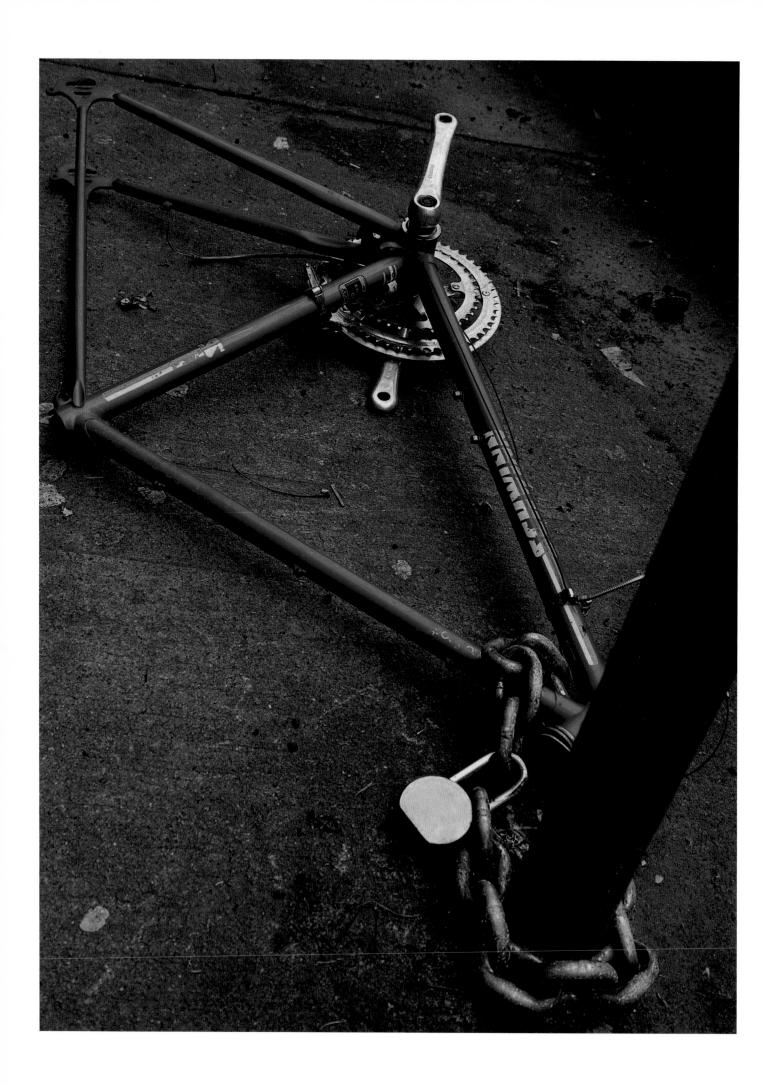

Phil Marco

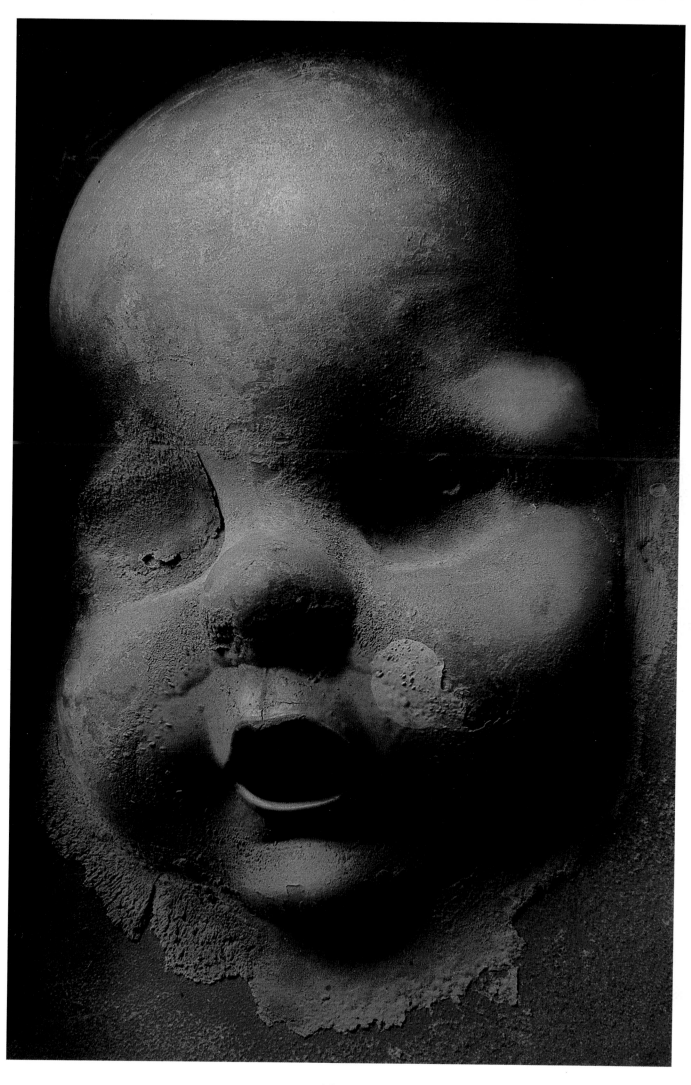

Phil Marco

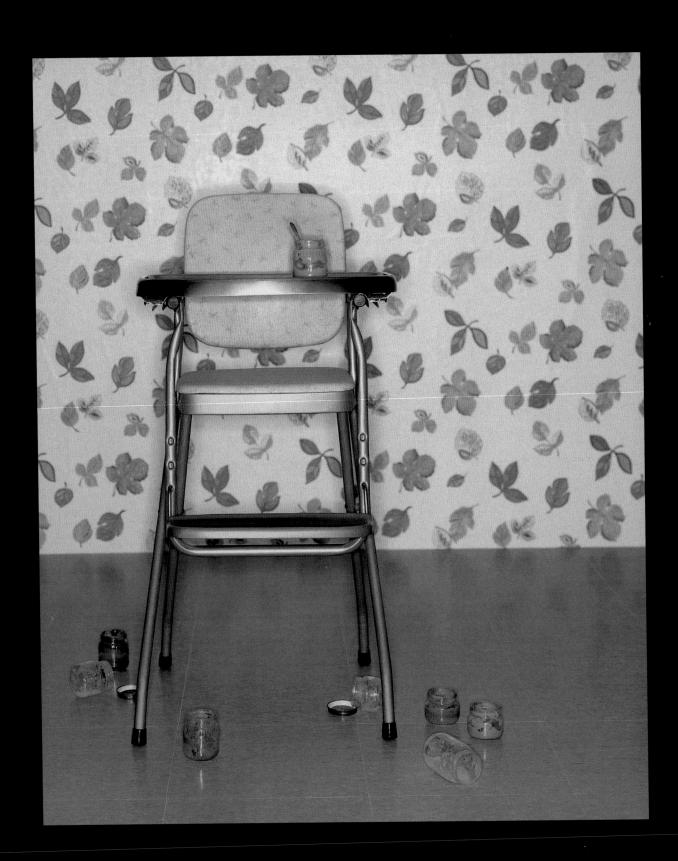

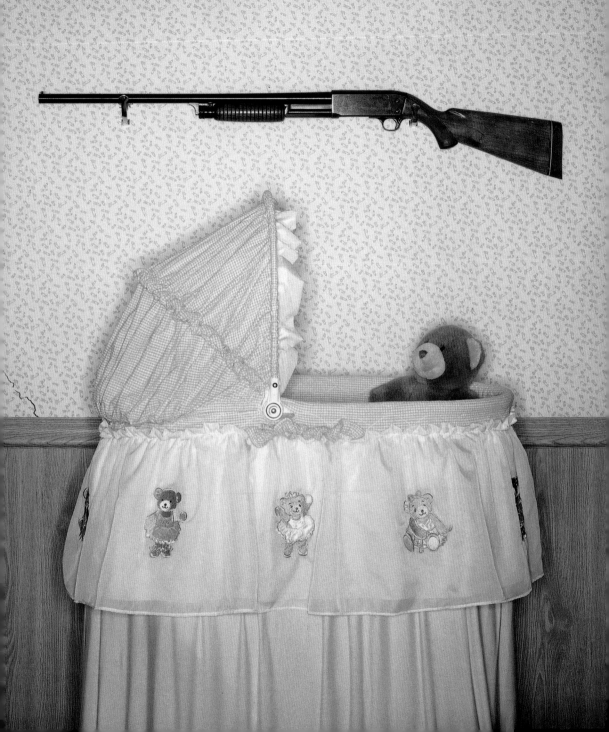

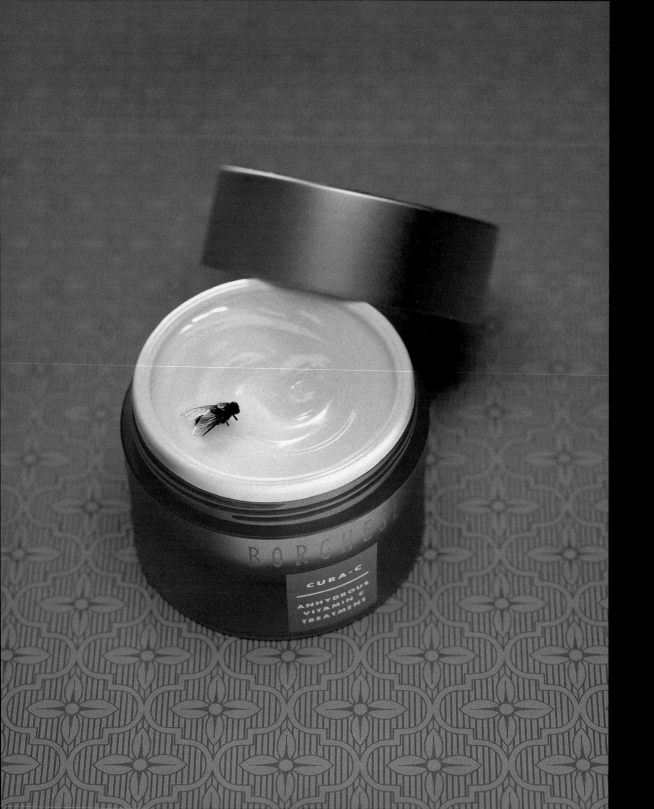

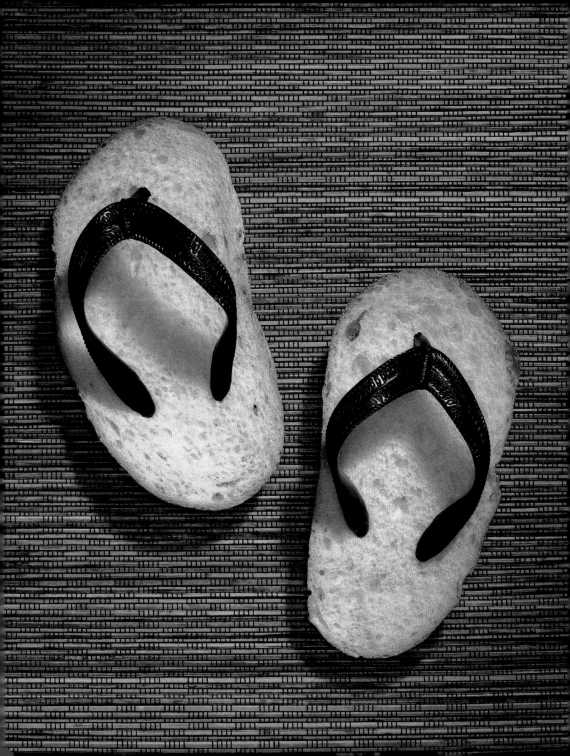

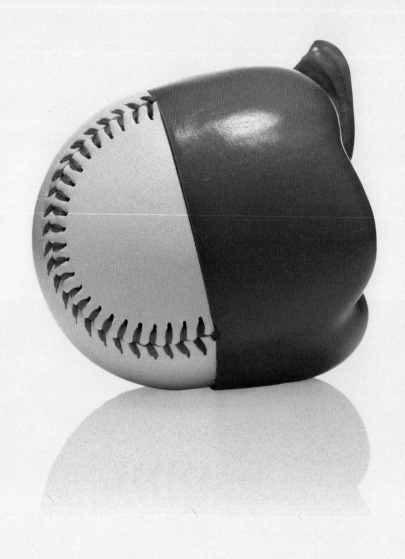

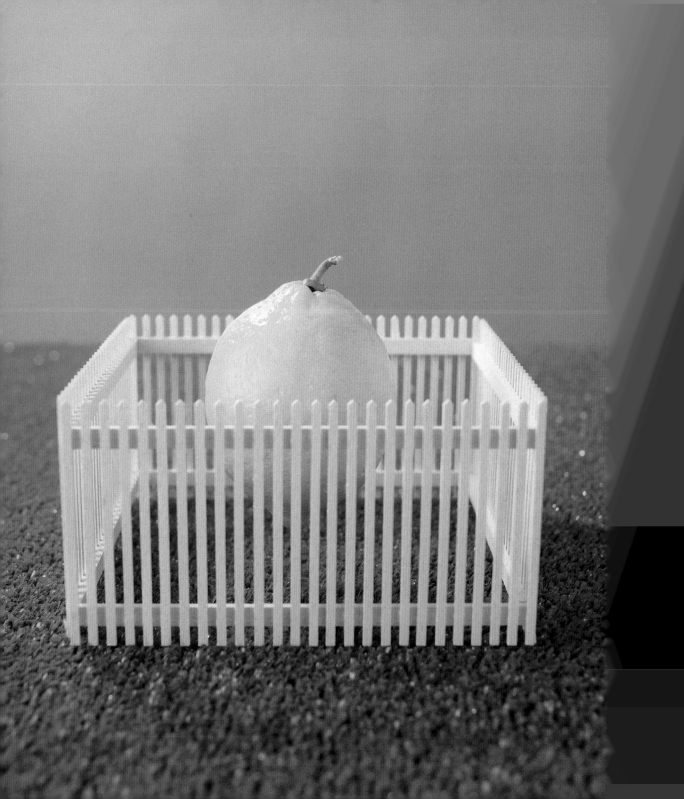

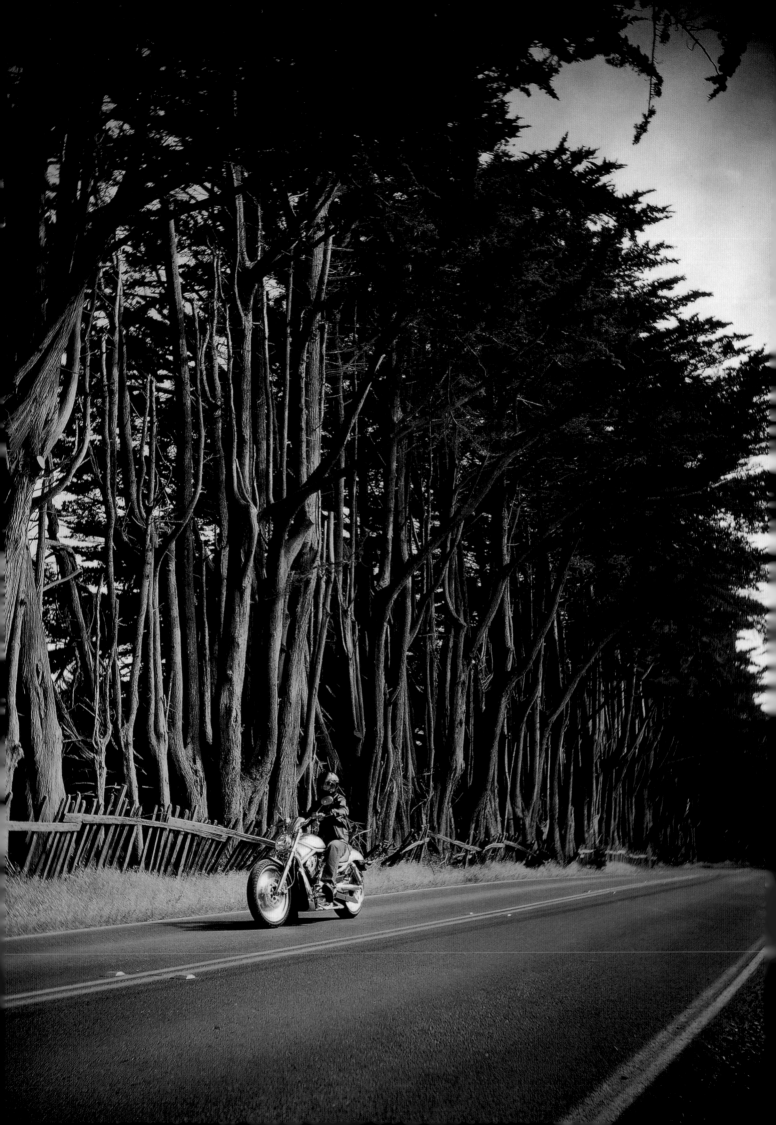

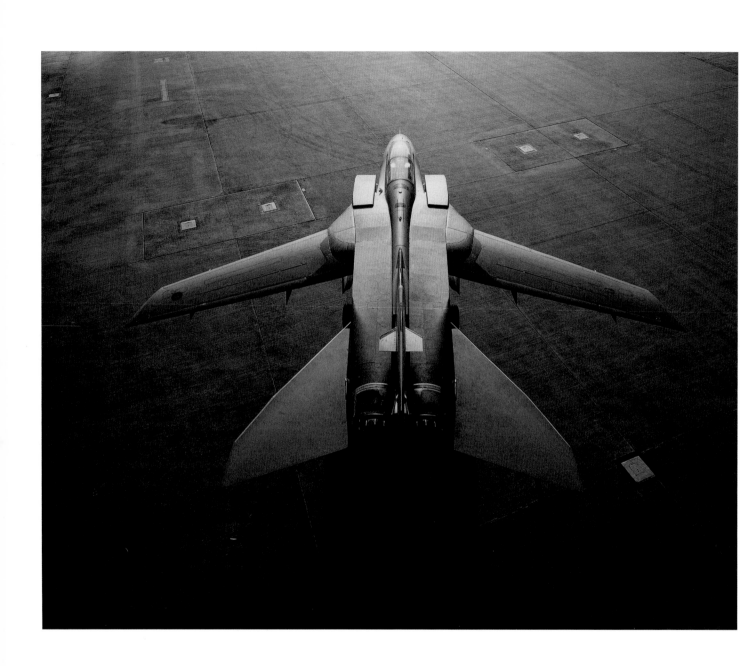

(previous page) Andy Anderson (this page) Jonathan Knowles

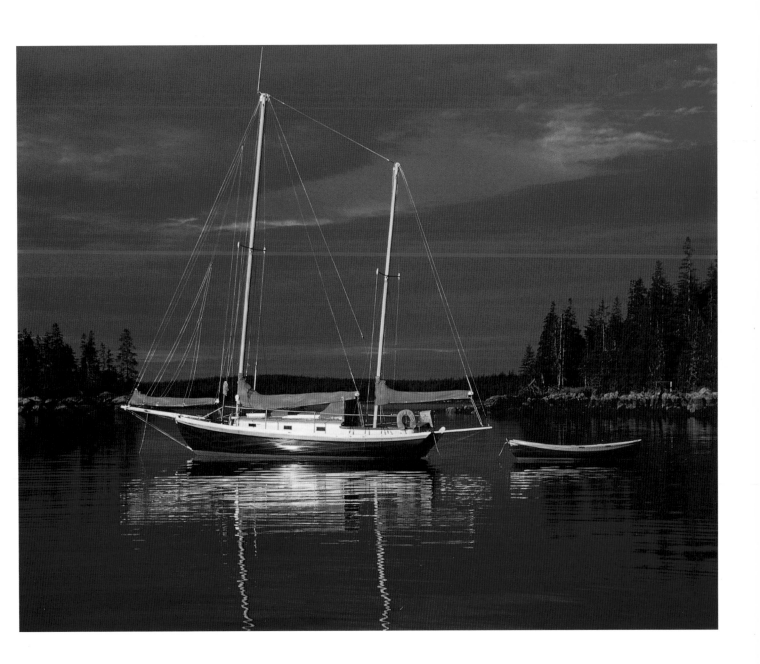

Benjamin Mendlowitz

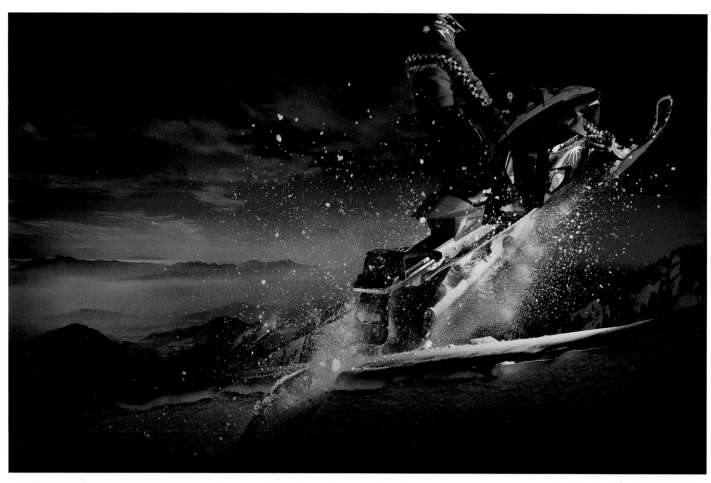

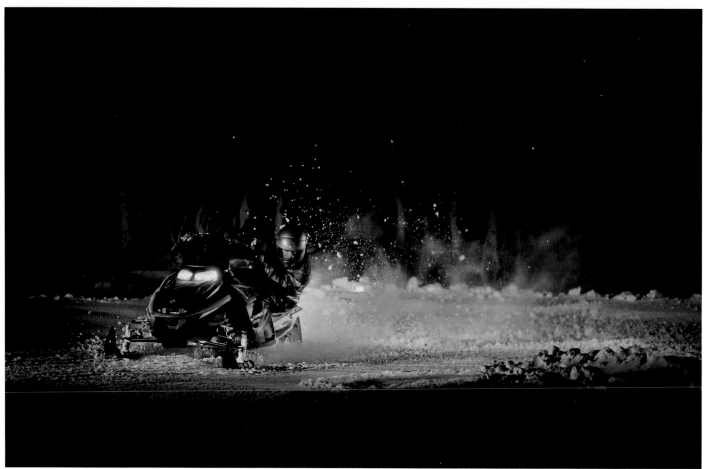

Jeff Ludes

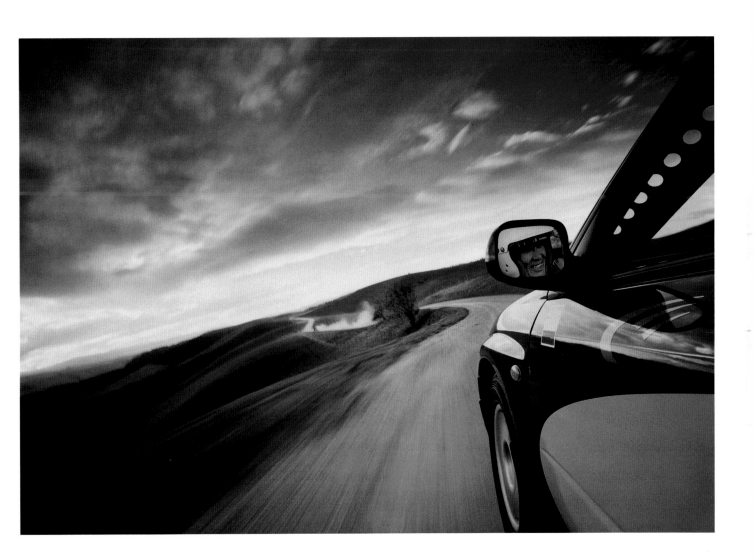

Christian Schmidt

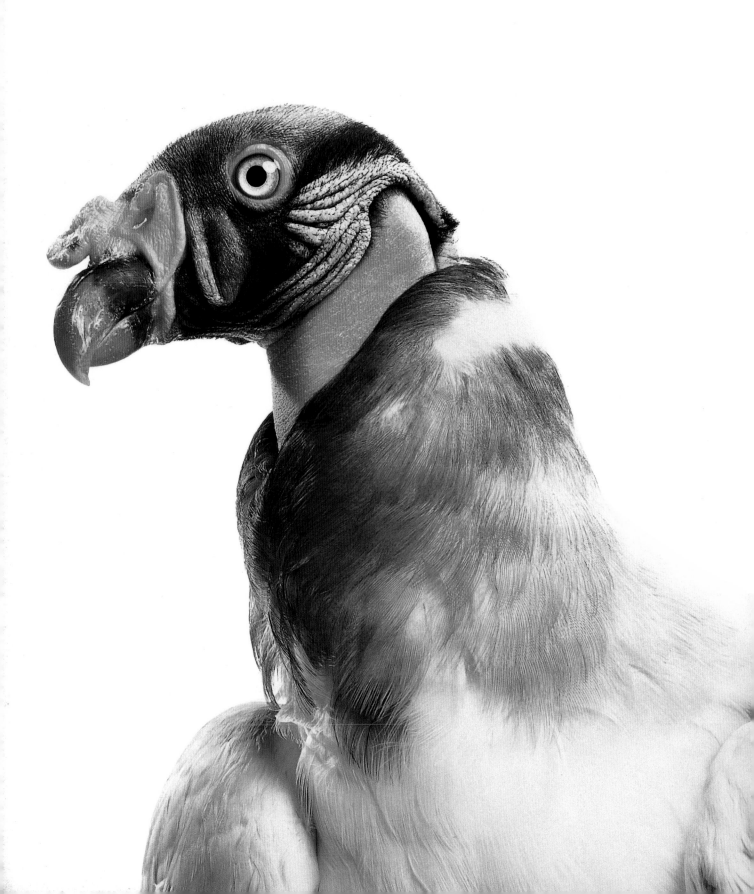

Wildlife/Pets

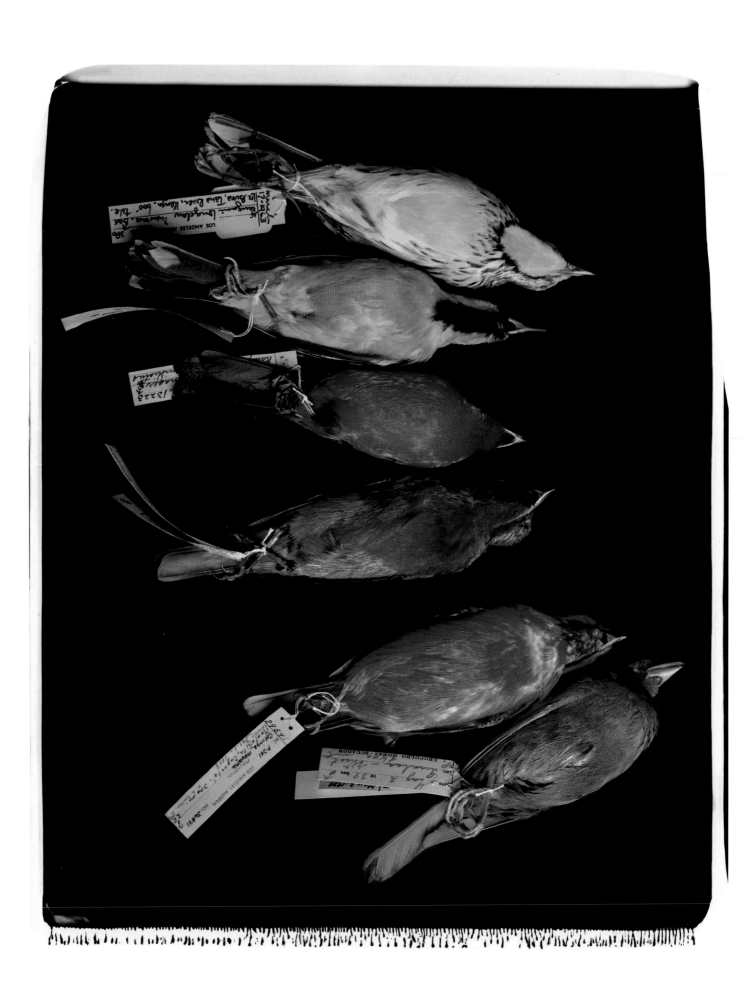

(previous page) Chris Gordaneer (this page) Mark Laita

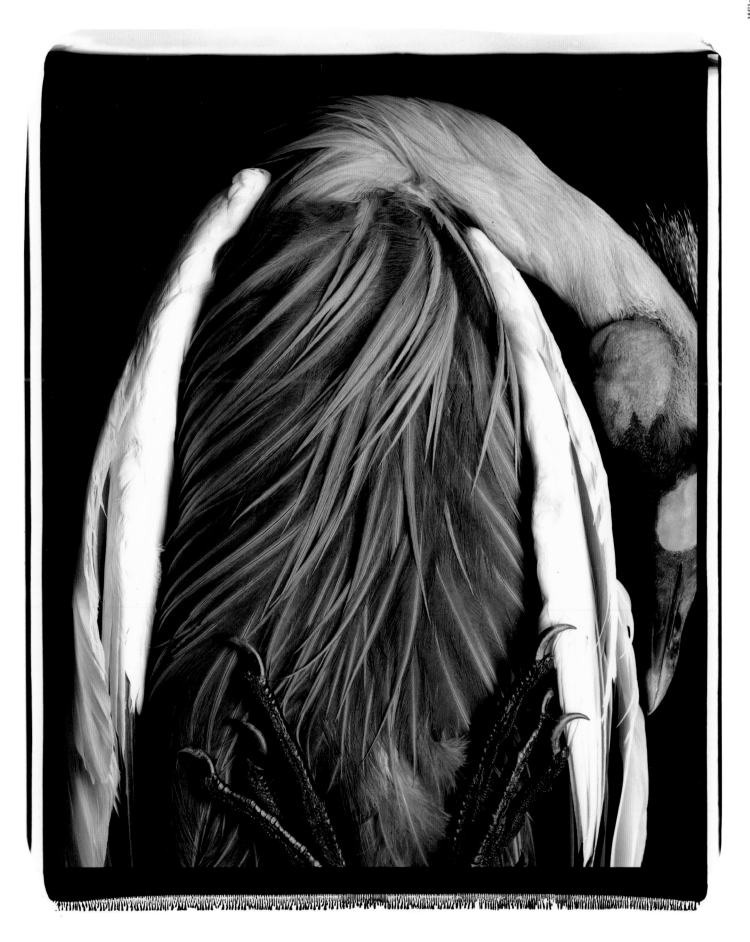

Mark Laita

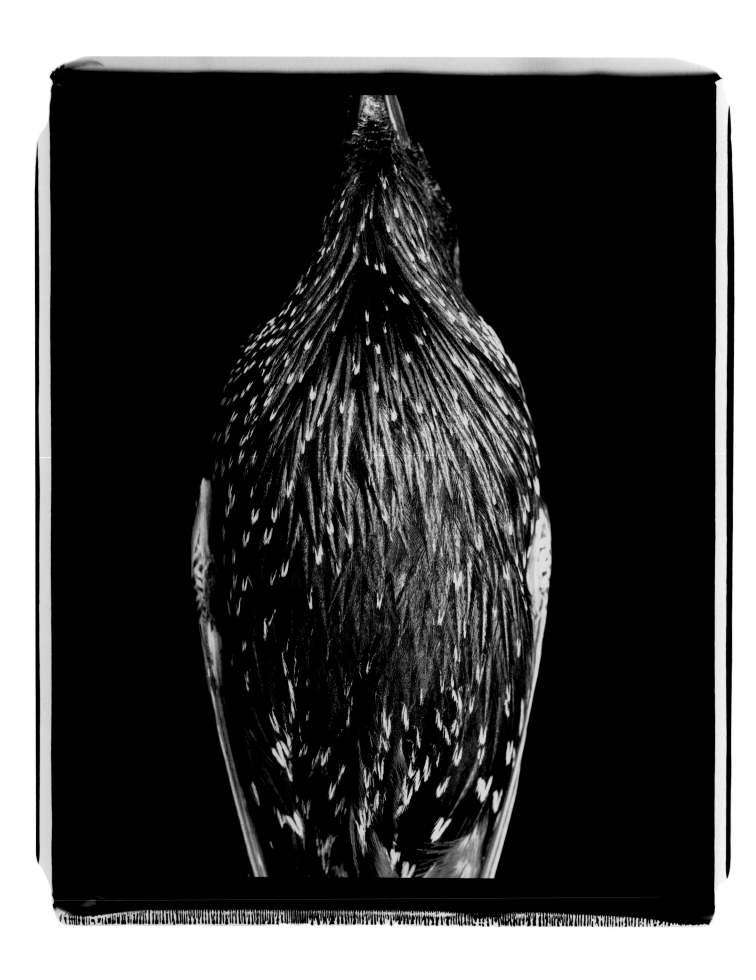

Mark Laita

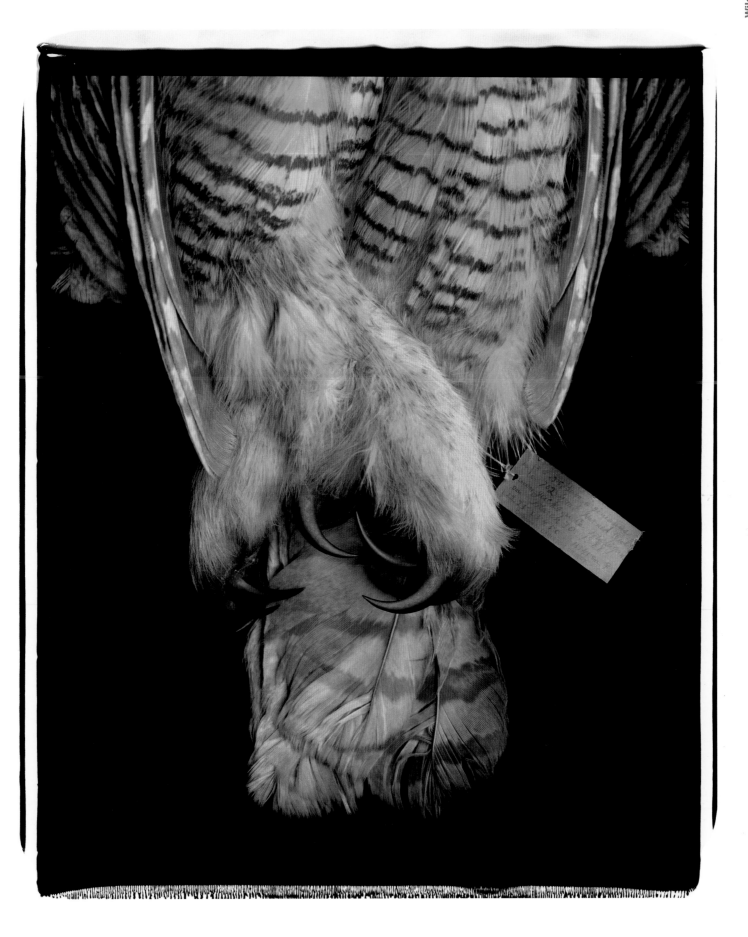

Mark Laita

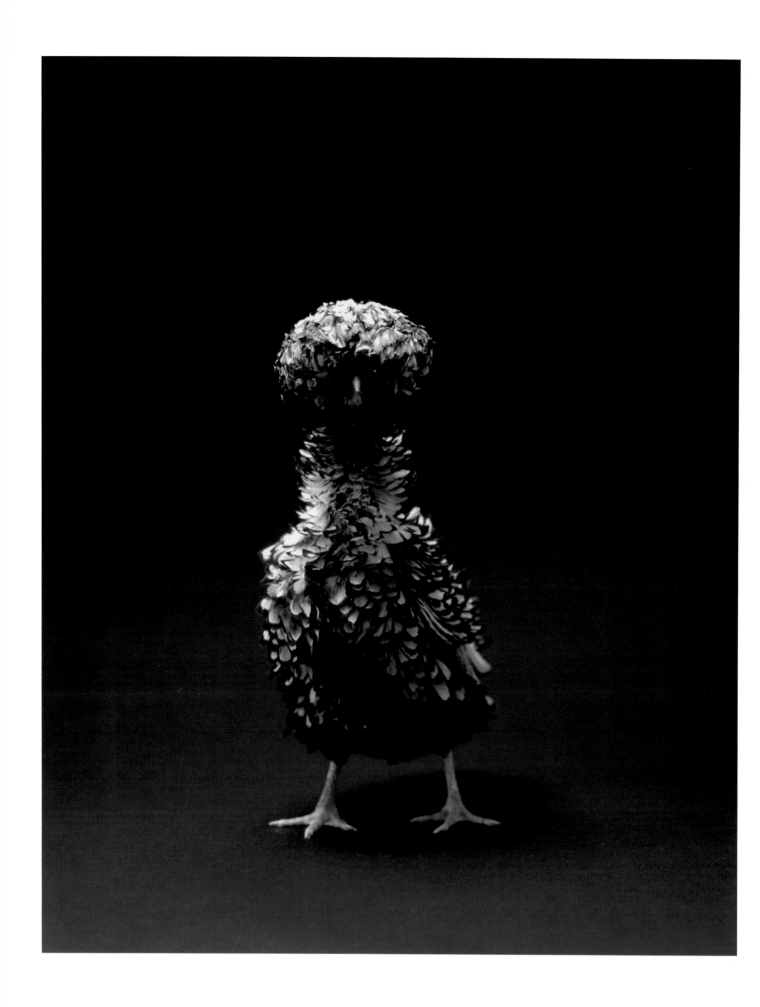

William Huber

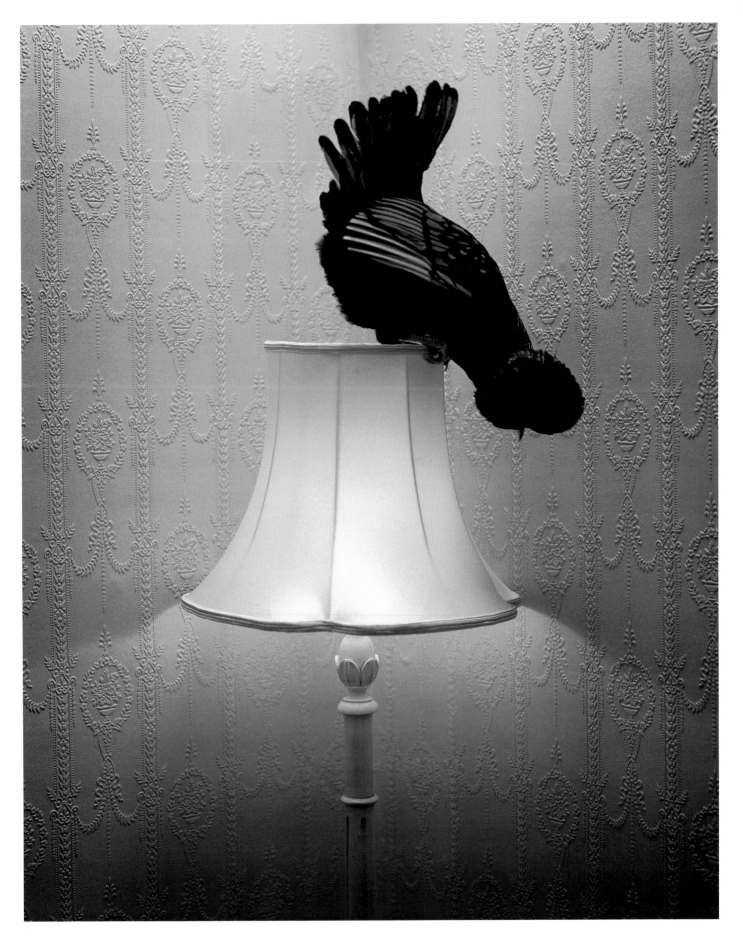

William Huber

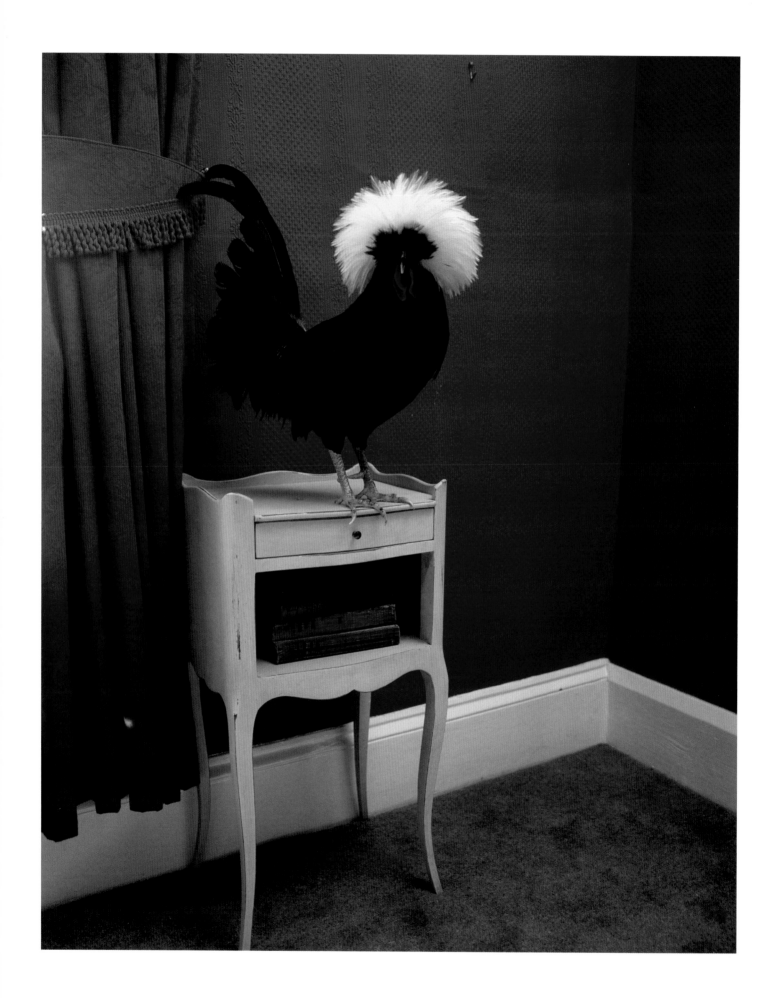

William Huber

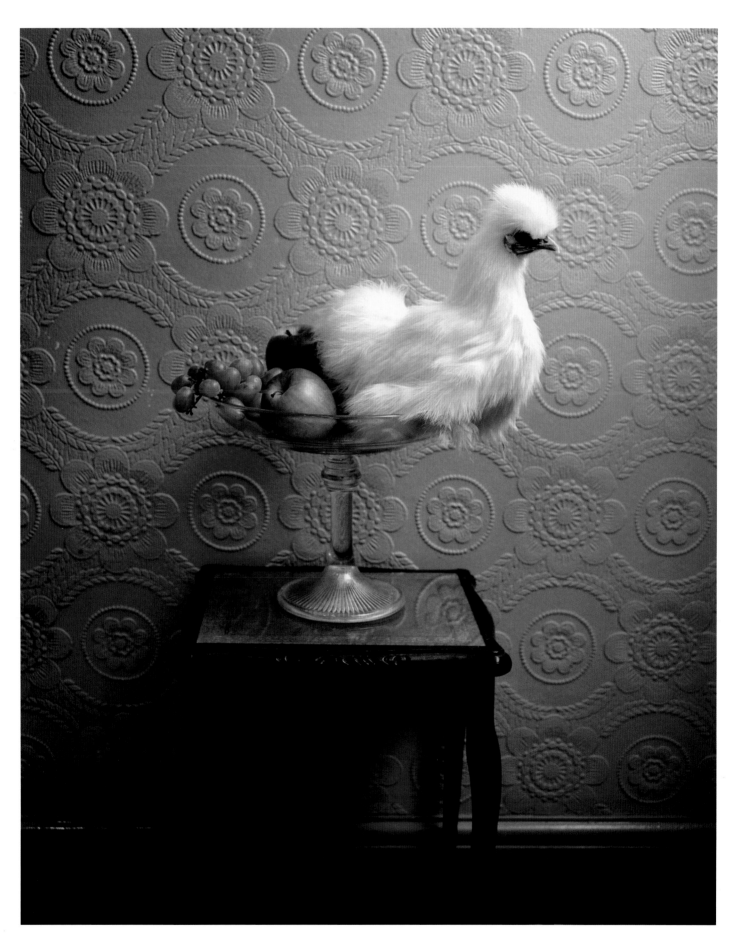

(this page) William Huber (next page) Jim Krantz

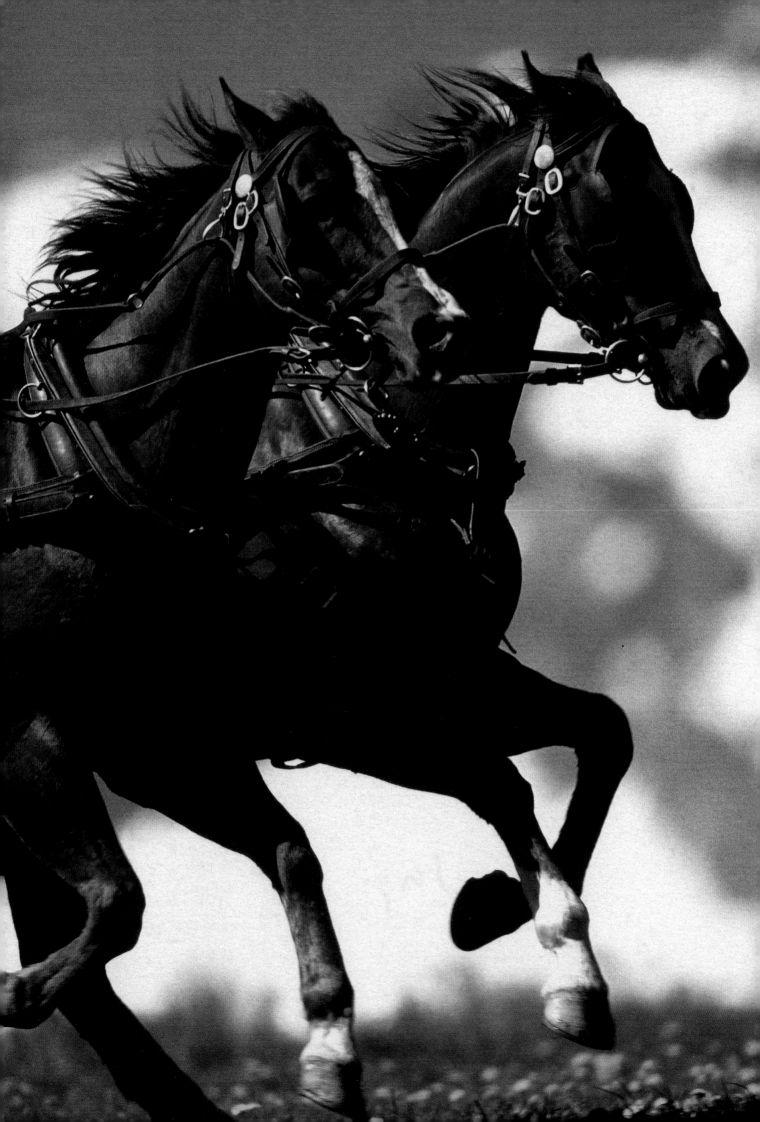

Andy Anderson
135 Bitterbush Street, Ste. D
Mountain Home, ID USA
Tel 208 587 3161

Anette Aurell
Newsweek Magazine
251 West 57th Street
Photo Department 15th Floor
New York, NY, USA, 10019
Tel 212 445 5113

Dick Baker
Saturn Lounge Photography
16622 W. Rogers Drive
New Berlin, WI, USA, 53151
Tel 262 821 3999
Fax 262 821 3910

Olaf Beckmann
PO Box 857
591 Deer Park Road
St. Helena CA, USA, 94574
Tel 707 968 0709

Natalie Behring
Discovery Communications
One Discovery Place
Sliver Springs, MD, USA, 20910
Tel 240 662 4683

Caterina Bernardi
2211 Castro Street # 201
San Francisco CA, USA, 94131
Tel 415 285 0330

David Bowman
4720 Lyndale Avenue South
Minneapolis MN, USA, 55419
Tel 612 209 0844

David Allan Brandt
1015 Cahuenga Blvd. #14C
Los Angeles CA, USA, 90038
Tel 323 469 1399
Fax 323 469 0522

Mauren Rubli Brodbeck
18, Chemin de Vers Plan-les-Ouates
Geneva, Switzerland, 1228
Tel +4122 534 0161
Fax +4122 534 0161

Steve Bronstein
B-hive Productions
38 Greene Street, 5th Floor
New York NY, USA, 10013
Tel 212 925 2999
Fax 212 925 3799

Mike Carsley Photography
35 Totteham Street
London, UK
Tel +44 20 76373937

Cristiana Ceppas
2169 Folsom Street #M105
San Francisco, CA, USA, 94110
Tel 415 553 8813
Fax 415 553 8813

Michele Clement Studio Inc.
879 Florida Street
San Francisco CA, USA, 94110
Tel 415 695 0100

Marcelo Coelho
8800 Venice Blvd. #210
Los Angeles CA, USA, 90034
Tel 310 204 4244

Chris Collins Studio
35 West 20th Street
New York NY, USA, 10011
Tel 212 633 1670

Craig Cutler
15 East 32nd Street 4th Floor
New York NY, USA, 10016
Tel 212 779 9755
Fax 212 779 9780

D'Amico Studios
700 South 10th Streer Studio 1A
Philadelphia PA, USA, 19147
Tel 215 923 8878
Fax 215 923 7244

Dazeley Studios
5 Heathmans Road Parsons Green
London, UK, SW6 4TJ
Tel +020 7736 3171
Fax +020 7371 8876

Stephanie Diani
656 South Ridgeley Drive #301
Los Angeles CA, USA, 90036
Tel 323 936 4905
Fax 323 936 490

Bill Diodato Photography
433 West 34th Street #17b
New York NY, USA, 10001
Tel 212 563 1724

Lonnie Duka Photography Inc.
352 Third Street, #304
Laguna Beach CA, USA, 92651
Tel 949 494 7057
Fax 949 497 2236

Chris Dunker
656 North 600 West
Logan UT, USA, 84321
Tel 435 752 5211

Paul Elledge
1808 West Grand
Chicago IL, USA, 60622

Tel 312 733 8021
Fax 312 733 3547

David Emmite
615 SE Alder Street, Suite 300
Portland OR, USA, 97214
Tel 503 239 5135
Fax 503 239 5170

Luis Ernesto Santana Photography
150 West 28th Street #1202
New York, NY USA
Tel 212 807 7020

Daren Fentiman
ZumaPress
2554 Lincoln Blvd. #511
Venice CA, USA, 90291
Tel 310 577 1864

Colin Finlay
ZUMA Press
2554 Lincoln Blvd. #511
Venice CA, USA, 90291
Tel 310 577 1864

Troye Fox
Saturn Lounge Photography
16622 W. Rogers Drive
New Berlin, WI, USA, 53151
Tel 262 821 3999
Fax 262 821 3910

Jim Gehrz
ZUMA Press
2554 Lincoln Blvd. #511
Venice CA, USA, 90291
Tel 310 577 1864

Chris Gordaneer
Westside Studio
70 Ward Street Toronto,
ON, CA, M6H 4A6
Tel 416 535 1955
Fax 416 535 0118

David I. Gross
ZUMA Press
2554 Lincoln Blvd. #511
Venice CA, USA, 90291
Tel 310 577 1864

Simon Harsent
Devin Monaco
511 West 25th Street
New York, NY, USA, 10001
Tel 212 647 0336

John Henley
1910 East Franklin Street
Richmond VA, USA, 23223
Tel 804 649 1400

Ethan Hill
Newsweek Magazine
251 West 57th Street
Photo Department 15th Floor
New York, NY, USA, 10019
Tel 212 445 5113

Timothy Hogan
135 West 26th Street, 6th Floor
New York NY, USA, 10001
Tel 212 967 1029
Fax 212 989 9144

William Huber Productions, Inc.
374 Congress Street, #503
Boston MA, USA, 02210
Tel 617 426 8205
Fax 617 426 8026

Wu Jianguo, Imaginechina
ZUMA Press
2554 Lincoln Blvd. #511
Venice CA, USA, 90291
Tel 310 577 1864

Brandon L. Jones Photography
2636 North 4th Street
Columbus OH, USA, 43202
Tel 614 309 0241

Gabriel Jones
41 Joralemon Street
Brooklyn Heights NY, USA, 11201
Tel 718 852 0880

JoSon Photography
1121 40th Street, Suite 2201
Emeryville CA, USA, 94608
Tel 510 653 1194
Fax 510 653 1194

Ira Kahn
4312 19th Street
San Francisco C.A, USA, 94114
Tel 415 626 8976

Nadav Kander
Alexia Politis
601 W 26th Street, Ste. 1150
New York NY, USA, 10011
Tel 212 598 2900
Fax 212 598 2938

Emy Kat
8-10 rue Titon
Paris, France, 75011
Tel +33 661 90 3344
Fax +971 4 347 5012

Sean Kernan
28 School Street
Stony Creek CT, USA, 06405
Tel 203 481 0213
Fax 203 488 6164

Gary Knight
Newsweek Magazine
251 West 57th Street
Photo Department 15th Floor
New York, NY, USA, 10019
Tel 212 445 5113

Jonathan Knowles Studio
48a Chancellors Road
London , UK, W69RS
Tel +44 20 8741 7577
Fax +44 20 8748 9927

Jim Kranrz
14 North Peoria Street
Chicago IL, USA, 60607
Tel 312 733 9958
Fax 312 733 9968

Hans Kwiotek
442 Shotwell Street
San Francisco CA, USA, 94110
Tel 415 378 8288

Brigitte Lacombe
Newsweek Magazine
251 West 57th Street
Photo Department 15th Floor
New York, NY USA
Tel 212 445 5113

Gary Land
Alexia Politis
601 W 26th Street Ste. 1150
New York, NY USA
Tel 212 598 2900
Fax 212 598 2938

Mark Laita
3815 Main Street
Culver City CA, USA, 90232
Tel 310 836 1645
Fax 310 836 1645

Jeff Ludes Photos
2028 Madison Avenue
Altadena CA, USA, 91001
Tel 626 791 8736

Phil Marco
137 West 25th Street
New York NY, USA, 10001
Tel 212 929 8082
Fax 212 463 0514

Robert Maxwell
Newsweek Magazine
251 West 57th Street
Photo Department 15th Floor
New York, NY USA
Tel 212 445 5113

Benjamin Mendlowitz Photography
PO Box 14, 751 Reach Road
Brooklin Maine, USA, 04616
Tel 207 359 2131

Alexa Miller
PO Box 4745
Bozeman MT, USA, 59772
Tel 760 920 1773

Jeff Minton
Newsweek Magazine
251 West 57th Street
Photo Department 15th Floor
New York, NY USA
Tel 212 445 5113

Patrick Molnar
346 Glendale Avenue
Atlanta GA, USA, 30307
Tel 404 378 5082
Fax 404 378 4196

Ted Morrison
286 Fifth Avenue Ste. 1207
New York NY, USA, 10001
Tel 212 279 2839
Fax 212 967 1848

Theo Morrison Photography
115 West Broadway #3
New York NY, USA, 10013
Tel 917 499 0457

Michael O'Brien
908 Eeast 5th Street, Ste. 116
Austin TX, USA, 78702
Tel 512 472 9205

Charles Ommanney
Newsweek Magazine
251 West 57th Street
Photo Department 15th Floor
New York, NY USA
Tel 212 445 5113

Bob Packert
319 A Street Rear
Boston MA, USA, 02210
Tel 617 357 8890
Fax 617 357 8891

Nigel Perry
Alexia Politis
601 W 26th Street Ste. 1150
New York, NY USA
Tel 212 598 2900
Fax 212 598 2938

Sean Perry Photographs
PO Box 49848
Austin TX, USA, 78765
Tel 512 454 1741

Directory of Photographers

Alessandra Petlin
115 West Broadway #3
New York NY, USA, 10013
Tel 917 743 2777
Fax 212 393 9210

Kah Leong Poon
1201 Broadway #711
New York NY, 10001, USA
Tel 212 685 0066

Rafferty/DeCristofaro
191 East Villa Street
Pasadena CA, USA, 91103
Tel 626 862 3948

Chris Rainier
1145 17th Street NW
Washington D.C. 20036 USA
Tel 202 429 5733

Joseph E. Reid
14 Harrison Place, #3R
Brooklyn NY, USA, 11206
Tel 1 917 769 6327

Reimers + Hollar
441 East Columbine Avenue, Ste. I
Santa Ana CA, USA, 92707
Tel 714 545 4022

TC Reiner
PO Box 6249
Santa Barbara, CA, USA, 93109
Tel 805 963 8817

Mark Richard
ZUMA Press
2554 Lincoln Blvd. #511
Venice, CA USA
Tel 310 577 1864

Dan Saelinger
631 11th Street
Brooklyn NY, USA, 11215
Tel 718 369 0228
Fax 718 369 0228

Gregg Segal
Newsweek Magazine
251 West 57th Street
Photo Department 15th Floor
New York, NY USA
Tel 212 445 5113

Jerome Sessini
Newsweek Magazine

251 West 57th Street
Photo Department 15th Floor
New York, NY USA
Tel 212 445 5113

James Salzano Studio, Inc.
29 West 15th Street
New York NY, USA, 10011
Tel 212 242 4820
Fax 212 463 0584

Howard Schatz Studio
435 West Broadway #2
New York NY, USA, 10012
Tel 212 334 6667
Fax 212 334 6669

Christian Schmidt Photography
Silberburgstrasse 119 A
Stuttgart , Germany, 70176
Tel +49 711 615 1133
Fax +49 711 615 1132

Tami Silicio
ZUMA Press
2554 Lincoln Blvd. #511
Venice, CA USA
Tel 310 577 1864

Brent Stirton
Discovery Communications
One Discovery Place
Sliver Springs, MD, USA, 20910
Tel 240 662 4683

Shimon & Tammar Rothstein
210 West 29th Street
New York NY, USA, 10001
Tel 212 290 2995

George Simhoni
Westside Studio
70 Ward Street
Toronto, ON CA
Tel 416 535 1955
Fax 416 535 1955

Marcus Swanson Studio Inc.
1526 NW 17th Avenue
Portland OR, USA, 97209
Tel 503 228 2428
Fax 503 228 2122

Brett Traylor
61 Parnassus Avenue
San Francisco, CA USA
Tel 415 681 8137

Leonardo Vilela
Platinum, FMD
Rua do Catete,92
Casa 19, Catete Rio
De Janeiro, RJ Brazil
Tel +5521 22257224
Fax +5521 22257224

Janez Vlacy
Grintovska 25
1000 Ljubljana, Slovenia
Tel 003 864 185 5740

Frank Wartenberg
Leverkusenstr. 25, 22761
Hamburg, Germany
22761 Hamburg, Germany
Tel +49 40 850 8331

Yonathan Weitzman
ZUMA Press
2554 Lincoln Blvd. #511
Venice CA, USA, 90291
Tel 310 577 1864

Matthew Welch
743 South Citrus Avenue
Los Angeles CA, USA, 90036
Tel 323 549 0251
Fax 323 549 0231

Georg Wendt
Jung von Matt AG
Hasenheide 54
Berlin, Germany
Phone +49 30 78956311
Fax: +49 30 78956119

James Worrell
307 West 38th Street #1201
New York NY, USA, 10018
Tel 212 367 8389
Fax 212 604 9887

David Zimmerman
19 Mill Pond Road
Otisville NY, USA, 10963
Tel 845 386 8085
Fax 845 386 8085

Photographers

CreativeContributors

Credits&Comments

Pages 14,16,17
Los Angeles Series
Photographer Mauren Brodbeck

Pages 18, 19, 20
Transitory
Photographer/Client Sean Perry
Transitory is a series of industrial landscapes and architecture images presented as metaphors of various struggles and relationships within modes of communication. Photographing under certain conditions of light and tone, I have rendered static structures as symbols displaying an unexpected beauty and graceful clarity, only briefly revealed. The work is being exhibited nationally with hopes of a broader commercial application in campaigns and or annual reports design.

Page 21
The Oscar Niemeyer Series
Photographer Marcelo Coelho
A personal series about the early work of Oscar Niemeyer, one of the great legends of modern architecture in the 20th Century. It features his work in Belo Horizonte and Brasilia, Brazil. The first city was the project that encouraged Juscelino Kubitscheck, the President in the late 50's, to create a new capital for Brazil: Brasilia.

Page 22
Mitsubishi Eclipse 2006
Photographer Jeff Ludes
Art Director Talin Baharian
Creative Director Ross Patrick
Client Deutsch
Images for the brochure of the 2006 Eclipse, a new design that returns the styling to its aggressive and sporty roots.

Page 24
Pontiac Pursuit
Photographer George Simhoni
Art Director John McDougall
Creative Director Sean Davison
Writers Joe Musicco, Jonathan Frier
Client Pontiac
Imagine yourself in a new Pursuit from Pontiac.

Pontiac Solstice
Photographer George Simhoni
Art Director Peter Knight
Writer Gary Lennox
Client Pontiac
New sports car blowing the doors off as it passes others.

Page 25
GMC Plane, GMC Hose
Photographer Chris Gordaneer
Art Director John Mcdougal
Client GMC

Image shot to launch Pontiac G6 campaign

Pages 26, 28
Fashion Orchestra
Photographer Caterina Bernardi
Art Director/Creative Director Wiesia Mancewicz
Designer Washington Theotonio
Client Zefa Images
Fashion Orchestra: Wardrobe and instruments express a musician's souls

Page 29
"Find your Center"
Photographer White/Packert
Art Director Brian Wood
Creative Director Artie Megibben
Copywriter/Creative Director Matt Bergeson
Client Fashion Center Dallas
The assignment was to create a series of dramatic "fashion portraits" to be used in trade publications and posters, drawing buyers to The Fashion Center Dallas. Using the tag line "Find Your Center." Each image was to be thought provoking and calm, using dramatic lighting and converting to tinted Black & White images.

Page 30
Opinions For Sale
Photographers Joseph Rafferty, Angela DeCristofaro
Client Bloomberg Financial
This series of photographs entitled "Opinions For Sale" for Bloomberg financial magazine illustrates the way in which banks will seek the advice/counsel of other banks before giving their own advice to a lucrative client.

Pages 31, 32
Hat Series
Photographer/Art Director Cristiana Ceppas
Client Cristiana Ceppas
Personal series of models with hats.

Page 33
Negative Thinking
Photographers Joseph Rafferty, Angela DeCristofaro
Client Oprah Magazine
This series of photographs created for Oprah Magazine is a stylistic combination of vintage cinematic and painterly inspirations, using humor and irony to illustrate various situations regarding negative thinking.

Page 34
Walking On Rooftops
Photographers Joseph Rafferty, Angela DeCristofaro
The grouping of photographs, "walking on

rooftops", is a highly stylized set of fashion imagery, showcasing shoes and hosiery. Vintage black and white cinema is a primary source of imagination and inspiration. We will be presenting these images as well as our upcoming fashion series for December to a list of applicable fashion clients.

Page 35
By The Sea
Photographer Matthew Welch
Art Director Tanya Watt
Client Flare Magazine
Fashion Editorial.

Page 36
Untitled
Photographer Timothy Hogan

Pages 37, 38
Rayban, Under the Table
Photographer/Client Bill Diodato

Pages 39
Shoe Locker
Photographer/Client Reimers + Hollar

Page 40
Swim Wear 2
Photographer Kah Leong Poon
Client Flow the Magazine

Page 41
Natalia
Photographer TC Reiner
Client Q Models

Page 42
Fashion Orchestra
Photographer Caterina Bernardi
Art Director/Creative Director Wiesia Mancewicz
Designer Washington Theotonio
Client Zefa Images
Fashion Orchestra: Wardrobe and instruments express a musician's souls

Page 43,44
Fantasy, Fantasy Nude, Snuggle
Photographer Michele Clement
Client David Beal

Page 45
Autumn Leaves
Photographer/Client Bill Diodato

Page 46
Hell
Photographer Georg Wendt
Art Director Christian Bobst
Creative Director Burkhart von Scheven

Credits&Comments

Illustrator Paul Roberts
Writers Mirko Stolz, Jan Harbeck
Client Melinda's Figueroa Brothers

Page 48
Metro
Photographer Leonardo Vilela
Art Director Diogo Mello
Creative Director Marco Dias
Designer Flavio Albino
Illustrator Luciano Honorato
Client 3G Optimus
Fast Internet company. You
can receive heavy e-mails anytime.

Octopus
Photographer Leonardo Vilela
Art Director Paulo Salgueiro
Creative Director Luiz Nogueira
Designer Flavio Albino
Illustrator Luciano Honorato
Client Falmec

Page 49
Untitled
Photographer/Art Director
Creative Director/Designer
Phil Marco

Page 50
Orchis
Photographer/Art Director
Creative Director JoSon
Client Fotanical

Page 52
Stem
Photographer/Client Bill Diodato

Page 53
Calla 357
Photographer/Client
Brandon Jones
Produced purely for personal work.

Page 54
Tulips 3
Photographer/Client
Brandon Jones
This is 35mm shot for personal work
and experimentation.

Page 55
Birds of Paradise
Photographer/Client
Brandon Jone
This photograph was for my
personal work

Pages 56, 57
Photographer Lonnie Duka
Client Duka Photo
Color study of orange sunflower.

Page 58
Photographer
Client Ted Morrison

Page 59
Sex Among the Lotus Exhibition
Designers Brett Traylor,
Pentagram Partners
Client Museum of Sex
This image was used as the identity for an
exhibition of Chinese erotic art, titled "Sex
Among the Lotus: 2500 Years of Chinese
Erotic Obsession." It was used on all the
communications materials for the exhibition:
posters, advertisements, mailings, etc.

Pages 60
Bread Spread
Photographer/Client
Reimers + Hollar

Page 62
Canaletto S.F.
Photographer Ira Kahn
Canaletto S.F. is a piece of fine art, 35" x 46".
It's a statement about San Francisco that
embraces qualities particular to the city and
the region. I took the emphasis away from
trite subjects in familiar contexts in order to
express her grace and her stately beauty.

Pages 63
Fish Scale
Photographer/Client
Reimers + Hollar

Page 64
Sundays Suppers
Photographers Tammar Shimon
Writer Suzanne Goig
Client Knopf Publicity

Page 65
In the Face, Guy Splash;
In the Face, Girl Splash
Photographer Steve Bronstein

Pages 66, 68, 69
Untitled
Photographer/Client Craig Cutler
A series of window studies taken from the
interior of an empty corporate office in Time
Square

Page 70
Indonesian Earthquake:
Identifying the Dead
Photographer David I. Gross
Client ZUMA Press
January 11, 2005; Khao Lak, Thailand;
Corpses lie on the ground in a dry ice mist,
keeping cool, while volunteers take a rib for
DNA samples, at the Yan Yao temple in
Thailand where forensic scientists are work-

ing on the identification and storage of the
dead. Most of the bodies are Thai, but occa-
sionally a foreigner is found. Mandatory
Credit: Photo by David I. Gross/ZUMA
Press.

Pages 72, 73
Off To War: Iraq
Photographer Brent Stirton
Photo Editor Linda Samuel
Client Discovery Times Channel
Arkansas National Guard is stationed in Taji,
Iraq. Filmed for the Discovery Times
Channel program, Off To War.

Pages 74, 75
Off to War: Homecoming
Photographer Brent Stirton
Photo Editor Linda Samuel
Client Discovery Times Channel
The Arkansas National Guard returns home
after serving for 14 months in Iraq. Photos
used to promote Discovery Times Channel
program, Off to War.

Pages 76, 77
Against All Odds
Photographer Jim Gehrz
Client Minneapolis Star Tribune,
ZUMA Press
U.S. Army Staff Sergeant Jessica Clements,
27, was given less than 2% chance of survival.
She is one of 12,000+ U.S. soldiers wounded
(more than 1,600 have been killed) in the
Iraq War. Clements, a former model and mas-
sage therapist, was critically injured outside
Baghdad when a roadside bomb exploded
beneath her convoy sending shrapnel into the
right side of her brain. Clements beat the
odds with courage and character. Behold her
life-affirming, miraculous recovery.

Page 78
A War's Hidden Hands
Director of Photography
Simon Barnett
Photographer Jerome Sessini In Visu
Photo Editor James Wellford
Client Newsweek
A Man lies in the streets of Najaf after police
open fire on protestors there. Hundreds of
loyal Shiite supporters came from all over
Iraq to accompany the Ayatolla Sistani in
Najaf who had come to bargain for a peace-
ful alliance and an end to the crisis in the
Holy city with the Medhi, loyal supporters of
Moqtada al Sadr.

House Raid in Tikrit
Director of Photography
Simon Barnett
Photographer Gary Knight VII
Photo Editor James Wellford
Client Newsweek

Credits&Comments

A raid in the city of Tikrit during which plastic explosives were recovered. A number of people were detained. Members of TF/122 part of the fourth ID were involved.

Page 79
21 Flag Draped Coffins Returned to US
Photographer Tami Silicio
Client ZUMA Press
April 09, 2004; Kuwait, Kuwit; Exclusive! twenty-one flag draped coffins are carefully strapped down and checked prior to being returned to the United States aboard US military transport aircraft. The soldiers were all killed in Iraq. Mandatory Credit: Photo by Tami Silicio/ZUMA Press

Page 80
Surgeons
Director of Photography
Simon Barnett
Photographer Jeff Minton
Photo Editor Sue Miklas
Client Newsweek
Surgeons at work

Page 81
Atlas: China
Photographer Natalie Behring
Art Director Yoni Sandler
Photo Editor Nancy Walz
Client Discovery Channel

Page 82
Indonesian Earthquake:
Survivors Portraits
Photographer Yonathan Weitzman
Client ZUMA Press 1.) Jan 08, 2005; Matera, Sri Lanka; K.H. Gilan and B. Jayarathna, fishing partners, stand in front of their boat ruined by the Tsunami in Matera, Sri Lanka. 'My daughter swallowed a lot of water during the flood. Our boat landed 5 km from where it was docked and now we are trying to repair it.' Mandatory Credit: Photo by Yonathan Weitzman/ZUMA Press 2.) Jan 08, 2005; Hikkadua, Sri Lanka; The Apasra Family stands in front of their ruined house destroyed during the tsunami in Hikkadua, Sri Lanka. 'There was nobody hurt in our family and I was at work and my wife said she saw the sea water becoming brown and strange and ran into the jungle with the children. When I came back I found our destroyed house and found my family after two days in a refugee camp.' Mandatory Credit: Photo by Yonathan Weitzman of ZUMA Press 3.) Jan 08, 2005; Wellawawta, Sri Lanka; E.Jayantha, 43, stands on the ruins of his house in Wellawawta, Sri Lanka, holding pictures of his daughter and wife. 'I was working as a porter when the Tsunami hit. I went to the second floor of a house and I waited until the danger was over and

returned to see my house totally destroyed. After 3 days of looking for my family, a soldier came to my sisters house with these photos. I was relieved with this confirmation, not like others who do not know the fate of their family.' Mandatory Credit: Photo by Yonathan Weitzman/ZUMA Press

Page 83
To Have and to Hold/Raising Kevion
Photographer Alessandra Petlin
Art Director Kathy Ryan
Writer Jason DeParle
Client The New York
Times Magazine
August 22, 2004 cover of The New York Times Magazine on welfare reform. The article tells the story of Ken Thigpen, who traded his life as a pimp and a drug dealer for one as a pizza delivery man to raise his son Kevion alongside Jewel, Kevion's mother. Welfare reform which targets single-mother families has sent many more women than men into the work force, transforming their lives. But evidence shows that it has not necessarily improved the lives of their children. The missing link being a consistent father/partner making Ken an anomaly.

Pages 84, 85
My Husband's Cancer
Photographer Stephanie Diani
Several weeks before our one-year anniversary, and almost a year exactly from the date my mother's second bout with cancer began, my husband was diagnosed with non-Hodgkin's lymphoma. Photographing him throughout his six-month treatment helped me to put the disease in a box that I could carry, and gave me an outlet for the rage, anxiety and exhaustion that I felt.

Pages 86, 87
Young Breast Cancer Survivor
Director of Photography
Simon Barnett
Photographer Anette Aurell
Photo Editor Sue Miklas
Client Newsweek
Breast cancer survivor, Suellen Bennett, at home in North Brunswick, New Jersey

The New Face of AIDS
Director of Photography
Simon Barnett
Photographer Anette Aurell
Photo Editor Sue Miklas
Client Newsweek
Woman suffering from AIDS.

Page 88
Windmill
Photographer George Simhoni
Art Director Marcella Coad

Creative Director Phil Copithorne
Client Enbridge
Enbridge, a gas and power company, showing the serenity and peacefulness of the windmill electric farm versus coal.

Page 90
Rock wall at Etude's vineyards
Photographer Olaf Beckmann
Designer Kimiko Chan
Client Etude Wines
We wanted to show the land next to the vineyards, the interaction between the vines and the landscape.

Page 91
Tinyhomes.com
Photographer John Henley
Art Director Tyler Darden
Client Virginia Living Magazine

Page 92
Yunnan Province in Southwestern China
Photographer Wu Jianguo
Client Imaginechina/ZUMA Press
Yunnan province, China; Farming Ladder fields, or terraced fields in Yunnan pro-vince of southwestern China. Mandatory Credit: Photo by Wu Jianguo, Imagine-china, ZUMA Press

Page 93
Route 66
Photographer Mark Richards
Client ZUMA Press

Page 94
Argentina
Art Director/Photographer
Client Andy Anderson

Page 95
Four States: Compositions
Photographer Theo Morrison
This is a series of personal work shot while traveling throughout the country on various editorial jobs. My hope is that the work creates a dialogue about the way that humanity relates to nature in its physical manifestations. With that said, I also hope the work speaks for itself.

Pages 96, 97
Churches I & II
Photographer Chris Gordaneer
Images shot for Portfolio

Pages 98,99
Silo's I, II, III & IV
Photographer Chris Gordaneer
Art Director Angela Sung
Shots Taken in Alberta for Portfolio

Credits&Comments

Credits&Comments

Joe Paprocki
Client Atlanta Food Bank
Advertisement for Atlanta Food Bank.

Pages 142, 143
Christina Ricci, Mark Zupan
Photographers Nigel Perry, Gary Land
Art Director Warren Eakins
Creative Director
Randy Van Kleeck
Client Reebok

Page 144
Amelie Mauresmo
Photographer Nadav Kander
Art Director Warren Eakins
Creative Director
Randy Van Kleeck
Client Reebok

Page 145
Lance Armstrong
Photographer Marcus Swanson
Art Director Janet Jenkins
Client Nike Inc.

Page 146
Ira Yeager in his Napa Valley Studio
Photographer Olaf Beckmann
Art Director Linda Corwin
Client Napa Valley Museum

Page 147
Magazine
Photographer Alessandra Petlin
Photo Editor Freyda Tavin
Client Entertainment Weekly
Portrait of actress and author Jane Fonda for a feature on her in conjunction with her memoir. Psychological portrait is reflective of the two worlds she lives in her interior life and her famous outward persona as suggested in the image of a different room being reflected in the mirror behind Jane.

Page 148
Untitled (Atong-Profile)
Photographer David Allan Brandt
Art Director Jonathan Meitus
Client Sony
Part of Advertising Campaign.

Page 149
Portrait3
Photographer Simon Harsent
Client Simon Harsent

Page 150
Julius
Photographer Dazeley
Client Zefa Images

Page 151
Airstream Lady

Photographer/Art Director
Troye Fox
Client Saturn Lounge Photography
Self-Promotional Piece

Page 152
John Keston
Photographer David Emmite
Creative Director Adam Goff
Client New Scientist Magazine
This is a portrait of John Keston. He is a 70-year-old man, who is still running and winning marathons.

Page 153
Bull fighter
Photographer/Art Director
Client James Salzano
Bull-fighter Aculpoco, Mexico, this is part of a personal series on bull-fighters. These photos will appear as self-promotion.

Page 154
Ryan
Photographer/Client Bill Diodato

Page 155
Childhood
Art Director/Photographer JoSon
Client Getty Images

Page 156
Dean in the Primaries
Director of Photography
Simon Barnett
Photographer Charles Ommanney
Photo Editor Michelle Molloy
Client Newsweek
Dean in the Primaries
Potential Democratic Presidential candidate Howard Dean does local (Iowa) TV interviews as the Caucus gets under way. Ames, Iowa, January 19, 2004.

Page 157
Actors Later in Life
Director of Photography
Simon Barnett
Photographer Gregg Segal
Photo Editor Paul Moakley
Client Newsweek
Vamping: The Jefferson's try some lines at home in Los Angeles. Edith, 89 and Joseph Jefferson 82, have become actors late in life. Photographed at home in Los Angeles while acting out a few scenes. December 2004.

Pages 158, 159
Nude Faces
Photographer/Art Director
Creative Director/Client
Janez Vlachy
Pictures for my exhibition, studio photography, self promotion

Page 160
Mr Bryant, D-Day Veteran
Photographer/Art Director
Client Hans Kwiotek
In June 2004 I went to the D-Day beaches in the Normandy for the third time to continue photographing the remaining military installations and D-Day veterans (during the celebrations for the 60. anniversary of D-Day). Mr Bryant's portrait is part of a series of veterans I was honored to photograph at the place where he landed on D-Day, June 6, 1944.

Page 161
Feet
Photographer/Art Director
Client David Zimmerman

Pages 162, 163, 164, 165
Petrol Station Bathrooms
Art Director Ron Salmon
Client DDB London

Pages 166, 168, 169, 170, 171
Furniture Nudes
Art Director Gunter Frivert
Client Pomp
Campaign for furniture store

Page 172
Lipsticks
Photographer/Client Bill Diodato

Page 173
Faucet
Art Director/Photographer
Dick Baker
Client Saturn Lounge Photography
Self-Promotional Piece

Pages 174, 175
Fragrances, Men's Accessories,
Brown Beauty, Blue Beauty
Art Director/Photographer
Luis Ernesto Santana
Client Luis Ernesto
A series of four promotional cards to introduce the photographer to prospective clients. Cards can be stored in its own envelope or detached at perforation for display.

Pages 176, 177
Topkote
Photographer Craig Cutler
Creative Director/Designer
Carol Layton
Writer Doug Kamp
Client Unisource
To use photography of fabrics to illustrate the excellent printability of an imported coated paper. To play off the name of the paper by using "topcoats" for imagery

Credits&Comments

Credits&Comments

Graphis www.graphis.com

GraphisBooks

DesignAnnual2006

October 2005
Hardcover, 256 pages;
300 color photographs;

Trim size: 8 1/2 x 11 3/4"
ISBN:1-931241-47-3
US $70

GraphisDesignAnnual2006 is the first Annual ever produced by Graphis and has been a consistent best seller. The definitive presentation of more than 300 of the year's most outstanding graphic work produced in all the design disciplines. The award winning work is conveniently categorized for easy referencing into sections such as annual reports, corporate identity, editorial, exhibits, interactive, letterheads, logos, packaging, and typographic design with an extensive index.

Letterhead 6

October 2004
Hardcover, 256 pages;
300 full-color photographs;

Trim size: 8 1/2 x 11 3/4"
ISBN: 1-931241-20-1
US $70

A striking collection of stationery designs that seamlessly combines art and function to visually represent a client's identity. This powerful communication tool is explored through more than 300 original letterhead designs, convenie-ntly arranged by business category and indexed for reference. In addition to an unparalleled reproduction quality, *Letterhead6* features a story by collector Norman Brosterman that focuses on 19th C. art used for fine letterheads.

AdvertisingAnnual2006

November 2005
Hardcover, 256 pages;
300 color photographs;

Trim size: 8 1/2 x 11 3/4"
ISBN:1-931241-48-1
US $70

GraphisAdvertisingAnnual2006 is the advertising art community's premiere showcase of print ads from around the world. Registering the pulse of advertising creativity, this high quality Annual is arranged into trade categories such as automotive, beauty & cosmetics, corporate, and sports. Over 300 examples of single ads and campaigns, plus detailed credits and indexes ensure that art directors, account managers, and graphic designers will find this edition an invaluable reference tool.

AnnualReports2005

July 2005
Hardcover, 224 pages;
400 color photographs;

Trim size: 8 1/2 x 11 3/4"
ISBN: 1-931241-42-2
US $70

GraphisAnnualReports2005 presents the best 33 reports, selected by a jury of some of the best designers of annual reports in the business. Each piece was reviewed for clear concepts in appropriately presenting the clients business as well as for design. The jury consisted of Dana Arnett, Jill Howry, Tom Laidlaw, Greg Samata and Michael Weymouth who has an essay on A/R's along with "Investor Relations Magazine" on what makes for a successful or unsuccessful CEO letter.

NewTalent2005

"The experience of seeing your work published for the first time is like having your first love affair. You can't wait to scream it out to the world."

April 2005
Hardcover, 256 pages;
500 full-color illustrations;

Trim size: 7 x 11.75"
ISBN: 1-931241-44-9
US $70

GraphisNewTalentDesignAnnual2005 is the only international forum giving students the recognition and exposure they deserve. Showcased in full color, featured works include examples of effective advertising, corporate identity design, photography, packaging, and product design. Included is an interview with the progressive design school Ecole Cantonale d'art de Lausanne "ECAL" Director Pierre Keller with his exciting result directed education program in Switzerland.

PosterAnnual2005

July 2005
Hardcover, 256 pages; 300
plus full-color photographs;

Trim size: 8 1/2 x 11 3/4"
ISBN: 1-931241-43-0
US $70

GraphisPosterAnnual2005 presents outstanding poster design by the world's leading graphic designers. This edition shows a variety of graphic virtuousity and modes of expression that only this powerful medium makes possible. Featuring Commentary with Rene Wanner poster collector from Basel Switzerland and a Q+A with the Ginza Graphic Gallery Creative Team on what qualifies posters for their museum design collection, and what they predict may be the values in the future.

GraphisBooks

PackagingDesign9

October 2004
Hardcover, 256 pages; 300
plus full-color photographs;

Trim size: 8 1/2 x 11 3/4"
ISBN: 1-931241-38-4
US $70

Interactive3 is the premier international presenta-tion of brilliantly produced websites and interac-tive media. The dynamic visuals of this still emerging industry were all created over the past two years. Included are more than 100 award win-ning results by some of the top art directors, designers, programmers, developers along with their clients all listed in the index for convient ref-erence. Also included is an article on the design media firm of Bob Greenberg of R/GA.

InteractiveDesign3

July 2005
Hardcover, 256 pages;
300 full-color illustrations;

Trim size: 8 1/2 x 11 3/4"
ISBN: 1-931241-45-7
US $70

GraphisPackagingDesign9 is an international col-lection of the best 3-D designs. As packaging design becomes more integrated into a full circle branding campaign, our selection focuses on the highest stan-dards of execution and innovation Divided into cat-egories such as food & beverage, promotion, and cosmetics, this edition includes detailed indexes and credits. Q+A with package collector Tamar Cohen, a case study of VOSS Water, and a sampling of inno-vative materials from Material ConneXion library

Brochures5

September 2004
Hardcover, 256 pages;
300 full-color illustrtions;

Trim size: 8 1/2 x 11 3/4"
ISBN: 1-931241-37-6
US $70

In today's corporate communications clutter design-ers are challenged more than ever to conceive and produce high quality brochures. The fifth edition of *Brochures* presents more than 250 international designers and showcases complete design solutions and techniques with reproductions of covers, details and inside spreads. An index provides creative per-sonnel, clients, and design firms. Includes Q+As with Taku Satoh, Anders Kornestedt, and the duo Terry Vine/Lana Rigsby.

PromotionDesign2

November 2003
Hardcover, 256 pages;
300 full-color photographs;

Trim size: 8 1/2 x 11 3/4"
ISBN: 1-931241-15-5
US $70

GraphisPromotionDesign2 is an international collection of the best designs created for various promotional purposes. The pieces shown range from holiday greetings and wedding announce-ments, to film premiere and retail openings. Detailed indexes, credits, and other information about each design firms is included, plus categories such as corporate, fashion, food & beverage, and awards. Commentary with Charles S. Anderson, Domenic Lippa, and Richelle J. Huff.

Logo6

October 2004
Hardcover, 256 pages;
300 full-color photographs;

Trim size: 8 1/2 x 11 3/4"
ISBN: 1-931241-19-8
US $70

This is the best book on logos available, with the examples of logos, corporate symbols, and trade-marks by top designers from around the world, this collection is an invaluable resource for design firms, clients and students alike. All logos are indexed for easy reference, and presented with a description of the business they serve. Stories include the making of the logo for the city of Venice under the creative direction of Philippe Starck and interviews with designers working in an illustrated logo vein.

Nudes4

November 2005
Hardcover, 272 pages; 300
plus full-color images;

Trim size: 10 1/2 x 14"
ISBN 1-931241-49-X
US $70

Nudes4 presents the body's infinite possibilities through the work of internationally acclaimed photographers who have explored the diverse beauty of the nude figure. With it's international scope, *Nudes4* is an elegant presentation that will continue to inspire and intrigue an audience as diverse as its contents.